LIFE

SENTENCES

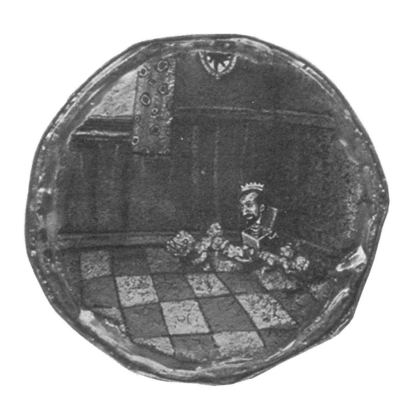

LIFE

SENTENCES

WRITERS, ARTISTS, AND AIDS

Edited and with an Introduction
by Thomas Avena

MERCURY HOUSE
SAN FRANCISCO

Published in the United States by
Mercury House
San Francisco, California

An earlier version of "Spiral," including the accompanying image, appeared in *Memories That Smell Like Gasoline,* © The Estate of David Wojnarowicz, 1992. Poems from *What Silence Equals,* by Tory Dent. © 1993 by Tory Dent. Reprinted by permission of Persea Books. "At the Post Office," "Post Script: The Panel," and an extract from "The Second Month of Mourning" first appeared in *The Threepenny Review.* "Explosion of Emptiness" and "A Wart on My Foot" originally appeared as "El Estampido de la Vacuidad." © Severo Sarduy, 1993 and Heirs of Severo Sarduy. Artwork by Jerome Caja © 1992 Jerome Caja. Photograph of Diamanda Galás by T. J. Eng.

Frontispiece: "Charles as King of the Broken Dolls" by Jerome Caja. 5-1/2 inches in diameter; ash on metal.

United States Constitution, First Amendment: Congress shall make no law respecting an establishment of religion, or prohibiting the free exercise thereof; or abridging the freedom of speech, or of the press; or the right of the people peaceably to assemble, and to petition the Government for a redress of grievances.

Mercury House and colophon are registered trademarks of
Mercury House, Incorporated
Printed on recycled, acid-free paper
Manufactured in the United States of America

Library of Congress Cataloging-in-Publication Data

Life sentences : writers, artists, and AIDS / edited by Thomas Avena.
 p. cm.
ISBN 1-56279-063-3 (cloth) / ISBN 1-56279-051-X (paper)
1. AIDS (Disease) and the arts — United States. I. Avena, Thomas.
NX180.A36L54 1994
700'.1'03 — DC20 93-38922
 CIP

5 4 3 2 1

To William Lyon Strong,
whose support and insight into every aspect of this
endeavor made its fulfillment possible

CONTENTS

ACKNOWLEDGMENTS

THOMAS AVENA

PRIMARY THANKS are due to the editors and staff of Mercury House: to Hazel White, for her superlative copyediting; to Thomas Christensen, whose recognition of the value of this project encouraged me to continue; to Sandy Drooker and David Peattie, for their striking cover and text design; to William Brinton, Po Bronson, Ellen Towell, Barbara Stevenson, Cindy Gitter, Joni Owen, Kristien Dinelli, Jon Boilard, and Katy Kennedy; and, finally, to Kirsten Janene-Nelson, for her patience and professionalism.

Many individuals have given graciously and selflessly to this endeavor; I would like to extend my appreciation: to Marilyn Sobel, James Lough, Ilene Wolff, and Ellen Romano, for their readings, editing, and advice; to Richard Nardi for his expert and extensive computer support; to Jewels Drury for audio reproduction of interviews (courtesy Mieuli & Associates); to Marina Berio for her assistance in securing Nan Goldin's cover photo; to Suzanne Jill Levine for alerting us to Severo Sarduy; to Billi Goldberg, Charles Caulfield, Blaine Ellswood, Jim Henry, and all the other guerrillas; to Jim Lightinheart and Leola Jiles, who joined me in defying prediction; to Jason Dilley for creating and directing Project Face to Face, to James Curtiss for guiding it, and to D. S. Black for assisting me in editing that project and for divining this book's name; to Jain Haggerstone, Nonie Greene, Todd Werby, Donna Hughs, Kyle Roberts, Brenda Lee, Mark Spainhower,

Yahya Salih, Mark Geller, Dan Carmell, Akiba Onada-Sikwoia, Roberta Ruozzi, Howard Pugh, Jennifer Wollin, Karen Schwartz, Adrienne Rich, Ana Daniel, Ira Silverberg, Amy Scholder, Sharon Towster, Don Northfelt, Julie Tracey, Misha Cohen, and Linda Robinson-Hidas; and to the contributors of this work, in particular Adam Klein, William Dickey, Essex Hemphill, Michael Flanagan, and Diamanda Galás, for their insight and personal support.

To the remembrance of Bo Huston, Christopher Mountain, Richard de Villescas, Philip Dimitri Galás, and others; to all survivors, familiar and unknown.

THOMAS AVENA

> I wanted to bring together a disparate group of writers and
> artists, having in common seropositivity for HIV or an exten-
> sive commitment to confronting the plague. I wanted to ex-
> amine the fear of disease, the avoidance or indulgence of the
> sexual, and, most importantly, the divestiture of the body and
> the implications of such loss for those who struggle to create.

IN 1991, A NATIONAL SURVEY revealed that, given the choice, half of the primary care doctors in the United States would not treat patients infected with the AIDS virus; a third of all physicians surveyed further agreed that "caring for these people is not an ethical responsibility" (*Journal of the American Medical Association,* v. 266, no. 20). Such a response, a decade into the AIDS epidemic, seems egregious, yet it characterizes both the history of revulsion and neglect and the double standard applied to a condition described as a plague. It helps explain the endless organizing at a grass roots level, the spawning of "guerrilla" Clinics (lay treatment centers), the militancy of ACT UP — and, finally, the forcefulness of the artistic response by those most directly affected. This activism informs many of the contributions to *Life Sentences.* Still, this book is not only about anger, survival, death, or any single theme, but also explores the multiplicity of responses with which even the individual confronts AIDS, which is why art speaks so eloquently about this condition.

IN THE SHORT SKETCH "A Wart on My Foot," the only known writing in which he refers to having AIDS, Severo Sarduy

describes this condition as "a stalking." It is certainly that, and also an occupation in both senses of the word: the body is invaded and undermined by forces beyond our control — our future circumscribed and its outcome determined by this occupying invader. It also becomes our *occupation,* in the sense of principal work — in Edmund White's words, "something we think about night and day." At this story's end, we greet the specter of extermination . . .

Is AIDS atrocity in the sense that the Holocaust was atrocity? The roles enacted by victim and villain are less clear — they may be one and the same. Repeatedly, we encounter the body as unreliable, as betrayer, and still unmistakably part of oneself, constituting oneself. The histories in this book, whether in prose narrative, poem, or essay, recount the struggle to make peace with the imperiled body, and still to maintain its capacity to create. Though each artist may labor to subject the body to human will, the refusal to allow its erasure becomes the eternality of art.

In his interview, Edmund White talks about trying to publish the remarkable novel of a young seropositive man, his student, and meeting constant rejection. When he describes the sadness inherent in losing the important work of a young artist to AIDS, he invokes the historical loss of art to neglect and ignorance. Perhaps the most poignant aspect of an artist's life — particularly an artist who is young, talented, undiscovered — is that his or her work comes down to an act of faith that something distinctly individual outlasts the body.

The unreliability of the body besieged by AIDS compels the race to create, and, more importantly, quickens and exacts as its price the imperative for an artist to mature *as life itself is relinquished.*

I am reminded of the last three stories Jean Rhys wrote, while in her eighties: after years of literary brilliance, worn down by age,

the strength necessary to make manifest her vision failed her. And failed the reader. It is that diminishing of the vitality needed to excavate the physical and the subconscious world that an artist often fears most. The many works in *Life Sentences,* embodying such an excavation and written in the face of death, have exacted something extraordinary from their creators.

SINCE ANTIQUITY, art has concerned itself with the central issues of mortality, sexuality, and the relationship of survival to the artistic imperative and to the larger concerns of living. *Life Sentences* develops these themes within the context of AIDS. Of course there are other, and equally compelling, ways of looking at AIDS. Biologically, AIDS involves the survival of the fittest organism — the complex strategy of the virus, the simpler and attendant strategies of the bacteria, fungus, or protozoa. Still, the biological view is also encompassed by the existentialist tenet, *All life exists at the expense of other life.* Anthropologically, AIDS has been seen as a reaction of the biosphere — a response by nature to "a rampant infection of humanity" that causes ecosystems to perish: "AIDS is depopulating the African countryside . . . bodies [are] stacked up like cordwood in Bulawayo, the second biggest city in Zimbabwe . . . the main road that traverses Zaire is going back to grass and jungle. . . . Without AIDS, people would've literally eaten Africa up — and then died from famine. As it is, it's still terrible beyond belief — but an Africa may [emerge] that can live within its bounds. . . ." ("Death and Life in Africa," *San Francisco Chronicle,* June 24, 1990).

These ways of viewing the plague may seem too clinical, even inhuman. Are they less valid for that? Several of the works that follow are informed, however ambivalently, by such awarenesses.

Perhaps most frightening is AIDS as metaphor for a type of

explicit demonic transformation, a view that has seeped into popular culture. In the Cronenberg film *The Fly,* what becomes clear is that the protagonist does not want to continue existing as a "thing." The nascent man/fly Brundle vows: "I won't be just another tumorous bore talking endlessly about his hair falling out and his lost lymph nodes," as parts of his human body begin to atrophy or to bulge and a new and unknown type of life begins. For a person with AIDS, it may be impossible to witness these transformations with any degree of detachment. Such use of metaphor is sister to the type of demonizing with which adherents to fundamentalist religion have greeted AIDS, and the subjects of AIDS. Their scriptural condemnation has been beautifully appropriated and confounded by artists such as Diamanda Galás:

> It's that subversive voice that can keep you alive in the face of adversity. . . . I have this text: "You call me the shit of God? I am the shit of God! You call me the Antichrist? I am the Antichrist. I am all these things you are afraid of." (interview in Re\Search Publications #13: *Angry Women)*

Near the close of *The Fly,* Brundle reveals, "I am an insect who dreamt he was a man — and loved it. But now the dream is over, and the insect is awake." This moment suggests a radical transformation in thinking: one accepts, after the ravaging, that one has become "host" to the virus.

ESSEX HEMPHILL's book-length "Vital Signs" began as a highly internalized poetic narrative — more religious in tone, less public in its concerns than "Civil Servant" or "Heavy Breathing." During the course of its revisions, Hemphill suffered a loss in the

integrity of his health. As the poet's health declined and the poem took on the flesh of this experience, the narrator emerged fully as a figure battling physical deterioration:

> *I am simply afraid of the man*
> *I am to become in the morning.*

These closing pages of "Vital Signs" are alarming: they speak forcefully of AIDS as raw, personal inquisition; of the need, which David Wojnarowicz talked about in *Witnesses: Against Our Vanishing,* for reaching a sense of truth beyond the "preinvented world." Within this truth, the narrator admits implication in his condition and explores the implications of others. In a poem of remarkable breadth, conviction, and ultimately grave tenderness, the narrator explores the closure of life — at least of life as he had known it — fostered by betrayal of the body.

IN THE PROFILE I asked Adam Klein to write for *Life Sentences,* Jerome Caja explores his reliquary use of the bone fragments and ashes of fellow artist Charles Sexton — confronting mortality head-on. Here, AIDS is an omnipresent fact: "AIDS is everywhere — think of the Bush years, where small things became big things, small catastrophes became big catastrophes — a catastrophe party. . . ." Yet Charles's life, his death, and by extension AIDS never become objects of sentimentality. Jerome's account remains true to his nature: irreverent, salacious, irremediably bitchy. It is death woven into life: "So now, with the ashes I have remaining, I can sell her — make her work for a living. . . ."

"The New Eyes" closes with a ritual enacted countless times — the gathering of the family and of the extended gay family in the chamber of dying. A scene ensues around the bed: friends will

conduct what is necessary, but rarely recorded — the euthanasia. Charles's mother waits in another room, because she understands that while the mechanics of death must be enacted, she cannot bear to witness them. What remains is what cannot be revised by memory — the paintings by Jerome, memorializing, yet never elevating, Charles; and those by Charles, a complex man who was losing his sight to CMV retinitis and whose love of color and light and fascination with metaphorical image — his *vision* — is entrusted to his paintings.

BO HUSTON RETURNED MY CALL, explaining that we had better finish our editing immediately, as "I won't be around much longer." It didn't take me a moment to comprehend this:

"Then the cryptococcus is worse?"

"I don't think now it's ever going to go away."

I said that I supposed that he had tried everything.

"Yes. And I've just been through so much pain for such a very long time."

I asked if there was anything I could do.

"No. I have everything I need. The doctors know. My family's here. My lover's here. It's scheduled for Sunday."

I thought of Jean Rhys's maxim: One must earn death. I thought, but didn't say, that Bo had certainly "earned" his death. I said that I had always admired him, that his last novel, *The Dream Life,* was a perfect work, seamless . . .

We went carefully over the edits.

WHEN I FIRST HEARD TONY KUSHNER perform "The Second Month of Mourning," I was reminded how each of us

could be confounded and undone by an experience. The work
— and its performance — revealed itself in repetitions, in hesita-
tions, in a halting or broken voice.

As happens in life, the dying figure expresses a system of im-
agery incomprehensible or barely known to the beloved:

> You wrote:
> A rose for the rose quarter
> and said:
> It would be nice
> to be able to say
> enough.

But the monologue doesn't so much address the life of the one
who dies as the universal struggle with loss, and the narrator finds
such loss incomprehensible. He is employing different species of
language — from the colloquial to the scientific, from the gothic
to the cartoon — in order to grasp the enormity of loss, from
which one emerges stunned, as if from nowhere or from all di-
rections one had been dealt a mortal blow.

Life Sentences addresses this loss, as it chronicles the effort to
recognize, beyond hysteria, the integrity of the mortal body —
even as that body changes. For though there is no way to prepare
for the uncertainty of living with this disease and its bewildering
manifestations, this living in uncertainty, this state of radical
doubt, parallels, even *represents,* the engagement with life. In Mar-
lon Riggs's words, "To live with this disease, to actually *live* and
not simply survive it, means that you're constantly engaged in
some way with it. And it may not be AIDS directly that you're
engaged with, but with all of the different struggles that are part
of living, and being human."

LIFE

SENTENCES

"Crawling at your feet," said the Gnat (Alice drew her feet back in some alarm), "you may observe a Bread-and-Butter-fly. Its wings are thin slices of bread-and-butter, its body is a crust, and its head is a lump of sugar."

"And what does *it* live on?"

"Weak tea with cream in it."

A new difficulty came into Alice's head. "Supposing it couldn't find any?" she suggested.

"Then it would die, of course."

"But that must happen very often," Alice remarked thoughtfully.

"It always happens," said the Gnat.

— Lewis Carroll, *Through the Looking-Glass*

YESTERDAY MORNING, on a dark day heavy with rain brought down by a cold storm from the Gulf of Alaska, a red-and-white recycling truck from Sunset Scavenger hastily took away the eight-foot naked frame of our Christmas tree from the curb in front of the house. This was the first year of a new distinction. Because the tree was placed at the curb on the first lawful occasion after the start of the new year, it qualified as a Recyclable. If we had delayed disposing of it for another week, it would have been downgraded and officially have become Trash.

I watched only long enough to make sure that the tree did

make it into the recycling truck, so that I wouldn't have to phone later and complain. It wasn't a day to look out at, not individual or attractive, and besides I didn't want to see the tree go. It was the handsomest of those we have had in the seven years we've lived in this house — though it's true that I've thought that every year — and by now the ornaments, the lacquered bells from Kazakhstan or somewhere equally remote, the angel carrying a computer, baked out of bread dough by nuns, the bright-colored little wooden locomotive and its freight cars — all of these had become family, like courtesy aunts and second cousins once removed, part of a collection of continuations. And what I felt, watching the stiff or silky figures go back into their protective windings of tissue paper, watching the tree go into the recycling truck, was that I was seeing this, this image, this ritual, for the last time.

It has the Romantic note about it, doesn't it? The rain, the cold, the disappearing emblem of celebration — Violetta ought to hear, through the high windows of the garret in which she lies dying, the waltz song from the first act echoing distantly from the Paris street outside, and try, for a moment, to rise from her bed and dance. And then the great gold curtain falls, and a work of art is over.

And so I might be able to feel, this January, if I had not felt the same emotion the January before, when another tree was carried from the same house, felt it — it's hard to remember for sure — with greater intensity the January before that, the January that would have come two months after the phone call from my internist that told me I had tested HIV-positive, when my sense, my very uninformed sense, of what was happening to me was truly that I was experiencing the places, the people, the events around me, for the last time. How many times can the gold

curtain roll up again, Violetta come out to take her applause, to launch on another year's worth of encore? My death from AIDS, which when I first heard my diagnosis I expected within a matter of months, seems to have become Recyclable. The special truck has passed, the fabulous black barge with its shrouded oarsman has left the bank for the opposite, unknown shore. Some time or other, I suppose, on a day of total neutrality and anonymity, I'll find myself on the street corner thumbing a ride with the ordinary weekly collectors, another incident in the round of somebody else's hard day's work. I will have made the descent from Recyclable to Trash.

And Trash, our term for objects that have no usefulness, no value, is a word that has some applicability in the social and political climate of AIDS in this country. For one thing, drama and striking image are the last qualities the cold oatmeal voters of the United States want to associate with AIDS, as Colorado's recent election demonstrated. "We have no hate in our hearts at all, at all," goes the refrain, "but who are these people who think they're important, just dying, and costing us money, dying? And now they want laws to protect them! Let's just smooth all this out, let's just rake over these faggots this nice fine ash we got from the camps in Germany. No hate, no hate in our hearts at all!"

And then there are too many. Looking at the obituary columns — and I always do look at obituary columns now — I can predict, given an age, certainly given an age and a profession, with something like 90 percent accuracy the paragraphs that will end "of complications resulting from AIDS." Are there any single legendary figures among the lepers from the Middle Ages, the plague victims from Europe in the fourteenth century? The more something happens the more it becomes a statistic, and the more it becomes a statistic the easier it is to forget. The shattered

countenance of a Rock Hudson or a Rudolf Nureyev may startle out at us for a moment from the cover of a newsmagazine, but how can we hold in mind all the faces dying behind them? A single panel of the AIDS quilt does for its moment warm the bed of a single sleeper, but beyond it the other beds, the wards, the corridors, recede to darkness, no way to be beside them, to follow them into the reach of their increasing night.

The strangest comment I ever got on a poetry manuscript, submitted to a press that had already published one book of mine, came from an anonymous reader who said, "If the dead wrote poetry, this is the poetry they would write." I don't know how the reader arrived at that stark conclusion — I assume he was the same reader who argued that books of poetry sometimes needed to be rejected on moral grounds — but whatever he was thinking, his conclusion has had the power of a prophecy. I do feel now, when I write poetry, as if I were writing from some place outside of life, a waiting room, but a waiting room that has no clear or final wall to it, a space that is both terminal and keeps extending.

The first reason for this feeling is that AIDS time keeps changing. A character in a novel I read early on in my awareness of my own HIV-positive condition, learning that another character shared that condition, said firmly, "Then he has sixteen weeks to go." I can't remember whether I believed that — not enough, certainly, to sell all my worldly goods and devote myself to prayer. But it did seem reasonable to me that there was a limit, and that the limit was roughly the same for all of us. Month by month, since then, that idea of a limit has come apart. There are people who have been HIV-positive for ten years without encountering pneumocystis, or meningitis, or Kaposi's, or any life-threatening condition at all, whose T4-cell counts, that black thermometer I watch so carefully, do not decline. How many? What proportion?

I don't know. But the size of the waiting room is not the same for everyone, and sixteen weeks has become a blind absurdity.

My other sense of being outside time comes from my age. This last December, before the handsomest Christmas tree was bought, I turned sixty-four. As a result, my Social Security configuration changed; this year I can, if I wish to, earn more money without being penalized for it, because Social Security sees me as being sixty-five for the whole year. I think this is worth mentioning because the very ideas of Social Security and AIDS sound incompatible. At the end of every "Aidsweek" column in my newspaper, in every issue of the *Advocate,* there is a necrology, a selective listing of the newly dead. Their ages are mostly in the forties, the thirties, a few younger, not very many older. Certainly I cannot believe I am the oldest HIV-positive American or would or will be the oldest person to die of complications of the condition. But I am old enough so that of the people I know who die, there are more deaths from cancer, from heart attacks, than there are from AIDS. The clocks in the hospital are ticking, and they are ticking in more than one ward.

I have no doubt that someone who has to accept a diagnosis of terminal cancer, who begins to check the pages on a calendar of what terminal means, has the sense of having arrived at an end of time. I have watched friends deal with that sense, graciously, generously, shaping for themselves and for those around them memorable conclusions to lives that had been filled with accomplishment and vitality. And I've known others who have lived their whole lives in the precarious company of diseases that might at any moment make sudden ultimate assertions, and who refused to succumb to that intimidation. Is my own situation, the situation of anyone who is HIV-positive, so different from these?

The first warning about AIDS I can remember receiving

came from a man who had been my internist for twenty years, and who, as the early knowledge of the condition began to gather, said to me, "Well, Bill, it looks like it's celibacy or monogamy from now on." A while after that he was no longer available at the hospital, absent on sick leave. A while after that he died, with an obituary that gave no cause of death. It was not until several years later that the hospital, buffeted by who knows what pressures, what community hysterias, identified him as himself an AIDS victim, and I was able to recognize, as he had not felt it possible to tell me, the personal authority out of which he spoke.

One difference, then, between the victim of a heart attack or cancer and a man or woman whose death is AIDS-related has to do with secrecy. There are, as it happens, very good reasons for someone who has tested HIV-positive not to reveal his or her condition. The revelation can easily be followed by loss of a job, loss of medical insurance, loss, as a rental agreement is suddenly canceled, even of a place to live. And there are emotional losses, too; not every relationship of lovers, no matter how apparently stable and long-standing, can survive the knowledge that one of its partners is likely to undergo not just death, but an indeterminate series of painful and disfiguring illnesses. A kind of heroic behavior is called for in the human being who must take this kind of responsibility for another, and over and over it has been heroically demonstrated, but at extraordinary emotional cost.

But there is another element that compounds the secrecy, and one that has less to do with economics and more with superstition. When I was a child in a small town in the Pacific Northwest, a little girl who lived across the gravel street suffered on occasion from sudden illnesses, illnesses my mother felt she could not explain to me. The illnesses, I eventually discovered, were epileptic seizures; the reason they could not be discussed was that, as

recently as sixty years ago, epilepsy was still understood, in the popular consciousness, as a form of madness. To be an epileptic was to suffer not from a physical, medically defined condition, but from a derangement of the mind.

That attitude toward epilepsy, I hope, has largely passed, as more information about the causes of the condition and better medical means of mediating it have become known and available. But an analogous superstition exists for AIDS: it is not simply a complex of physical diseases, medically treatable or not. It is, in addition, and for many people primarily, a moral disorder, whose physical manifestations are the signs of retribution, of religious judgment. The god of Leviticus, the god of Pat Buchanan and Cardinal (or Capo) O'Connor, the god of Louis Sheldon, is revenging himself on those who have dared to love outside the iron boundaries of his supposed commandments.

I'm sure — I hope I am sure — that there are men and women in the United States who have been able, early in their lives, to recognize that their essential experiences of affection and commitment, of sexual dedication and fidelity, would be to members of their own sex, and to arrive at that recognition without a sense of guilt. But I do not think they can easily be members of my generation. And even if a sense of guilt is absent, a fear of punishment may not be, surely cannot be if New York City, as an example, has felt it necessary to establish separate schools to save its homosexual children from the predation of heterosexual attackers.

To feel guilt is to feel wrong, inferior, and we try to keep secret our guilts and our inferiorities, whether we have defined them for ourselves, or received them as definitions from the society we inhabit. Stonewall, Gay Freedom parades, the establishment in law of protections against the physical and legal

persecution of gays and lesbians are heartening parts of a long redefinition of who can be fully human. That redefinition has brought forth monumental and exhausting exercises of bravery: the campaign for the rights of children, for universal suffrage, for equality of race, back to the original fight for the abolition of slavery. All of these campaigns try to diminish the ability of a society to believe that it is composed of people and objects, white people and black objects, straight people and gay objects, and that objects, because they are inferior, have no right to feel, no right to resent anything that is done to them.

But if the United States has been forced increasingly to recognize its gay and lesbian citizens as human, or almost human, no battle of this kind is ever entirely won, and the AIDS epidemic has provided the persecutors a new opportunity, a new group to be regarded as objects, a new definition of the inferior and guilty. The reality of that definition cannot be evaded, not in the face of serious political suggestions that all of us who test HIV-positive represent a moral and physical contagion, and should be isolated from the real people, whom otherwise we might infect with our own dissoluteness. Such suggestions are made always with the hope of depersonalization, of the removal of a body of human beings from the consciousness of a society, and are accompanied by patterns of economic greed, as was the case with the establishment of Native American reservations, or, more recently, the forced relocation of Japanese Americans to isolated, almost invisible internment camps.

So that if I feel, at sixty-four, a sense of having lost some of my hold on ordinary time, I also feel to a degree unpeopled. There may be no rational explanation for this feeling. I have no symptoms of AIDS-related complexes. I have not lost a job — being retired, I have no job to lose. Nothing has happened to my medical

insurance. The doctors I have been fortunate enough to see have been closely informed about AIDS and its developments and therapies, and have been sympathetic and helpful. For thirty years I have lived in San Francisco, the least dangerous location for an openly gay existence that the United States provides. I have experienced none of the objective disasters undergone by others who share my condition.

But the diagnosis, the knowledge of my participation, repeats the vulnerability that came originally with being gay and with refusing to believe, to admit it. I can hardly suppose that arguments from the formidable Joint Chiefs of Staff are designed to prevent me, personally, from enlisting in the military. Long ago in Des Moines, Iowa, I was exempted from that obligation. I was sent, with another draftee, to a psychiatrist; my exemption was on the grounds of homosexuality, his on the grounds that his intelligence level was not high enough to permit him to be an effective soldier. Still, reason does not dismiss my fear and anger, my sense as I open every evening's newspaper that the frozen dicta, the implacable reactionary prejudices of the Joint Chiefs, are directed at me, that they mean to make me recognize how much of a threat I am to the placid psychological and sexual innocence of our present armed forces, an innocence so fully demonstrated in the instructive Tailhook episode.

To retire from a job one has worked at continuously for thirty-five years is to make a radical redefinition of oneself, to change from a demanding engagement in the expectations and conventions of a complex community, from a pattern of understood locations in time and space — if this is Thursday afternoon, I am the person teaching this computer poetry workshop — and from the sense of security that comes from expertness in speaking the special language of that community, to an unpatterned

existence in which the clock radio clicking on with the morning news no longer initiates a required and repetitive series of actions. I still find myself, in sleep toward morning, caught in anxiety dreams about the imaginary classes I may not be well enough prepared to teach. But then I wake, not to the alarm, and realize that there are no classes, no prescribed obligation to a community, that I can go back to sleep if I want to, that I could even be so anarchic as not to shave, not to apply an underarm deodorant, not to brush my teeth.

Nothing is so dangerous as freedom, because freedom is an isolation; to be perfectly free is to be without responsibility to others. A significant number of Americans do not survive the freedom of retirement, but die within a year or two of their extrusion from their accustomed communities of obligation, believing, at some subliminal level, that they have been translated from person to object, and that as objects they have no human will, no valid persuasion that they should continue to exist.

Like the official letter, the retirement parties, the Leatherette-bound diploma that assures its holder of all the rights and privileges of emeritus status, that even ensures free university parking for the rest of the holder's life, the phone call that came from my internist, asking whether the time was right, whether I could listen privately, and then informed me that my HIV test was positive, removed me from a community, the community of the healthy, and left me, as retirement does, in an isolation, a country extending only to the borders of my own body. And a country with, I think, a greater and more dangerous freedom than would be the case with tuberculosis or cancer. There is no Magic Mountain to serve as a controlling aesthetic metaphor for the whole experience of AIDS, as there was for Mann with tuberculosis, no City of London with its formal mortality lists from the

various parishes to give Defoe a shape and a personality for bubonic plague. With AIDS we are in a condition that has, amid its changing protocols and manifestations, no distance of conclusion; we are not even, or not yet, part of the historic community of a work of art.

The isolations of retirement and of an HIV-positive determination both lead to an increased awareness of the individual body, away from images of the interconnected active crowd and toward those of the stilled particular mirror. I look at myself in the Christmas photographs and wonder that I should look old, the animal a little grayer, a little more stooped, a little more tortoiselike in its accumulated neck wrinkles. In a country so much of whose sense of personal validity resides in youth, color, smoothness, these realizations of age may be dispiriting, but at least they follow an expectable pattern; it's possible to look sardonically at youth and say, "Someday you'll be here, too."

Allen Barnett, before his untimely death from the complications of AIDS, titled his moving first, and last, collection of short stories *The Body and Its Dangers*. To look in the mirror, once the HIV-positive identification has been established, is to be aware, in a way I have never been aware before, of my body both as endangered and as a danger. Some time ago that body — it becomes curiously tempting to look at it as an identity of its own, separate from personality — developed a sudden dermatitis. I went with all speed to my internist, whose first words, after she had examined me, were "No, it's not Kaposi's." She had not needed to have me ask the question. In the amorphous world of AIDS, what is and what is not a symptom, and of what? The body sends messages we may not understand; listening for them, one day after another, it becomes harder to offer full attention to other conversations.

There have been times in the past when I have, as anyone must have, realized that my body was a danger to others, with measles, with whooping cough, with hepatitis. Those threats, because they are common, are generalized. To watch the first drops of blood well from a tiny cut incurred shaving, and to consider the blood as a poison, to consider semen as a poison, to wonder what fluid, what touch, what endearment, will destroy another, makes of my body not a passive unfortunate, experiencing the gradual decline of its mortality, but a potential weapon, a knife to be wielded, a revolver to be fired. It has already been used as such a weapon, by the HIV-infected prisoner who bites the flesh of his jailer in the hope of infecting him, by the victim become so wholly the fact of his own anger that he enters, like a knife entering, as many women as he can, wanting nothing but to take his world down to pain and death with him.

Homosexuality is classically seen, by those who find in it a necessary enemy, as an explosion and intoxication of the body. "Are you ready, citizens of X, to see topless women riding motorcycles through the streets of our respectable city?" "The latest issue of your magazine, which shows two men kissing, is so disgusting that I am canceling my subscription today." It is not the idea of two gay men discussing whether they can afford a new television set that kills, nor the idea of two lesbians considering the adoption of an abandoned child. It is the idea of nakedness that has the force of nuclear reaction, nakednesses brought together until they touch one another, that moment when critical mass is achieved and civilization as we have known it is destroyed. The most universal of our taboos are against cannibalism and incest, and both involve bringing the naked flesh together.

We use the phrase "naked violence" to mean, for reasons that seem more hypocritical than just, actions more terrible than those of clothed or covert violence. And it may be that it is the

new implications of my own naked body, both as a fragile space waiting to be invaded by microscopic aggressors, and as itself a weapon, that make me see the world around me as more consistently, more intentionally, violent. Maybe, when our energies are absorbed by the demands of our communities of work, of health, we do not have as much time to spend looking at violence. And it may even be that it is the experience of all people growing old to see the violence of a society as more prevalent and more naked, if only because they are less able physically to answer that violence or to protect themselves from it.

The climate of violence has matching sides, and the fear of it can easily produce a desire for it, an anger which, because it cannot with decency be expressed or acted upon, is as emotionally crippling, as destructive of creative life and accomplishment, as is the fear. If Helms, lung cancer's principal ally in our legislative bodies, or if Buchanan, that voluble coprolite drifting in the peripheries of centers of power, survives a surgical operation, I resent the survival; I picture these figures, naked and invaded, dead on the operating table, my revenge for the suffering they have scarred into others. And here again I cannot escape the image of the body. It is not pictures of humiliation, poverty, social degradation, that enlarge themselves in my mind, but a blow breaking open the enemy mouth, a knife castrating the secret sources of the oppressor's blood. I am not proud to have the screen of my mind reddened by these images; they violate the calm landscapes in which I had hoped I could learn to live as I grew old; they interfere, an obscene static, in any effort to civilize the mind, to become more generous or more wise.

How hard it is not to respond to the names that are given us. Told that I should be isolated from the active body of my community because I represent a moral and a physical infection to it, I accept that name, and begin to isolate myself; it becomes subtly

more difficult to leave the house, to go out to dinner, to buy tickets to the theater, to write a letter. Told that I should be dying, I hear, over and over, the agonized voice of a man I never saw, saying, in a clinic examination room, what I was not supposed to overhear: that he has decided not to undertake a new AIDS therapy, that the pain he has experienced in the last two years is such that he does not want to prolong it, that he has talked to his priest and his priest has told him that to refuse the therapy does not constitute a sin. If it is not a sin to die, then surely dying is more acceptable, even more seductive. Told that the condition I experience is so charged with danger and contamination that I must keep it secret, I keep it secret; it has taken me more than two years to arrive at the decision to undertake this memoir, and the writing has been as slow and difficult as if it too were suffering some kind of organic disability — already it is a month since I began, since the last handsome Christmas tree went out January's front door.

A recent and controversial study says that the AIDS epidemic will effect no serious or lasting change in the political structures of America, in the way in which we are aware of the nature of our community. People will continue to die, but they will die at the margins of the community's consciousness, in the still often secret or unspoken subculture of the homosexual world, in African American or Latino ghettos, in the politically invisible wastelands of the poor. Yet at the same time, in response to the bloodlit and feral opposition to the free enlistment of gays and lesbians in the military, organizers of a gay march on Washington begin to believe that they can bring a million citizens onto the streets, into the broad ceremonial plazas that unfold before the white marble monuments we have agreed to see as the ethical embodiments of our society: the Capitol, the Washington Monument, the Lincoln Memorial. Which of these possibilities is right? What does it take to make the invisible visible? It was from the steps of the Lincoln

Memorial, well within the time of my own personal memory, that Marian Anderson sang to a celebratory gathering of her fellow Americans, singing under the open sky when the pursed and terrified holders of the keys to the concert hall refused to let her in.

I believe there is a time, for a person or for a civilization, when a change has taken place, whether it is realized to have taken place or not, when even in the painful confusion of the struggle we have passed a border, perhaps by night, and a different country begins to open itself before us. There was a time when the legal ownership of one human being by another was possible, a convention as understood as marriage or the wearing of shoes or the hour of dinner. And then the idea of a world that could be believed in as human changed, and the fact of the civilization changed after it — somewhere in the night the idea had prevailed, and the travelers, caught between hope and despair, had crossed the border. Those of us who are gay or lesbian may feel ourselves buffeted by the chaos and intemperance of that night, but the idea that we have equal rights to live, to vote, to work, to enlist in the military, to make our most generous and most humane commitments to one another, is now so strong that I do not see how it can help but continue and grow in resolution, and as it does, carry the fact of the society after it. That border is crossed; we are engaged now in defining the country on the other side.

In its more intimate way, the voice over the telephone that said to me, regretfully, with a slight Swiss accent, "I'm sorry, the result of the test is positive," had also the quality of an idea, a recognition of death, a border. After it the question is one of exploration, of penetrating into the reality of a new country. It has its own mundane observances, of medications and blood tests, its own images of Swiftian deformity, as the naked patient is spun upside down on a Catherine wheel to allow his lungs to be

drained of fluid, as the desperate gather in an unsanctioned clinic to force into their rectums the gas that might conceivably arrest the acceleration of their disease. It has its carefully chosen gestures of consummation, the Mozart Requiem one sufferer has chosen, to make of his passing an integration into pattern, the rose placed on the breast of another after the breath departs. It has denials and refusals, incredulity locking itself tighter and tighter in. And dedications of heroism, as the figure on the other side of the idea of death seeks out the unknown information, the therapies and disciplines, that may yet save his companions. The rituals of community, the ways in which people have known they belonged not singly to themselves but to one another, have over the centuries included sacrifice; for us in the gay community no day passes in which we cannot see the space our sacrifices have left empty around us.

The nature of AIDS is to compromise the immune system of the body; we become less and less able to resist the invasions of the microscopic indifferences to us we have been able, earlier, to ignore. In social, in intellectual understandings of our world, as well as in medical ones, there is a value in being able to be immune, in maintaining a continuity of similar experience, so that we are not bewildered by strangeness, so that what we see today we are confident we will see again tomorrow. If this immunity, like the immunity of the body, is compromised, then pain, depression, loss, all of those deprivations follow. But in the obscurity of their night we may still find that we have crossed a border. The Christmas tree is gone; on the street outside the Japanese plum trees are coming into blossom, and I feel more perfect in my seeing of them in this country where I may be seeing them for the last time.

VITAL SIGNS

ESSEX HEMPHILL

I — XXXVIII

Ecce Homo — Behold the man

— Friedrich Nietzsche

I

When you say,
"Be a *man!*" chil',
I think of cages,
cages, dahling!
Mama know.
We don't have to
live in cages.

II

Erection my downfall
as opposed to my rise.

III

You are so young
in my hands,
the gossip
of my neighbors
so true.

Some of the poems in this collection are dedicated to: XIII – XV to Stan and Tavon, XX to Anthony, XXXI to Yves and Jan, and XXXII to Ajamu.

IV

The police found him
with his dick
wickedly hacked off
and stuffed into his mouth.

Impossible for him
to answer their questions.
Impossible to tell them
who did it.

V

The shiny knife
clatters
to the floor
as you undress,
cutting the air
as it falls.
The blade: longer
than any dick
I've ever wanted.
I quickly
put my clothes
back on
and leave
the two of you
alone.

VI

Beside the Schuylkill River,
near the Philadelphia Art Museum,
a calla lily is in bloom

in a thicket draped in gloom.
Its long pistil dangles down
swollen full of nectar.
A swarm of black bees
buzz in the moonlight.

VII
A flock of queens
gather on the corner.
A line of cars
snake around the block.

VIII
These bejeweled
exotic birds
preening
and trilling
on the corner
are in danger.
Even those
with talons.

IX
This is the edge
society leaves them
to live on: lacerated,
lewd and lawless
curbsides to click down
after midnight.
A cluster of shadows
lined with car seats,
alleys, bushes,

secretive
doorways
indistinguishable
from clusters
of ink blots.

X
At the bathhouse
the thin white towel
loosely tied around
his dark waist
barely conceals
the excitement
I anticipate.

XI
He stands before me,
lean, unshielded warrior.
I drop my thick white towel
to the floor, so he can see
I am also not afraid.

XII
I am sure
as I lower his legs
from my shoulders
we will do this again
in the near future.

XIII
The two Black beauties
sculpted the length
of my white sheeted bed

are so still
in the moonlight
spilling through
tall windows,
lingering over them,
curious about their peace.

XIV
Hard to imagine them
anywhere else
for anyone's eyes
other than my own.
Hard to imagine
any other blessing
I care about more
at this moment.

XV
The kiss I give his mouth
is passed on to his mouth
and his mouth then
returns it
to mine
to bloom.

XVI
I tell myself
I can't sit here
too long,
but I remain
in his lap
all night.

XVII

Whatever birds of paradise dream
I want those dreams
for both of you.
Though I must confess
I am ready to catch him
should you let him go.
Should he for any reason
fall from your arms
I am ready to catch him
even if it kills me.

XVIII

If you are all he has
be thankful
that someone
loves you
with such singular purpose.
You are lucky.
You are not like
so many of our generation
hungering for love.
All along the city streets
you see us begging,
begging to be worked.

XIX

I offer you
the only leverage
I possess:
a strong
stern tool.

Take it!

Use it
for anything
but raping,
anything
but killing.

xx
Location
On the bullet-riddled
homeboy streets,
in the cunning wilderness
of sallow-faced cities,
call me Ifa, Man.
Say my name
to arouse your dreams.
Bless your nature.
Say my name
sixteen times and twirl
in no apparent confusion.
Arms flung wide apart
declaring the limits of freedom
as I declare
the limits of possession.
The same difference.
The same location.
The same.

What you own, what you claim, I want.
I will share this with you
to prevent it being used against us:

I don't want the erotic fantasies
of your solitary masturbation.
Give me more than that
or I can give you less.

Instead, come stir
the ink blue dusk with me,
come stir it with me
'til it's thick enough
to rub onto our skins,
massage into our
thirsty pores and follicles,
so that distant stars
might see themselves
reflected in our shiny
new blackness,
and the planets, too,
and the galaxies
where our new names await us
in full bloom, their succulence,
the taste of victory will dribble
down the sides of our mouths,
sweet juice that will cause us
to be high with liberation
when we announce our new names.

Call me Ifa, Man, Yo' Man,
call me, Man.
I can kiss both your mouths.
Esu, are you listening to me?
I can kiss both your mouths.
Will you kiss both of mine?

Isn't that what is meant
by double-consciousness?
Or maybe I'm confused:
this is desire, isn't it?

Talk to me sweetly.
Sing to me, Esu.
Dance my sweet
salacious drum.
Dance, Pussy.
Say my name
sixteen times
and twirl, twirl,
trick me, trick me
in no apparent confusion
about our liberation.

XXI
All afternoon
I am your lover.
You can keep me
until we expire
of old age,
ambush,
or disease.

At the threshold
of synthesis
I feel brave enough
to surrender
not in a game
of conquest,

but one of truth
and consequences.

I risk
hidden masks,
silent fears,
secret passageways.
Distance
suspended between us
like particles of air
and pollen.

XXII
This cloak we share.
This bed for our embracing.
This glass of wine
to sweeten our mouths
before we kiss.
I would tell no court
I am not familiar
with these things.
But if you ask me
not to
I will not say
you know them
as well as I.

XXIII
In an election year
my kisses gain
political currency
in a context

in which I'm portrayed
as the threat most critical,
most menacing to the values
of family and flag.
I am the new Communism.
The cause for declining profits
on Wall Street. I am the reason
God is punishing America.
I am Sodom and Gomorrah.
Willie Horton. Crack. AIDS.
My erections are SCUD Missiles
aimed at the suburbs, the pulpits,
the shopping malls
where the mythical family gathers.
My anus is not a safe house,
my soul is, that's the blessing.
I have no quilt for my bed,
no red ribbons for your hair.
I live to sabotage patriarchy,
butt-fuck it to its knees
because the other options
are much more violent
if I should choose them.

XXIV
If something must die,
then let our masks die, dahling.
Donate them to the Smithsonian.
Auction them at Sotheby's.
Immerse them in jars of piss.
But do not pass them on

to another soul
knowing full well
their uselessness.

XXV
Maybe
we should
use a condom,
Mister. Can you
please, Sir.
Please, Sir.
Daddy please
make me,
please.
I don't really
want to hurt you.
I don't want
to be hurt
by you. Mister.
Please, Daddy. Sir.
Please use a condom.
It's the best
crash helmet we have
if we're gonna play rough.
If we're gonna play at all.

XXVI
I should learn
to dance with death,
so when my turn comes
I won't stumble.

XXVII

I don't want a necklace

of shrunken heads

buried with me.

The heads of tricks,

trade and other

nameless pieces,

strung together

with shells,

provocative ornaments,

the fetishes

of my sex rituals.

I can avoid this

injury to my soul

by staying home,

locking my door,

lowering my shades.

I can learn to fulfill

my particular needs

all over again.

There are enough mirrors

all about the house

so that I can

easily do this.

I can stand

in front of any

one of them

and have a partner.

I can put them

all together

and have an orgy,

a family, a community.
Just imagine,
I can believe
I am not alone.

XXVIII
Rights and Permissions
Sometimes I hold
my warm seed
up to my mouth
very close
to my parched lips
and whisper
"I'm sorry,"
before I turn my hand
over the toilet
and listen to the seed
splash into the water.

I rinse what remains
down the drain,
dry my hands —
they return
to their tasks
as if nothing
out of place
has occurred.

I go on being,
wearing my shirts
and trousers,
voting, praying,

paying rent,
pissing in public,
cussing cabs,
fussing with utilities.

What I learn
as age advances,
relentless pillager,
is that we shrink
inside our shirts
and trousers,
or we spread
beyond the seams.
The hair we cherished
disappears.

Sometimes I hold
my warm seed
up to my mouth
and kiss it.

XXIX
Critical Care
I am sorting out
my patterns of habit,
those things genetics
cannot precisely pinpoint,
those things religion
cannot righteously refute.
Those things
the paramedics cannot save.
This kiss, this cum,

this single T cell
I cling to,
these are my referents,
this is my religion,
my resistance,
my desire. These are
the offerings I take
to the feet of death,
but death is impatient
with me, it wants my
cock, my ass, my soul.
I am hungry for a lover,
but there are no other suitors.
Death's whispers are sweeter
than the silence
in a bell jar room.
Am I to be accused of listening
like a sailor to the Sirens?
Or can the attention I pay
to the whispers be described
in some other metaphor
that will not remain
bleeding when I'm gone?

I am searching for whatever
we relinquished that was
deemed sacred between us.
A living memory of this exists
and I want to find it.
Whatever commonality we shared
that at one time would not betray us,
I want to find it.

We were not loathsome then.
We were not dealing in cruelty,
sabotage, torment, grief.
I am searching for whatever
faith sustained us,
whatever made us important
to one another.
Vital to one another.
I hope I am not seeking in vain.

Our anger burns so brightly
illuminating our hostilities.
I should be able to hold your gaze,
not fear what I find there,
but instead I see malevolence
tossed back at me.
Suspicion. Annihilation.
When I see the fires of death
flaming red in your black sockets,
when I know your heart is corrupt
with violence and evil
against brothers,
against your ancestry,
your greatness of being,
the sadness of that knowledge
kills me twice and twice more,
before your fist, your bullet,
your blade, your bad attitude
strikes me at all.

I am searching
for the irrefutable clarity

to all I don't presently comprehend
at any hour
about the hatred in our lives,
the misplaced anger,
the presence of death.

When the ciphers to
these bloody mysteries
are found
perhaps we will stop
slaying one another.
Perhaps we will stop
accepting the deaths
of one another
as solutions.

Attempting is dangerous:
Building a bridge,
forging a bond,
helping one another.
Let no one sway us otherwise.
We must keep on
loving one another
through the killings.
We are all we have.
We must remember this.
Keep memories of this alive
even if there is no flesh
to contain them.

xxx
The responsibility of the self.
The care of my temple, my yard.

I am learning how to do this
in the middle years,
at the dawn of the settled years.
I am trying to take time to account
for the many choices I have made.
I am trying to take care
of my blessings and learn
to live with my memories,
my elected consequences.
Some of this is what
I occasionally fear,
although there is no difference
between my bravery and my fear.

XXXI
The Couple
You occupy
so much
that defines
my mind's
breadth
and territory.
Only you
have been
welcomed
like spring
in what so soon
became our
intimate
winter twilight.
We had no way
to know,

to foresee
or predict
our love
would occur
in the midst
of mayhem
and chaos.

We could have
tossed coins,
played cards,
consulted oracles,
lit candles.
None of this
would have
told us
what we know now.
We could only
prepare for this
by first loving
one another,
forging one strength,
one force, one trust.

Now,
instead of carrying on
we carry one another
back and forth
to the bathroom,
the hospital,
the bed.

The years were ours
to do away with
as we pleased,
or so we thought,
so we imagined
there just might be
an Oz,
a fountain of youth,
a way to settle
our arguments
with God.

I have chosen you before
in other lifetimes.
I have been your choice
in other centuries.
I spend each life
I return to
searching for you
to give back
the kisses
from our previous blessings,
so I will have something
to return to Earth for
in the light years ahead.

When I touch
the continent of your lips
I arrive home safely.
You don't always remember me.
I have never forgotten you.

Now I bathe you, my love,
in this present life
surrounded by its gifts to us.
I found you again.
I bathe you like a birth
I never fathered.
We watch the walls
of our bedroom change color
as they catch the light
the television throws
into an otherwise
darkened habitat,
where we prepare
to die again
like flowers.

Now I dress you, my love,
in your man's body.
I hold you
to my nipple.
It hurts too much
to hold you like a man,
my embrace more
than your frail frame
can now bear.

I dress you
in my stated prayers,
my whispered curses,
my chosen love.
From grave to grave
I carry my loyalty to you.

XXXII

Baby Can You Love Me?
Are you willing to kill me
if I ask you to?
If I'm unable to do so
are you willing to kill me?
If I can't, by my own hand,
if I'm unable to
for any reason
and the prospect of my life
is diminished beyond recovery;
if I can't remember my name
or recognize my mother
or identify you; if I can't
sleep beside you anymore
holding your stomach
in my calloused hands;
if I lose control of my body
and the intricate systems
I'm required to operate;
if I should become hopelessly bedridden
will you understand my unwillingness
to linger on? Can you be as brave
and as clearheaded as you are now,
professing that you would
love to love me?
But could you kill me,
if I asked you to?
Would your love
let me not linger
in my dying bed?

XXXIII

Laying on Hands
I wait for you
in the candle-softened light
of an empty apartment,
offering a voyeur's view
of a popular, seasonal
cruising park, which is now
all but empty as winter lengthens,
and naked trees shiver
scratching their frozen branches
in the silver light,
accompanied by whistling winds
and the whispers of your name
I repeat as a sign of patience.

Soon your footsteps
will resound on my sidewalk.
Soon your nappy head
will recline on my pillows.
Soon the air around me
will be full of your odors
and the manly moans
I coax from you
will bloom.

In the candle-softened light
fueled by the whispers of your name,
everywhere you kiss me,
everywhere you touch me
I respond with life,
even though I'm dying

for someone

to watch over me.

XXXIV

Internal Affairs

I am writing back to you

from the scene of the crime;

from the other side of disintegration

I employ telepathy for my conveyances.

From the rubble and ash,

the turmoil and chaos,

this is the thorny dream

I fashion for you.

From the confines of disappointment

I draft this document,

part testimony,

part biography,

the essential evidence of being.

I possessed a mortal,

flesh-driven appetite

exceeding the control of laws

and moral codes.

It was necessary to wander

among the living cemeteries,

copulating where I will,

with whom I please,

witnessing, participating.

This was an interior journey,

and no maps in existence to follow,

I bid farewell to very few

before departing with only my name.

It wasn't my intention
to create a disturbance
when I entered rooms
where I was unknown
and perhaps, unwelcome.
I simply ascended stairs,
stepped through open doors.
I may have mistaken the doors
for many things: a journey home,
an opportunity to erase silence,
the threshold between me
and a lifetime love.

Whatever I thought of the doors
I passed through
is insignificant now.
I am inside the text
of this moment,
an unerasable part of it,
the metanarrative,
the attitudes.

In this territory
I have relentlessly sought
shelter and pleasure.
In the framework of my longings
I sought an elusive commitment.
I willingly accepted
the momentary orgasm
for consolation,
divorced of love
and gardens,

which is to say
I accepted the burden
of my loneliness
with no complaint
until now.

I began looking at the world
as a leather skullcap of countless
driven nails meticulously bonneted
on the head of the Christian God
many offered me or tried to
force-feed me. Or more often
than not this figure was used
to impose, contain and undermine
my journey, all in the name
of salvation, which was
one more cemetery
I sadly discovered.
One more burning flag.

I have only resisted
those things
I have not
personally fashioned
for my survival.

In the middle of my life
I pause to finally consider
the meaning of dying.

Turning it over in my hand
like a simply wrapped box,
a gift given and given again.

Presently, I pick at the wrapper,
loosening it little by little
to get at what's inside.

XXXV
In the Morning, We'll See
Knowing what I have to do
to transform myself
is frightening me more
than having to transform.
I am simply afraid of the man
I am to become in the morning.
But I cannot wisely sabotage
or resist the change.
The consequences
would be severe,
the stuff of masochism
and such as I
would not want to be
personally known for
in my biographies.

All of this change
is to occur by morning.
It really won't be
a sudden transformation.
I will dress in the same drag
as I did yesterday. I will walk
the same road I started down
without a map, destiny ahead of me.

The lucent flames in my eyes
have dulled a bit,

but for this moment only
as I heal and reconstitute myself
into a stronger being.
A more resilient being.

Imagine transformers
changing into God.
Mine is a process
similar to that,
though not quite the same,
not quite as perplexing
I imagine.

The man I am
kissing goodbye,
crying for,
letting go of,
loving always;
I am likely to never
see him again
after the maelstrom
of this transformation
settles and the
habit of being resumes.

He was my companion
longer than the man
I will meet in the morning.
Or perhaps I'm wrong.
Perhaps the man I embrace
will have always been there,
waiting for me to find
the blood of courage

and drink it, an elixir
to clear my mind,
a potion to steady my hand.

XXXVI
The Faerie Poem
I am not the wand waver I used to be.
I realize this as I realize
the changing shape of my body,
and accept that I must
continue to own it
until there is no more
use for it,
until there is
no more purpose
I can reasonably claim.

I hope that
somewhere in the midst
of my grand queen conflama,
I will learn to let go
gracefully,
that in my gestures
there will be
some larger sign,
a broader lesson
to be applied
to the daily civil wars.

Once upon a time
I was black and fertile,
I was virile, coltish,

straining leashes,
refusing collars.
Once upon a time
balls of energy
exploded from
my fingertips,
rolled out of me
in brilliant flashes
that blinded
even me.

Now I ponder defenses:
how to save my life,
how to avoid CMV, pneumocystis, TB.
How to break my nicotine habit.
With twenty-odd T cells
I am nearly defenseless
and counting. I have to learn
multiplication tables, after all,
and put them to wise use.

I am not the wand waver
you may be quick to recall.
I cannot make another thing
disappear. The illusionist tricks
all fail me now,
they draw on my strength
in ways that endanger me.

My greatest feat of all
will not be levitations
or doves out of my hat.

If I can simply transform myself,
win myself a measure of dignity
from my Earth life, accept grace,
then my flight may be free
of remorse, clear of guilt.
I might soar unencumbered
through my shadows,
and sort my way
to other conclusions.

XXXVII
Despite all appearances
I cannot speak with authenticity
for anyone but myself.
Any other utterance
is just a stumbling
through hieroglyphics
and prayers,
my enunciation
terrible, at best,
impenetrable
otherwise.

In the cluttered afternoons
I rearrange little bits
of my person.
I carefully excavate
those memories
that are most delicate
and for that reason
could still cause
harm and injury.

And I thought
these would be my tasks
when I became an old man,
but I am clearly
not a prophet or a seer.

I am a witness
where very few
would stand and testify.
It wasn't always bravery
or duty that made me
rise and speak.
My reasons were
sometimes selfish
and ego-driven,
the moment
calculated
for my gain,
my expansion,
my relief.

Tell me there is
a new political slogan
in the air
and I will learn it
with bombastic verve.
Show me a new
club dance
and I will learn
that, too,
eagerly surrendering
to a new movement.

Now show me
the signs for love,
the practices,
the vital signs.
I have spent
all these years
trying to live
ways of being
I've seldom seen.

XXXVIII

June 25

Yesterday, my new doctor, based in short-skirted, fashionable
Los Angeles, on trendy, palm-tree-lined Wilshire Boulevard, in-
formed me that I now possess only twenty-three T cells. Need-
less to say, my face cracked, but I'm a show boy, I learned long
ago how to keep things together even under the most strained
and pressing of circumstances. I haven't always known how to
use this facility, but of late it comes in handy, although I think
it costs something internally to hold oneself in check in the
face of provocation and overwhelming emotions.

By the end of my visit, I was armed with prescriptions for six
different medications, which the pharmacist assured me will
not interact violently. Quite frankly, I don't know whether I
should calculate my remaining T cells into nanoseconds and
minutes, days and weeks, or hours and years.

Some of the T cells I am without are not here through my
own fault. I didn't lose all of them foolishly, and I didn't lose all
of them erotically. Some of the missing T cells were lost to ra-

cism, a well-known transmittable disease. Some were lost to poverty because there was no money to do something about the plumbing before the pipes burst and the room flooded. Homophobia killed quite a few, but so did my rage and my pointed furies, so did the wars at home and the wars within, so did the drugs I took to remain calm, cool, collected.

There are T cells lying dead by the roadside, slain by the guise of friendship, the pettiness and jealousy of minds and talent in the process of wasting to nothingness due to envy, gazing into other yards instead of looking closely at and tending to their own. There are T cells sacrificed between the love and anger my mother and I hold for one another, T cells that have simply exploded due to the decibel of our screeching.

There are countless wasted T cells between my father and me, the result of painful, subterranean silences that I cannot resolve with only twenty-three T cells, nor should I really be expected to, nor should I try, since it was his violence I witnessed and re-main scarred from. I am forced to remember him in certain ways, to always see him punching and pushing, slapping and yelling, not because I want to, I just haven't learned how to make so many scars into things of beauty, and I don't know if I ever will.

Actually, there are T cells scattered all about me, at doorways where I was denied entrance because I was a faggot or a nigga or too poor or too black. There are T cells spilling out of my ashtrays from the cigarettes I have anxiously smoked. There are T cells all over the floors of several bathhouses, coast to coast, and halfway around the world, and in numerous parks, and in countless bars, and in places I am forgetting to make room for

other memories. My T cells are strewn about like the leaves of a mighty tree, like the fallen hair of an old man, like the stars of a collapsing universe.

That is who I am now, *one of them,* one of *them.* A single strand, a curling leaf, a burning star foretelling grief. I say this only to dispel such gloom. I say this loud to kill death's bloom.

(*August 1993*)

NOTES

"*Esu* is the guardian of the crossroads, master of style and of stylus, the phallic god of generation and fecundity, master of that elusive, mystical barrier that separates the divine world from the profane. Frequently characterized as an inveterate copulater possessed by his enormous penis, linguistically Esu is the ultimate copula, connecting truth with understanding, the sacred with the profane, text with interpretation, the word (as a form of the verb *to be*) that links a subject with its predicate. He connects the grammar of divination with its rhetorical structures. In Yoruba mythology, Esu is said to limp as he walks precisely because of his mediating function: his legs are of different lengths because he keeps one anchored in the realm of the gods while the other rests in this, our human world. A partial list of characteristics and qualities particular to Esu might include individuality, satire, parody, irony, magic, indeterminacy, open-endedness, ambiguity, sexuality, chance, uncertainty, disruption and reconciliation, betrayal and loyalty, closure and disclosure, encasement and rupture. But it is a mistake to focus on one of these qualities as predominant. Esu possesses all of these characteristics, plus a plethora of others which, taken together, only begin to present an idea of the

complexity of this classic figure of mediation and of the unity of opposed forces." (Henry Louis Gates, Jr., *The Signifying Monkey: A Theory of African-American Literary Criticism* [New York: Oxford University Press, 1988], 6.)

"*Ifa* consists of the sacred texts of the Yoruba people, as does the Bible for Christians, but it also contains the commentaries of these fixed texts, as does the Midrash. Its system of interpretation turns upon a marvelous combination of geomancy and textual exegesis, in which sixteen palm nuts are "dialed" sixteen times, and their configurations or signs then read and translated into the appropriate, fixed literary verse that the numerical signs signify. . . . In African and Latin American mythology, Esu is said to have taught Ifa how to read the signs formed by the sixteen sacred palm nuts. Ifa is frequently called "scribe" or "clerk," or "one who writes books." Ifa wrote for his fellow gods. . . . Ifa speaks or interprets on behalf of all the gods through the act of divination. . . . The voice of Ifa, the text, writes itself as a cryptogram. Esu then assumes his role of interpreter and implicitly governs the process of translation of these written signs into the oral verse of the *Odu*." (Henry Louis Gates, Jr., *The Signifying Monkey: A Theory of African-American Literary Criticism* [New York: Oxford University Press, 1988], 10 − 13.)

Conflama — Black gay slang for confusion, drama, tension.

THOMAS AVENA

The struggle with AIDS is the struggle of the double body:
the old, reliable, even beautiful one and the new, unpredictable one.

MY BODY

I crouched on the hospital bed, nude. Dr. N. rolled up his sleeves.
I noticed beautiful forearms.

"Wouldn't it be easier if you were to cross your legs and sit?"

"I'm sorry. I can't remember how we did this last time."

He isolated my lower spine with a plastic drape, numbed me
with novocaine. I felt several sensations, like a beesting. I looked
at Bill's sweet face. Dr. N. inserted a needle into my spine. I took
a sip of iced coffee.

"This is going very slowly today," said Dr. N.

"That's because he already gave you all his cerebral spinal fluid
last week," said Nurse Julie, but nobody laughed.

After fifteen minutes, Dr. N. removed the needle from my
spine. I was told to lie flat. I lay on my belly with no elevation for
the next two hours, drank iced coffee near the open window in
the busy ward, dazed by sunlight. Bill read to me from the Ellman
Oscar Wilde:

All beauty comes from beautiful blood and a beautiful brain.

IT GREW AT NIGHT, at first a soft, small movement under
the flesh, then increasingly hard and sore. Though it was so dis-

turbing at night, still you dreamed. Your dreams were nightmares, but you didn't remember them, just their guttural taste.

But does it reason . . . would it want to exist at my expense . . . or was I feeding it information all along . . . time to surge . . . time to spread roots in the soil of my throat, to grow a branch (harden), to enbranch (and harden) . . .

"It's Birkett's lymphoma — a cancer usually seen in African children." The surgeon couldn't tell me anything more.

NECK SO STIFF. Take Percocets. Terrified. But soon I am a little distanced from the pain — can examine it . . .

"Methotrexate spinal taps cause inflammation of the meninges." My brain seems to have sunk inside my skull. "Inside your brainpan," said Dr. N. "Drink plenty of fluids, strong black coffee and tea. An IV of caffeine may be the only thing that will take care of those headaches."

For four days I throw up until there is nothing but sulfurous bile . . . Finally Bill reduces my intake to two ounces of baby food, followed by rest. A quarter-cup of weak black tea. Bread with the crust cut off. Followed by rest. An ounce of strained peas and drugged on Marinol, Ativan, Dilaudid, Compazine, Prednisone . . .

THEY EXPLAIN THAT REGLAN, given for vomiting, causes anxiety. We scrutinize my vein for infiltration — seepage of chemotherapy from the IV. Nurse Julie calls it "nuclear meltdown," because if Doxorubicin touches oxygen, it causes severe burns. I feel the clamoring anxiety — each time they bring you close to death — and then the body is left to retrieve itself. Bill casually massages my legs, my back, even my buttocks, under the

nurses' gaze. His touch is almost painful. Because the body, infused with death's serum, rejects this awakening to what is human. Because we are now unaccustomed to intimacy.

I lie on my stomach following the lumbar puncture, as prescribed, my arms spread straight out in the pose of crucifixion. I toss my head from side to side.

Wearing a red mantilla, a woman who speaks only Spanish lies in the adjacent bed. Her thirteen-year-old son sits at her feet. If he thinks anything strange about this roomful of reclining queers in the midst of torture, he keeps it to himself. His brow doesn't furrow. Before leaving, he helps his mother replace the mantilla with a blond wig.

LYING ON MY BACK. The mouth opens, explains: "You see, when a body dies, all sorts of things begin to feed off it: bacteria, fungus, parasites, gases, things that the immune system normally keeps in check. It is the same for us. We struggle constantly against becoming animated corpses . . . the fungus that grows on our skin, the parasites that bloat our bellies, the tiny monsters that consume our muscle and fat tissues, that tear into our brains. And somehow we have to live with this. To live with this knowledge. To walk along Polk Street and watch teenage boys and know that all of these breathe the blood of their bodies and exhale their poisons . . ."

DURING CHEMOTHERAPY, all of your cells are threatened with disintegration; your atoms shiver and dissolve — and the body knows it, begins to scream. The screaming, a translucent vibration, a siren wail, is unnoticed by doctors, nurses, and tech-

nicians — to hear it would drive them insane. But dogs can hear it, and insects. And the patient, infused with chemotherapy, who is not asleep. He enters the dimension of disintegration, lies there for an hour — and passes back into this physical dimension — barely alive. And he will have to live with the memory of this. In dreams or waking.

CHEMOTHERAPY DAYS: Wednesday, Thursday, Friday, Saturday. Bone-numbing fatigue. I am confined to bed, shivering . . . my thoughts turning vicious . . . the boy fed his own belly button in *The Cook, The Thief, His Wife and Her Lover;* and all the buttons cut off his jacket with a knife, a surgical knife . . . until there were no more . . . buttons; each scene set on an elaborately tricked-out sound stage . . . the barely electrified Gainsborough blue, the dim reds . . . I finger the scar on my throat, remembering the time Dr. N. felt the incision and the room turned red before I fainted. How they looked at me quizzically, removed.

NO LONGER IN PHYSICAL PAIN, but this unnatural weight visits daily. Weight or hollowness. It has no apparent cause, occupies the cavity of my chest, interferes with my breathing. Is fear . . .

IT IS A SULFUROUS YELLOW that almost hurts my eyes, as if the sun were brought into the room. It is this yellow that slices through tumor . . . an opaque beam of laser light. I raise my head from the pillow, and there . . . the yellow vase on the windowsill. I see it filled with soft gray matter, the breakable

container for my ashes. I am again seeing the world through a dead man's eyes . . . and liking it.

If I am going to live, I need to give up this attachment to death. I blink. I remember the need to eat . . .

Bill has left something on the windowsill: a catalog of photographs of the writer Cookie Mueller. Encased in a cover of mauve–chocolate brown are portraits of Cookie in a casket, and of Cookie lying on a bed, dying of AIDS.

I AM A GRIFTER . . . using deceit and trickery and a kind of *understanding* with this disease; the understanding or empathy a con uses on his subject. And the subject is the unreliable body. Dosing this body with herbs, rotating these herbs before the virus detects, defies, disrupts; and nightly penetrates the body; things blossoming where they should not — a garden after fallout, a corpse in its grave blooms with all of these . . . mocking the revved–up will to live.

THE THREATENED

His struggle with the quixotic disease . . . a surfeit of drink. And Bill is in the hospital, in their cold care.

"What is his temperature?" I ask, when the nurse removes his thermometer.

"It's 40.1."

"Isn't that nearly 104?"

"It's over 104. We'll call the doctor."

An hour and a half later: there is no doctor, the nurse has not returned, and I can no longer breathe through this paper-and-chemical mask.

The wrinkles have fallen from his brow — it is utterly smooth. I stand over him, touching his face, trying to see into him; he is like a body in a museum, under universal precautions.

"I'm sorry," he says. "I'm sorry."

I am at the nurse's station.

"His fever is so high, even with all the Tylenol. What if it's going up?"

"Well, you'll just have to wait. Can you wait?"

"I can wait. The question is, can his fever wait?"

"His fever couldn't have gone up in such a short time."

I have to be careful to maintain credibility, knowing, knowing now that these people lie as casually as they breathe. I am un-shaven, unslept, I know that my face looks terribly drawn. So I say nothing. I give the nurse an utterly blank look . . .

"Believe me," says the nurse, "if there was anything to worry about, you'd see a different type of action."

I wait, and wait . . . an hour and a half goes by. Another dose of Tylenol. It has been three hours since anyone has checked his temperature.

I am at the nurse's station, and my voice is a shaken whisper . . .

"Is there no doctor to see him? You promised me a doctor. He's critically neutropenic. He only has one hundred neutrophils. Even when I went through chemotherapy I never dropped below seven hundred neutrophils, and they wanted to transfuse me then. But he's only one hundred neutrophils."

I am aware I am repeating myself, and I begin to apologize.

"I don't mean to . . . I'm sorry . . ."

And then:

"I'm sitting over there shaking with anger. Because no one's taken his temperature in over three hours!"

The nurse looks me over. There is no alarm in his eyes. There is no concern in his eyes. I feel that I am a crazed species, screaming through a wall of glass . . .

The dead caring for the dying. Is that what you are? But he's not dying! There's no need for him to die . . .

His voice doesn't change.

"We take the patient's temperature every four hours."

"Even when it's over 104?"

"We just gave him some medication."

"He was already on Tylenol."

"You'll have to speak to his nurse."

"I have spoken to his nurse."

"What did he say?"

"That they're aware of all this. That's what scares me . . ."

The nurse retreats to the charts spread out before him, and I am left alone at the desk, and then a slight hallucination begins, with the desk and the nurse telescoping, shrinking away, or I am shrinking away before them.

I S A Y, "Look in the mirror and count those lesions. They're at the plaque stage." Some are still soft and flush with the skin; others are shiny, purplish discolored scar tissue — the plaque stage. There will be no wishing these away.

That night, I dream that Bill is at his smallest weight, back when I'd first met him. His eyes so blue. I am seated on a low slab of marble and Bill is lying in my arms, like the pietà, his body covered with lesions the color of his eyes, and he grows smaller and smaller in my arms, his unmarked flesh disappearing into the lesions . . . I want to present this body to someone, but there is no one, and what is the point?

And then we are drowning in the sea, the wine-dark sea.

DR. H. GIVES BILL another shot of Demerol. And once again the needle disappears into the body. We are looking for aspirate, but his bones are hard and there is no fluid . . . another shot of Demerol, another probe with the needle . . . it is like macerating meat. Well, I am holding Bill's hand and I don't know any jokes. Bill shouts, and I kneel down beside him. I begin saying anything. I am talking about skiing. I begin talking about our imagined trip to Mount Shasta.

Dr. H. is relentless. Her expression never changes. She is so finely made, so steely. Her resolve is truly phenomenal. Where has she learned this, to dissociate from the poisoned body on the bed, whose blood covers her gloved hands . . . She is twisting the needle into bone . . . It takes strength, and the patient, ideally, should feel nothing but a discomforting pressure . . . pressure.

"There's a house I'd like to go to. The walls are stone and they're heated from inside. It's in Sun Valley . . ."

Bill is talking about a house in Idaho, where someone will take him, but I am not part of this little dream . . .

The doctor puts the piece of bone into a jar filled with reddish fluid. The piece of bone is an inch long, an eighth of an inch in diameter.

TRIPTYCH

In the dream I am in the office of a psychiatrist and I am explaining myself as plainly as possible . . .

"I have Acquired Immune Deficiency Syndrome."

"Yes . . ." He is waiting for me to continue, and so I explain

the constellation of symptoms, the fevers, the night sweats, the brief moments of clearing before the symptoms darken. It is a crowded speech, and my head begins aching . . . but the psychiatrist looks at me without admitting disbelief or belief, and his belief is the only thing that will crowd out my fear.

"What is this thing, AIDS?"

But hasn't he heard me?

"What proof do you have about this you call AIDS?"

What proof do you have?

What proof do you have about this thing?

What proof?

And then I am flattened to the floor in disbelief and grief, flattened by everything I've described that infests us . . .

When I wake up, I want proof. And in the mirror, my lips are seared and scaled in white, my eyewhites a toxic yellow.

IN THE VERY HOT BATH, I am listening to Messiaen's *Theme and Variation for Violin and Piano* — a passage where the violin becomes relentless. I cup my hands over my throat, what my acupuncturist calls my phlegm nodules, where the primary tumor appeared. I pass the tone like a laser that slices through the soft mass of tumor, paring it away. I think of the mass as something less significant than nascent tumor — as benign, neoplastic flesh, cells accumulating to no purpose, unlike tumor, which is gray and purposeful:

This is me and I will grow.

The light of the ray, blue before entering flesh, then turns topaz.

THE YOUNG MAN FOLLOWED ME down the path to a dugout in the trees; he backed himself up against the fence with unaccountable violence, unbelted and unzipped me.

Then I backed away from him. I said, "I'm HIV-positive."

I think he said something in reply. Was it, "Don't worry"?

There was no inflection to his voice. Nothing to hook into. Then down on his knees, giving me gradual, then more vigorous head.

I'm HIV-positive. Well, that's the sin of omission. No? I have AIDS. I've had cancer. Or have cancer now. But I'm still alive.

His hair was nearly shorn, his cap fell into the trees, his throat was soft as a doe's. I forced my hand down his tight undershirt, creamy and white. His nipples were tiny and hairless. My fingers probed his armpits and brought the fragrance upward; inhaled, but there was nothing. . . . This man smelled of absence, clean as rain . . . the android I conjure at my pillow . . .

I thrust my cock down his throat and he moaned; I wanted to pull him to his feet, put my tongue in his mouth, suck the great vein at the base of his throat.

But his insistence . . .

"Angel," I said, and he moaned.

No.

I pulled my cock away and, a heartbeat later, shot into the branches . . .

I reached down and brought him to his feet, kissed the base of his throat . . . I wrapped my arms around him, which startled and confused him . . .

"Where did you come from?" I said.

"I don't come here often."

"No." I said, "Where did you come from? Are you human or

divine . . . Are you my past . . . Were you given to me for everything I've suffered?"

"I just come here when I want to suck dick . . ."

"Oh, yes . . . yes of course . . ."

"I'm Ron." He held out his hand.

"I'm Thomas . . ."

Well, good-bye Ron.

THE DIVA

I'm just a little bald head with a hole in it . . . there's a bag under my eye filled with blood. And the clot was all clotted and hard, and so they couldn't do nothing, and they sewed me back up. When I woke up I tried to get at the doctor, but they held me down and I still screamed "You put a hole in my head for nothing." And do you believe he said "yes"?

But now she is sitting profiled, resplendent in bed, and her face is simply and beautifully made-up. And when she turns her head I see that the skull, fuzzy with new growth, bears two long scars that form a T. And as I advance into the room, I see that the white of her eye is discolored with blood.

"You look so much better than we would have thought," we say.

"Better?" L. picks up a cotton pad and applies some cream solution from one of the bottles on the makeup tray before her. "I want to show you what I really look like."

And she wipes away the makeup, until black vertical lines climb from the corner of her mouth, and I see that her face is burned, burned into a mask by radiation.

We can't think of a thing to say. Or if we can, we don't say it. And so we sit quietly.

"Yesterday, I turned my head away when the nurse drew blood. I could feel that she wasn't getting any. I turned back to her and said, 'You have one more chance. Just one.' And now every time she comes to draw blood, I tell her, 'One chance. Just one.'

"So I refused a transfusion. I'm becoming just like you. Somehow my platelets went up from six thousand to eleven thousand overnight. I sang — because as you know that's what I do. And when I came to the verse 'Stand up. Stand up and walk . . .' I said 'Get up, little platelets, get up and walk.' And they did.

"I remembered what you said on the phone; you spoke so low so I could really hear, so that I would get it. 'You don't want to give any energy to the clot. You want it to soften, to become liquid, to drain away . . .' So I put my hands on either side of my head, and I sang — somehow, without my hair I can hear myself so clearly — and I sang this . . ."

And sitting straight up in bed, her hands on either side of her skull, her face a mask, she sang a lullaby to the clot of blood resting on her brain.

LEAVING THE DIVA SINGING in her room — not a chamber, but a room like any hospital room: uncomfortable, bare, all exposure, with tilting plastic walls and the peculiar, inhuman static of hospital rooms. Although it is true that I have lain in such a room with my throat slit open, excavated and stitched, I will do anything never to have to enter such a room again. I will give what it takes. . . . Still it is myself I see lying in the bed, vibrating like a hollow chamber.

I can't leave her lying there, and yet I can't, I won't, occupy her place. I leave her to vanquish the demons — the demons of the cut and burnt flesh.

And so I return to the city, and sit for a moment in Café Flore, and the dead enter my life again. There's Richard de V. (but Richard de V. is dead). And Christopher M. (but Christopher M. is dead). And the third dead friend walks into the café.

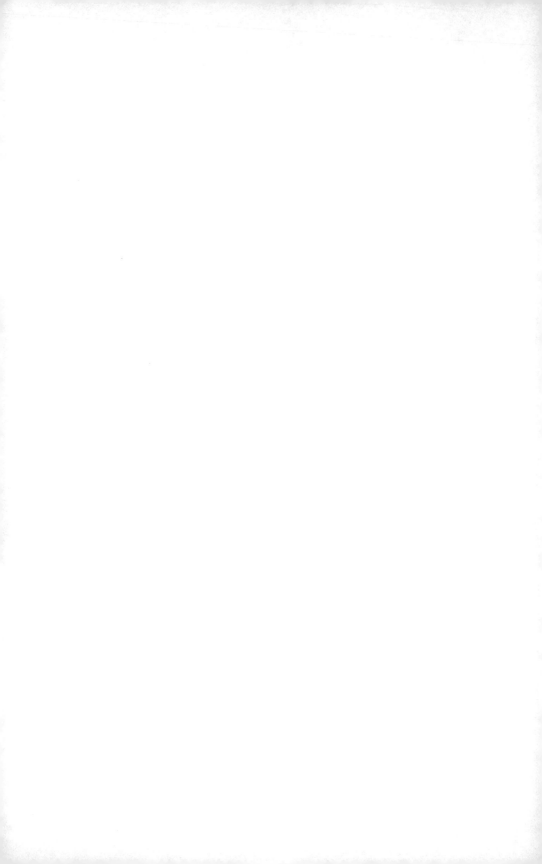

BO HUSTON

for Jill Tregor

The Second Coming

Turning and turning in the widening gyre
The falcon cannot hear the falconer;
Things fall apart; the centre cannot hold;
Mere anarchy is loosed upon the world,
The blood-dimmed tide is loosed, and everywhere
The ceremony of innocence is drowned;
The best lack all conviction, while the worst
Are full of passionate intensity.

Surely some revelation is at hand;
Surely the Second Coming is at hand.
The Second Coming! Hardly are those words out
When a vast image out of *Spiritus Mundi*
Troubles my sight: somewhere in sands of the desert
A shape with lion body and the head of a man,
A gaze blank and pitiless as the sun,
Is moving its slow thighs, while all about it
Reel shadows of the indignant desert birds.
The darkness drops again; but now I know
That twenty centuries of stony sleep
Were vexed to nightmare by a rocking cradle,
And what rough beast, its hour come round at last,
Slouches towards Bethlehem to be born?

— W. B. Yeats

25 OCTOBER 1991

I wake afraid. Even with the thick, dark green curtains pulled open, the tiny hotel room is dim. Through the window I see a silvery tin drainpipe and another building's wet window ledges. A slip of gray sky. Sagging chicken wire covers the narrow court-yard, to keep pigeons from losing their way and winding up in the guests' rooms. The pigeons are out there now, cooing like crazy.

On the table beside the bed is a lamp with tassels on the yellowing shade. I press the switch. I was dreaming. I dreamed that I was checking out of this hotel, that I asked the man at the reception desk for my bill and he said, without blinking: "Fifty thousand francs."

"*Fifty thousand?*" I was astonished.

"For all the phone calls you made," the man said, reasonable and pitiless.

Panic. "But I haven't *got* that much." Then I woke suddenly, afraid.

It is noon here in Zurich. I've been traveling. I left San Fran-cisco a couple of weeks ago, spent ten days in New York. Good times with people. I went to the theater with K. and V. Visited with E., who has remodeled her loft. C. is breaking up with her boyfriend, so she's depressed and tense, but I kept making her laugh. I spent a couple of days at my parents' house in Rhode Island. Then here, to Zurich. And I've been oddly proud about my organization: resetting my watch, packing and unpacking, not forgetting things in bathrooms, having perfectly calculated the number and styles of shirts, the right shoes, gloves for the East Coast. I've been a guest everywhere, settled on friends' sofas, carefully writing down their phone messages. In a week, I will head home.

This is the cheapest hotel room I could find in Zurich, and at that it is one hundred Swiss francs a day. It is also the barest, tiniest hotel room in Zurich, I'm sure. It has no pictures on the dingy beige walls, no television or radio. Is that a worm on the carpet? No, it's only a burn mark from a cigarette. The toilet is in its own closet, barely big enough for a person to fit inside. Indeed, when I sit on the john, the door won't close. That is disconcerting; I seem to desire privacy even in private.

There's a tiled shower stall and a sink in the corner of the room. The room is so small that I cannot go from the window to the door without banging my shin on the edge of the wooden bed frame.

The phone rings — that beepy European sound. "Yes? Hello?" But there is no one on the line. I dial the reception desk. I hear a bored "guten Tag." I recognize the voice of the man I've seen at the reception desk, the one in my dream. He's very tall, with close-cropped hair and a silver hoop dangling from each ear. He is the main concierge.

"Yes," I say, "this is room five-two-five. My phone just rang, and then there was no one there."

"Yes?" Inscrutable.

"Well, um, I was just wondering, did someone try and call here?"

"I suppose they did, if your phone rang. But they had the wrong number. Or perhaps they changed their mind." All this said with that superior Swiss calm.

When I go out, I must leave my room key, which is attached to a green plastic ball, with the concierge. I'm in agony. I feel him judging me. Scrutinizing my activities and moods. Wondering, I suppose, what I am doing here. Who is this person, the concierge no doubt asks himself, and why is he in Zurich?

Who is this person? I'm looking at myself in the small mirror

above the sink. My hair is limp, looks dirty. I lean closer to the glass. Red blotches on my forehead. And God, my teeth are so stained, from cigarettes and coffee. What? Is my hair thinning? Am I losing my hair? From this angle my eyes seem too close together, and from another angle they seem too far apart. A blemish. A scar.

I am suddenly in a frenzy of self-loathing. The mirror does not even reflect a face; it reveals a dilemma. The picture is of an ugly man seeing an ugly man. The glass withholds nothing. I've been gazing in mirrors since I was two feet tall; how did I never notice that I was such a beast?

I hurriedly take off all of my clothes. I yank the straight-back chair across the room and stand up on it, to get a whole view of myself, but I can only see my body in sections. Skinny legs and flat butt, arms without muscle, weak shoulders — this body has a grotesque shapelessness, and no new posture makes it look sexy or strong.

Is this me? I am that? But, no, really — who *is* this person? Relocated to another country, like a bird forever roaming because it has lost its way and can't land until it sees home. I am not in relation to the things and people I know, to other mirrors whose reflections are familiar and comfortable. I am not where I belong, and so whoever I am is unfathomable.

If I turn away from the horror of my own image, close my eyes tight, I can see what I believe to be me. California. In my beat-up old house, with pots under leaks when it rains. Humming as I wait for the coffee to brew. Clenching my teeth as I try to keep my temper when someone puts me on hold on the phone, or when an idiot cuts in front of me while I'm driving. Reading magazines in the doctor's waiting room. At my shrink's office, twisting my fingers in my lap and speaking not to her but to the huge, waxy green plant just to her left. My agent calls with good

news or bad news. I go to the gym. I have a favorite café, where I read the papers. I take walks on the beach. Commiseration and laughter with friends. I have an enemy here and there, too. Someone dislikes me, someone adores me. I have elaborate analyses of the ones who aren't on my side, rich psychological interpretations of them, inflexible judgments. About the loving ones, I feel ambivalent, embarrassed, not quite trusting. I'm delighted to run into this person; that person I swiftly cross the street to avoid. A thousand acquaintances, a million repetitions of *hello* and *good-bye,* small plans and sincere beliefs convince me, daily, that I am me.

Then there is Dan. His figure is slight but energetic, tough. His complexion is pinkish; his eyes are gray-green. Sometimes those eyes are earnest, sometimes angry, sometimes frightened. Dan, by his presence, confirms my presence. My alliance and exchanges with Dan complete my picture of myself. Jokes shared, or gossip or tension. Furious at Dan. Worried about him. A tangle of competition and loyalty, division and unity. In half-sleep, before dawn, my dick hard against his thigh, and then he snores and I give his shoulder a gentle shove, and he sputters, and the snoring stops for now. I'm preoccupied with whether Dan hears what I say; then, satisfied he's heard, I wonder if he'll remember, if it matters to him. I'm always inquiring, tentatively or aggressively, if Dan really knows me? Sometimes we are sitting for silent, content moments watching the cats; then I sense his gaze shift from them to me. . . .

But I'm a long, long way from California. As I climb down from the chair and cover myself with a robe, sit dejectedly on the edge of the saggy bed, all this that I have organized to mean me is dislocated. It is not even really self-loathing I'm experiencing — actually, this is a breathless fit of self-consciousness.

AFTER A NAP, around two, I phone Dr. R.'s office. Speak to his wife. "You are well?" she asks. This is my third treatment with Dr. R. — I've been coming to Zurich every six months or so. Since my last visit, they have moved to another office, though, and Mrs. R. gives me complicated directions by train. "Tomorrow at ten then, Bo." She says my name like "Boo." We say good-bye.

I bundle up in a sweater and overcoat, leave my key at the desk with that snooty concierge, step out into the cool drizzle. I walk along the Limmatquai, by the river. Last time I was here it was spring and the swans were gliding on the water, ducking their heads, wiggling their feathery butts. No swans now; where do they go?

I have the impression someone is following me, that footsteps behind me exactly coincide with mine. Turn around; no one is there. I stop in at a bistro a few blocks away from my hotel, a place I know has reasonable food and prices, and where the waiters speak English. I order a bowl of soup and a sandwich. But I can't finish the meal. Too anxious to sit here. I'm not looking forward to my gloomy hotel room, but I feel disoriented, anxious, and head back anyway.

Someone following me again, I think, as I hurry over the slick cobblestones. I'm going crazy. It's getting dark. The cathedral spires are lit. Despite the rain, people are set up on the street, hawking jewelry, carved wooden boxes, sweaters — younger people, passing hash pipes back and forth.

No messages for me at the hotel. Dan is supposed to call, but not for hours. In my room, I scoot past that mirror which had earlier assaulted me so, and pull my bags onto the bed to unpack. I've brought a cheap cassette player and some tapes; I have Sibelius, The Supremes, Brian Eno, Cole Porter, Billie Holiday.

I pull out my books, too. A Patricia Highsmith mystery; a true

crime account of a socialite who murdered her husband; a bat-
tered little volume my father gave me called *A Treasury of Modern
Poetry;* Flannery O'Connor short stories; *The Plague,* by Albert
Camus; and Christopher Isherwood's *My Guru and His Disciple.*

I've also got a shoe box full of pill bottles, liquid herbs, creams,
vitamin packets. An envelope containing my relevant medical
material — a letter from my San Francisco doctor, Dr. G., blood
test results, a record of my ups and downs since the last time I
came here — along with my passport and traveler's checks. I
brought along my typewriter, too; this has been a nuisance the
whole time, but I intend to use it. I have a cozy vision of myself
sipping lukewarm coffee, writing away, absorbed and inspired.
The typewriter's plugged in; there is an ashtray beside it, and a
stack of paper; the vision is waiting for me.

A map of Zurich. I spread it on the worn carpet, and get out
my used guidebooks. I know my way around this city well
enough. I know pleasant streets to walk along, a few cafés and
shops, how to maneuver through the Bahnhoffstrasse, a book-
store with plenty of English and American titles. I know one gay
bar, Barfusser, and a bathhouse called Apollo, which I have yet to
enter. I'm not at home in Zurich, exactly, but familiar with it.
And Zurich is neither a friendly nor an unfriendly place. Indeed,
it is neutral. People may nod at you, but they will not ask you
questions. Those ice-blue eyes just stare, giving no clues. Clerks
in stores will speak English, graciously hiding their frustration.
You will not see hung-over taxi drivers snapping their fingers to
radio music. You will not see T-shirts with slogans like Blow Me.
You will not know if the drivers of the cars going past are against
abortion or carry rifles or have been saved by Jesus or love their
pets. The Swiss do not advertise their opinions, passions, griev-
ances. No one's asking for spare change or preaching on the

corner. No one's in leather chaps. Skin is mostly white, the trains are on time, folks walk rather than run. And it's a clean town — ominously tidy. If you're walking and drop a cigarette wrapper on the curb and then, a few steps ahead, turn back, the wrapper will have been swept away.

All of this is familiar to me, though. I know the routine. And I am not in Zurich to see sights. I'm here to continue with Dr. R.'s treatment, which, despite the reasonable skepticism from my friends and doctors at home — despite my own weak faith — has been extraordinarily effective thus far. Dr. R.'s treatment requires an infusion once daily for three days, and some liquid medication to be taken in juice.

I have enough money, and these books to read. I have five days in Zurich that can really be for relaxation, quiet, meditation. My typewriter, some music. Rationally, I know that I am safe. But I feel lost.

STILL RAINING. Been sleeping on and off, without such troubling dreams. Isherwood or Highsmith? There's Camus — I can't imagine what made me bring this book. Written on the inside back flap of it, in smudged ink, is Walter's name and telephone number. I pick up the phone to dial, then quickly hang up.

Back to that mirror. I am calmed down, not so overtired. Now I do not see a monster in the mirror. Under the right light, it's a pretty face. More important, character and qualities are evident in the reflection. Now that it's lifted, I can even laugh at my despair.

My state here is a legacy from adolescence. Years of this, harbored by books and records and daydreams that never did, finally, make me feel loved. (And so I would sob, sob into my pillow until

my throat was sore and my eyes were stinging.) Before I was even grown, I was desperately mourning childhood. Innocence was lost early, and I knew that. Pull myself together, get on with things, secret away my longings and knowledge, and take comfort in melancholy. I am an optimist — a queer kind, but an optimist nonetheless.

I remember signal moments in my life, divided by years. Nine years old: sitting under my parents' pine tree. Eighteen: high on acid, walking across my college campus, guided by a misty moon. Twenty-two: on a barstool beside the pay phone, the smells of leather and beer. Driving, bathing, fucking, praying. In love, but the guy doesn't call. Wanting. Stealing. Lying. Waiting. At these and other moments would come a singular, ancient revelation: I'm alone.

Another moment, nearly five years ago: standing on the roof of my apartment building in San Francisco. Brisk night, under a dome of starry cobalt. Turning and turning in a small circle to see all the lights of this gorgeous new city. Turning, like dancing, for I felt free, hopeful, generous. I stopped, lit a cigarette. The next day I was to go in for my test results. With conviction born of this dizzying contentment I had another revelation: The test *will* be negative.

26 OCTOBER 1991

Made my way to Dr. R.'s this morning. Lightly raining, and cold. That train ride is gorgeous, along the lake, through centuries-old towns. Wetness slicked the shingled roofs. The countryside was neat and orderly, with even garden plots and balconies crowded with potted flowers.

Three other people were in Dr. R.'s office. Unremarkable but

pleasant gay guys from Manhattan. They all work at a nightclub there. The three were similar in appearance — white, in their twenties, wearing baseball caps and earrings. Like me, each of them had been for this treatment before, and each said he was doing fine. We traded stories, first of T-cell counts and infection history, then specifically about Dr. R.'s treatment. One guy said he had trouble taking the shots sometimes, his butt got sore.

Dr. R. and his wife were warm, welcoming. They are in their sixties. Mrs. R. is Swiss; she is fond of bright colors; she has long dark hair, which she keeps in a braid. She speaks English and acts as translator. Dr. R. is Hungarian, short, perfectly round. His face is red and continually smiling. He is like some kind of Slavic Dickens character. I have seen him angry, though. He gets loud, he gestures aggressively with his hands while denouncing American medical practices and pharmaceutical treatments. The villains for him are AZT and antibiotics. The first time I witnessed his passionate declarations, as a nodding Mrs. R. tried to translate for me, I felt an odd giddiness, almost an urge to laugh.

Today, Dr. R. looked over my laboratory results, but did not seem alarmed. "The T cells, you can see, are down to thirty," I said, pointing to the report. Dr. R. made a notation on my chart. He quickly proceeded with my infusion. It did not hurt, but there were a few seconds of light-headedness. I was stretched out on a table. Dr. R. stood on one side of me, holding my arm, adjusting the intravenous tubes; Mrs R. was on the other, her fingers lightly spread on my leg. I felt protected by these two, sheltered. Then there was a quick shot, and I was up on my feet. I'll return tomorrow, again at ten in the morning.

When I got back to the hotel, I felt in better spirits. I was able to smile at that concierge, and he dutifully smiled back. There was a message in my box — Dan had called and would try again later.

Here in my room, I was suddenly fatigued. Still not adjusted to the change in time, I thought I'd rest for a while. Then quite on impulse, I opened to the back of *The Plague*. I picked up the phone.

"Guten Tag. Polizei Haptquartier."

"Hello? Um, I'm looking for Walter D———."

"Walter D———? You have the wrong number, I think. You have reached the Zurich police headquarters."

"The police? You say this is the police?"

"Yes, sir. Can I help you?"

I hung up. I dialed again.

After four rings. "Hello?"

"Hello, is this Walter?"

"Yes."

"Hi, Walter. This is Bo. We met on the plane."

"Yes, of course."

"How are you, Walter?"

"Thanks. And you?"

On the flight from Boston to Zurich, we were sitting in a middle row — I was on the aisle, Walter in the center, and his friend, Marcel, on the opposite aisle. I had little interaction with Marcel, just smiles exchanged, but Walter and I chatted a bit. He asked why I was going to Zurich, and I said, "Business."

I had been pretty certain Walter was gay, but he confirmed it for me. First by indiscreet glances at my lap; then he said that he and Marcel had been vacationing in Key West. Then he asked if I had friends in Zurich, and if I had any favorite night spots.

"Night spots?" I looked directly at him.

He smiled with a transparent coyness, then asked, as though it had just occurred to him: "Well, what do you look for? Girls or boys?"

"Boys," said I. Here were the question and answer we'd been building up to through an hour or so of unimportant conversing. Elbows barely touching on the armrest, our complicity was established. It's out now, and we can get down to business.

Walter and Marcel offered to drive me to my hotel just off Schifflande Square. Initially I protested, because it was quite out of their way; but I was also tired and irritable, I only wanted to get to my room and cover myself with blankets. We rode in Walter's old Citroen along a narrow, busy motorway. Walter drove, Marcel was in the front passenger seat, I sat in the back. I did not say much. I was struggling to be polite, and I did feel lucky for the lift. They spoke in German, and then would laugh. I was wondering, Do they know I don't understand German? Are they talking about me? Or are they just rude? For a moment, I was suspicious of their generosity; then I chastised myself, and felt keenly just how exhausted I was.

Marcel was pointing, giving Walter directions, and it seemed they were arguing. But then they giggled.

Finally, I asked: "So are you two lovers?"

Marcel turned round. He seemed a bit younger than Walter and more at ease. He smiled broadly. "No. Just friends. Our lovers left us." He faced front and laughed. Walter did not laugh.

They dropped me off at the door of my hotel, and Walter got out to help me with my bags. It was just after dawn. The gray clock towers and bridges and buildings of Zurich were dimmed by rain.

"So, let me give you my telephone and in a day or so, after you are settled in, you will ring me."

I reached into my bag, impossibly crammed with books, tapes, cigarettes, sweaters, and wriggled out the first thing I touched: *The Plague*. Walter wrote down his name and number on the inside flap.

WALTER GAVE ME DIRECTIONS to a bar called the Tip-Top, only about a ten-minute walk from my hotel, and we arranged to meet there at eight. There were no signs or lights, it appeared to be closed; but inside, the bar was cozy, pleasantly lit, small. I did not see Walter, so I sat at the bar and ordered a Coke. The bartender eyed me unsubtly. In a few moments, Walter came in and sat on the stool beside me.

Our conversation began with the surface: this bar. Walter said it was one of the oldest gay bars in Zurich. Several men entered, shaking rain from their umbrellas, and exchanged greetings with Walter. We compared gay bars in America to gay bars in Europe. Then we talked about places he'd seen in Key West — a motel where men cruised at all hours, a bathhouse. Walter said that Marcel had enjoyed himself and fucked with many boys, but that he, Walter, had been unhappy and lonely some of the time. "I have the nervous conditions," he said.

"Here, I think," said Walter, sipping from his glass of beer, "we are not so much open as in the States. Here, it is simply a fact of life that some people are homosexuals, and this is understood."

I went on a bit about the gay community in America — when I was at college, then in New York City, now in San Francisco. There is nothing really comparable in Zurich, Walter told me. "We are behind America in these things. Here, the gay life is very much centered in the bars and baths. We do not have these organizations as you do in the States, political groups and churches and things."

I nodded and kept a mild smile, grateful for this small talk. I was recalling myself, only a couple of hours ago, in my hotel room — vexed almost to insanity. Each time the door of the Tip-Top opened and a figure entered, followed by a blast of damp cold, I shifted my eyes to get a quick look. I was feeling distinctly safe with Walter in this place, and affectionate toward him.

"Well," I said, "also, AIDS really changed everything in America. What is the situation with AIDS here in Switzerland?"

Quickly: "We have AIDS. Not like America, no. I know a couple of people who are positive." It sounded like "pohz-ee-teev."

"Have you lost a lot of friends, Walter?"

"No," with a shrug. "You?"

"Oh, Walter. I can't even count the people I've known who've died. And I mean friends, people I went to school with, or worked with, boyfriends. And then so many are sick, and so many more are infected."

He seemed to draw back, shocked, but repressing it. "That's terrible." He called for another glass of beer. "You have been tested?"

Walter is forty-eight, he's told me. Because of his two weeks in Florida, he's quite tan. His teeth are even and white; his hair is dark gray, cut short; his eyes, of course, are stunning blue, and he wears fashionable glasses. Tonight he was wearing olive green trousers and a handsome maroon sweater. His manner generally appears relaxed, and he's quick to laugh, but there is a constrained quality in Walter, too. As though he is troubled, but can't remember why. When the conversation turned to serious, complex subjects, his brow tightened, and he seemed to be in some startling, private predicament.

"Yes," I answered. "Yes, I was tested about five years ago. Positive. In fact . . ." I raised my eyebrows and smiled at the bartender, asking for another Coke. For a second, the question: Do I tell him this? But I knew I wanted to. "In fact, it's the reason I'm in Zurich."

"Yes?"

"I see a doctor here. He has an experimental treatment for

HIV. This is my third time coming for the treatment."

"Experimental? Is this some new kinds of drugs?"

"Sort of, yes. It's an herbal formula, all natural, made from plant extracts. The doctor gives me a series of infusions, and then I take medicine back home with me."

"Yes, I have heard of these medicaments. This is common in Europe."

"I don't understand it, exactly. I just know that it's been good for me. Before I came here the first time I really was quite sick. I was stuck in bed most of the time, losing weight. No energy, absolutely none. Every little task was a huge effort for me."

That expression of Walter's again, of displeasure and dismay, which communicated as clearly as if he'd said it in words that he did not wish to hear these things. "You know, I believe AIDS is caused by all of the antibiotic drugs the Americans have taken for years now."

I shrugged.

"You know, also, they think that the HIV virus was produced in a laboratory and escaped somehow accidentally."

I smiled.

"Also, I have heard very terrible things about the drinking water, the water from the taps in the United States."

I signaled for yet another Coke. Determining the cause of AIDS seems mostly distracting to me now, irrelevant. I neither believe nor disbelieve the theories. It became clear as Walter and I talked that though he *knew* of AIDS, and was presenting himself as thoughtful and informed about the subject, he had virtually no *experience* of AIDS. His relationship to AIDS was composed of rather ridiculous, desperate stabs at understanding its source. Everything from over-the-counter cold remedies to toxic chemicals in fast food. My grin was frozen and phony, as I found

myself becoming impatient, frustrated. I thought, he doesn't know what he's talking about, but he's talking on and on anyway.

"If I were to become positive, I would simply try and take very good care of myself. Eat well. The diet is the most important thing." He was looking at me — expecting something, or perhaps sensing my discomfort.

"You know, Walter," I tried to speak softly, calmly, "the thing about AIDS is that it's a sickness. People get weak, they lose weight. I've known people with AIDS who can't eat at all, they actually can't get food down. So it isn't a matter of choosing a healthy diet. People are . . . people get . . . *sick.*"

It seemed he hadn't heard me. "And I would absolutely refuse these treatments from the medical establishment — the antibiotics, AZT" (pronounced "A-zed-tay"). "I would take this treatment you are taking."

How confident he was, in a medical treatment he knew nothing about. "No, Walter," I said. "You don't know *what* you'd do. You're simplifying all of this. The decisions are really difficult and confusing. There's so little information, everyone contradicts each other. They tell you to take such-and-such a drug or you'll be blind in two weeks — so, of course, you take the drug."

He blinked at me, looking like a child who'd been scolded. There was a moment of strained silence. How had I got in that fix? Practically fighting there with Walter. I asked, "Have you ever seen anyone ill with AIDS?"

He shook his head.

"But you've known people who were positive. You never visited them in the hospital?"

"Here," he answered softly, as though distracted, "here, if they get sick, they disappear."

The Tip-Top felt stifling; it was difficult conversing with Wal-

ter above the jukebox music. I told Walter I was getting hungry. He knew of a good restaurant close by. We hurried through the rain. The place was brightly lit, not too crowded. We continued our discussion over plates of spaghetti.

"But I don't understand. You do believe in these experimental medicaments you are taking, yes?"

"I believe — it isn't a matter of belief. It's a matter of what seems reasonable at any given time. I've spent a few years taking all the therapies they have in America — AZT, ddI, all of these things. I'd also done some very toxic alternative stuff. So, what I was looking for was a treatment that, first of all, wouldn't make me feel worse. I talked to a few people who had come here to Dr. R., and they had very positive, enthusiastic reports about how they were feeling. I just took a risk and tried it. It's clearly been effective for me. So, I keep choosing to take it. Not because it's the right thing, or I have some kind of belief in it, or I'm convinced. Just because, for now, it makes sense to me."

"Yes, I agree. That's what I'm saying. People are given in America, as also here in Europe, these poisonous drugs, these antibiotics . . ."

"Antibiotics have *saved* a few lives here and there, too, you know."

"But I believe they are a destruction to the immuno system."

"See, the thing about AIDS — there is no cure. They don't have any treatment, really. So, if you have AIDS, you're in a position of choosing among a whole bunch of drugs and approaches and doctors, knowing that *none* of them is really going to be the answer."

"Yes, this is true. Yes, and the government pushes onto people these drugs for making money for the big companies . . ."

"And when you are faced with making these decisions, you

bring your whole life with you. Everything you've believed and been taught, about yourself, the world, the body. When you were a little kid and had something wrong and the doctor fixed it. Your experience in your family. Your ideas about sex. All of this goes into how you cope with AIDS. All you know about who you are is challenged."

"I believe . . ."

"So, if a person responds to AIDS by taking AZT, they are not right or wrong, Walter. They're just doing what makes sense to them."

I knew there was an acrimonious tone to my words, and that I was interrupting him, talking down to him. In some way I had been making a rather strident attempt to raise Walter's consciousness. But, I asked myself, What am I driving at? What do I want from Walter? His naïveté, his simplifications, had infuriated me. Why?

"What I believe is that you boys just went too far."

"You mean — what do you mean?"

"Well, all the fucking and the sucking and this and that. It's not a *bad* thing. I just say, years back, you went too far."

"And what were you doing years back? What were gay men in Zurich doing in the seventies?"

"It is not the same here. We do not have this identity based on being homosexuals. We're not organized, we have no power."

"No sense of community either, though. No protection for gay people, or support. Right?"

"There is not the need here."

"So. You're against antibiotics and the gay community."

"That's right," Walter replied, and we laughed.

We said nothing for some moments. We each concentrated on winding spaghetti on our forks, picking at our salads. Talk

turned then to easier things: he told me the best hours at the Apollo bathhouse and about a cruising park on the other side of the river. He asked me if I had a lover in San Francisco. He said he was just now in the process of breaking up with his boyfriend, a twenty-two-year-old Arab man named Kahmel.

I was smiling, appearing to be engaged with Walter, but feeling still a queer animosity. The reason for it suddenly came: I'm jealous. I wish that my experience did not include sitting at bedsides of wasting friends. I wish I believed my health was a matter of eating more vegetables. I wish that in my life, when pain approaches, it would not descend on me, but simply disappear.

IN THE BOOK OF POETRY my father gave me, there is that famous Yeats poem and I've read it again and again, and a certain line is stabbing me now: *Things fall apart; the centre cannot hold.*

Dr. G. flips through my blood reports, then looks at me with a blank gaze. He says he thinks we should really stop testing the T cells as, at this stage of the game, they will never rise significantly. *I am not my T cells.*

A reviewer thinks my last book is cliché and ineffective. Another reviewer says it's a masterpiece. *I am not my career, I am not my writing.*

A check is late. So I'm angry and broke. *I am not my bills or fees or bank balances.*

I'm counting out my pills for the week. *I am not AIDS.*

I'm exhausted, and cannot finish what I've started. *I am not my usefulness or competence.*

I know that at times I've disappointed Dan. *I am not my relationships.*

In relation to all of these things and countless other things, I am deluded into an understanding of myself. Passions and ceremonies, wishes and love — my life is made of endless tasks designed for maintenance and acquisition. To hold on to this life. To protect myself.

But, here in Zurich, moments at the mirror reveal an unsettling truth, like a snake's tongue flicking my ankle. This center, this self, which gets all my energy and attention, is not what I thought it was. Is not even real.

I am simply lonely, scared, because I'm far away from home. AIDS poses unanswerable questions — what to pursue, what to discard, what drugs to take or doctors to trust, how to fuck. How to live my life. Reeling in disturbed shadows of my identity. But doesn't merely being alive pose these same questions? Beneath this predicament of isolation is a more fundamental predicament. For if I am not this, not this, not this — what am I?

27 OCTOBER 1991

The rain has stopped, but there is no blue sky. Went to Dr. R.'s this morning. A young French woman and her parents were in the office. She'd been very ill for some months; this was her first treatment with Dr. R. She and her mother pounced on me with questions — how long I'd been infected, what effects the treatment had had, what other drugs I'd tried. The father kept a stony silence.

PLEASANT WALK from the central train station back to the hotel. Today, I did not imagine someone following me. When I picked up my key from the concierge, I considered again what he must think of me. He is alone, the man observes, and does not

often go out. Does not ask about tourist sights, or exchange money. He eats quietly, always alone and very early in the morning; then he is gone a few hours; then he is back in his room.

I settled down with Flannery O'Connor. ("Oh, yes," I remember one of my students declaring when I mentioned Flannery O'Connor, "I love his work.")

I wanted to sit at the typewriter, but felt alienated from that process. I couldn't concentrate. Ideas and images are splintered for me here, and it did not seem possible to write.

I'm keeping a bottle of mineral water and some apples on the window ledge.

Walter phoned. "How are you, Walter?"

"Thanks. And you?" He invited me to supper at his house tomorrow night, around seven. He lives on the very outskirts of Zurich proper. He told me which train to take. I wanted to decline the invitation, but I felt obligated and unable to come up with a reasonable excuse. Also, I knew socializing would be good for me.

LATE IN THE AFTERNOON, I took a stroll. The Grossmunster, with the famous windows by Chagall, is on a rise very near my hotel, overlooking the river. Teenagers were smoking pot on the steep, winding steps. I went inside. I've always noticed that churches, temples, or cathedrals in America do not interest me in the least, but in Europe, I am drawn to them.

I walked back down to the square and stepped into a café for tea. A young couple sat at one of the small round tables beside me. He likes her, I thought. He was handsome, with receding blond hair, an easy smile. He said something. I could not make out the words, though by his tone and inflection, I knew he was American.

She was Swiss. Sand-colored hair cut short, and light eyes.

When the waiter arrived, she ordered for them both, in German. They laughed. Fragments of what the American man was saying: "Last night . . . follow you . . . money on Friday."

Under the table, he nudged her knee with his knee. His eyes did not leave her face, but she looked down, away, then back at him. She was flirtatious, feigning shyness, then smiling. He was aggressive, purposeful. He liked her.

The pair were of course dressed tastefully, expensively. Everyone in Zurich, it seems, is well-dressed and groomed. There's a hole in the sleeve of my sweater. My shoes are scuffed. Are people looking at me and thinking, contemptuously, that I'm a cheap, tasteless American?

I motioned for the waiter, and my elbow knocked my teacup. Copper liquid splashed onto the table, soaking my cloth napkin. The waiter was approaching.

Do I appear as desperate as I feel?

FINALLY GOT TO TALK TO DAN. It was morning there; he called before leaving for work. I told him about the hotel, about Walter. I said I was contemplating trying the gay bath. I told him the treatment had been going fine. He said that he'd been keeping busy and fairly content, that the cats were well. So-and-so had called for me, and I'd had some mail from my publisher. "This has been too long now," he said, "I miss you."

"I miss you, too. I'm lonely. It's kind of sad here. It's too perfect here." These statements were inadequate. I knew, even as I spoke, that I could not articulate my real experience in Zurich. "For a little while, I'll feel okay, and then I get like a panic attack — it's hard to describe. Like I've lost myself." I was crying suddenly.

In our life, Dan and I trade rationality. Often, when he is

afraid, I am fearless; when I am overwhelmed, Dan is strong. To-day he was patient, gentle. He suggested that my weariness and tension were due to the time change and how long I'd been away from home. "And listen, Bo — don't forget why you're there. Just taking the treatment . . . dealing with that stuff is hard." All of this did comfort me, and is true. What I couldn't express to Dan was my internal experience here. I'm not in pain, exactly; it's like I'm in some deep meditation. Seeing things, hearing things un-known until now. My loneliness goes beyond missing Dan or not liking Zurich's weather. Beyond even the complex struggles with AIDS and its meanings.

"I'm falling apart," I said.

"No, you're okay, Bo. Just rest, take it easy. Have you eaten anything?"

And here is that whispering, toneless voice again, just behind me or off to the side, in my head — now it seems to have a trace of a Swiss accent — *What's falling apart is the illusion that you're falling apart.*

OF COURSE, a Gideon Bible's in the drawer of my night table. The New Testament only, translated into French, German, Eng-lish, and Dutch. Tonight I picked up the book quite carelessly, leafing through its delicate pages as though it were a *New Yorker* I'd already read. The appendices categorize passages of the Bible according to the needs of the reader, citing the chapter and verse one might turn to for comfort in times of loss, of challenged faith, of anger, of sickness, for those who feel guilty, lustful, lonely. My understanding of the Bible is as a limiting, irrelevant mythology. Mother's family were Jewish, Dad's were Catholic, and they took us kids to Unitarian church. We were told the

Bible stories, but they also told us Aesop's fables, which, I think, left a stronger moral impression. In America, the Bible is a weapon, a point of contention all around me.

I skimmed the Sermon on the Mount. I was astonished to find myself acquainted with the language, even though I had never read the Bible before. "Ye are the salt of the earth," Christ says. "Neither do men light a candle, and put it under a bushel . . . but whosoever shall smite thee on thy right cheek, turn to him the other also . . . let not thy left hand know what thy right hand doeth . . . neither cast ye your pearls before swine . . ." Good fruit and evil fruit. Wolves in sheep's clothing. Winds and floods. A house that did not fall because it was founded on a rock. Lust in the heart. These phrases and ideas are part of common discourse, uttered on TV talk shows or in the grocery checkout line. The meaning was not particularly comforting to me, but the familiarity made me warm, oddly pleased.

Blessed are all these: the poor in spirit, the mournful, the meek, the righteous, the merciful, the pure in heart, the peacemakers, the persecuted.

Got through a couple of the gospels. I can see how easily someone can be fanatical about this stuff. It is morbidly intriguing. Redemption is a hook, and suffering. And Jesus is compelling aspiration, a lovely wish . . .

In tears, I knew I would be. These were quiet, almost consensual tears. I got down on my knees at the edge of the bed. I laced my fingers. "Please get me out of this," was what I said. But what was *this?* Out of what? Despair? Fear? "Please get me out of this," I prayed. And to whom or what was I making this ambiguous request?

My own version of life seems now to be some kind of obstacle. Yeats wrote: *Surely some revelation is at hand.* Is it? Am I on the

edge of a richer knowledge? Will the meaning of things to which I'm so attached be carried away, like newspapers rolling along Zurich's wet sidewalks in a strong breeze? And will some other meaning be revealed?

Prayer is an embarrassment to me. It is not sensible, it's impractical. I'm a doubter, and loathe superstition.

"God, if you exist, get me out of Zurich." And I started to laugh, wiped wetness from my cheek with my sleeve. Up off my knees. How silly to be on my knees.

28 OCTOBER 1991

Today was my last treatment with Dr. R. I was the only one at the office. Mrs. R. gave me a bag with the medications to take home, and a letter asserting that these substances were for private medical use, in case Customs should stop me. I'll come back in six months. They both hugged me good-bye.

I did not get off the train at the Bahnhoffstrasse, but kept going, up into the hills. The Zurich Zoo. It was dewy and cold, and there were not many other visitors. Schoolgirls were playing on an iron railing, laughing. I walked in and out of the buildings, seeing monkeys and big cats, penguins. Some deer were in a fenced area, and I had a stare-down contest with one of them. We both refused to budge or glance away. Finally, the deer won.

MESSY TIME getting to Walter's this evening. Freezing, pounding rain. My umbrella got bent. Chatted with a German woman, Claudia, on the half-hour train ride. She was a flight attendant, staying at the Hilton. I asked her about the neo-Nazi movement in her country. "These thugs, of course, nobody likes.

But, also, we understand their anger. We are all upset about the foreigners in Germany." Of course, Claudia was well-traveled because of her job, her favorite city in the world was San Francisco. "Especially the homosexual district."

Walter lives in a complex of brick buildings a short walk from the train stop. There are tiny, fenced garden plots surrounding the place. His ground-floor apartment is small, unremarkable. I noticed immediately that he had only one shelf of books. A dictionary, a gay travel guide, and, of all things, *Ein Baum Wacht in Brooklyn,* by Betty Smith. On the walls, a couple of posters of nearly naked, oily men. When I arrived, Walter was making sausages and potatoes, a "typical Swiss meal."

Taped to the wall in the hallway were some snapshots of two blond teenage boys, and Walter, smiling, between them. I asked who these boys were. "Those are my sons," he said, standing beside me, in front of the pictures. "These were taken a few years ago. This one," he pointed, "is twenty now. This one is eighteen." He looked at me. "Yes, I was married for fifteen years. Before I came out I was married, and we had these boys and lived in a very good house in Richterswil."

He returned to the stove, and I stood in the doorway to the kitchen. "I wish often that I was still with them. I am really a man who likes a family. My wife was a very good person, and my children. And the life I had then was a nice life. My life hasn't been as good since then."

"Why did you come out, Walter?"

Speaking loudly, to be heard above the crackling of the sausages cooking, Walter answered: "Well — I was gay. This was the problem, you see. And it started me to having terrible nervous conditions. As the years were going by, I knew that I wasn't really being myself."

While Walter cooked, I sat in his front room and turned on the television, found the English-language channel. I'd not seen a paper or TV news for days. Things still look good for Clinton. George Bush seems ever more petty and raving, like a little kid banging his high chair with a spoon. Walter joined me in the living room, saying supper would be ready in about ten minutes. I pressed a button, muting the television sound.

His phone rang. "I'm not answering that," he declared. "That's Kahmel calling, and I'm promising myself not to answer his calls." I've heard some more about this relationship with Kahmel. He is in his early twenties and hustling Walter like crazy — for money, for a place to sleep, for affection. Kahmel is afraid his friends or brother, who also lives in Zurich, will see him with Walter — then they might know he is gay — and so he arranges to meet with Walter in obscure restaurants or at Walter's apartment.

Sipping his wine, Walter said: "He always is making me very nervous and full of so much anxiety. And I said to him, Kahmel, this cannot go on anymore. I cannot give you all this money and take care of you like this." Walter was unconvincing to me; how easy a mark he must have seemed to Kahmel. When the phone rang again, Walter glared at it, determined not to be captured.

"To tell you the truth," he said, then paused for a moment. "The reason I went to America was not only for holiday. It was to separate myself from Kahmel."

"I understand," I said. I did understand — that his attachment to Kahmel was deep, painful. "I know what that's like," I said.

Dinner was fine, and conversation was light, easy. Occasionally, I could not help glancing at the silent television screen: tonight, pictures of savage beatings in Bosnia and starving people in Somalia. I noticed that Walter was pointedly not looking at the

screen; he was chattering on about the expensive new motorways they're building in Zurich, about a certain spot by the lake where gay men sunbathe, more about Key West.

During coffee and continuing small talk, I caught sight of a particularly gruesome image on the color screen: a woman, beaten and bloody, crumpled on a sidewalk, being kicked by soldiers.

I gasped. "My God, look at that. My God," I said softly, miserably. Walter's response was to look the other way, at a blue glass vase with red carnations in it set on the coffee table. He was distinctly refusing to see. The moment was an awkward one. I pressed the button to turn the set off.

"I just think . . . sometimes . . . what a brutal place the world is," I said.

"And, you see, there's nothing we can do about all of these awful things in the world. Starving and killing, wars."

"You're right, I guess. But that's a pretty hopeless position to take."

"Not at all, no, not really. I believe that the thing for me to do is simply to be kind to the people I come across. The old lady down the hall here — I carry her groceries. The people in this neighborhood, I wish them a good morning. And this is all I can do."

Walter has described himself several times now as "typically Swiss" — and there it was, a practical philosophy of shutting the eyes to suffering elsewhere. Suddenly, something about Walter was illuminated for me — and something about my own ambivalent feelings toward him. He is apparently self-centered, insulated, but that is only a way to cope, a tactic. Walter is overwhelmed by the complexity of the world, of love and choice. He's a generous person, caring. But caring can hurt, and Walter knows this.

"I said to Kahmel, I said, 'Kahmel, you must take your papers

and go down to the office for the immigrants and be registered properly.' But, he didn't do this. So then he was in terrible trouble, and he came here, wanted to stay here. I said, 'Kahmel, you *cannot* stay here.'"

Then, Walter told me how Kahmel had seduced him. Walter's practicality and resolve were peeled away because this handsome young Kahmel had looked him in the eye, smiled with gorgeous white teeth, led him into the bedroom. "And then it was the touch," Walter told me. "Such a gentle touch. On my cheek, my throat." For a second, Walter forgot about me. He returned to the sensation, which had hooked him mightily. "I was completely with no power then." Tears formed in his eyes. "That touch — and so, whatever Kahmel wanted, I would give to him."

I was moved by Walter's testimony. He was not contriving an explanation, but telling the utter truth. He sat quietly, not looking at me, seeming raw.

"You have been with your lover for how long?" he asked.

"Just about five years."

"Really? Oh. And this is common, the gay couples being together for a period of years?"

"Common? I guess so. Yes."

"Oh, well, here, you see, we do not have this. Here, a relationship for gay men lasts only a fracture of a second."

Then, abruptly, Walter began talking about his apartment. He pointed out each piece of furniture in the living room, told me where he'd bought it and what he'd paid.

As I was getting my umbrella and coat, Walter said: "Listen, I have thought about something today. I would like to offer you to stay here, at my house."

I was flabbergasted and could think of nothing to say.

"Yes, you have another day or so in Zurich. Your treatment is

finished. You can be away from this terrible hotel and be more comfortable to stay here with me."

"That's very generous of you, Walter, that's a very gracious offer." His expression did not reflect graciousness though; it was a kind of pleading. Instantly, I could smell that stifling hotel room of mine, feel the eyes of the wretched concierge, see my little-used typewriter. Here was a chance to escape my loneliness, to be diverted. To be taken care of. I recalled kneeling at the end of my bed, praying; and wasn't the prayer really for this?

I said: "Look, why don't we both think it over. We'll talk tomorrow. If you still want to invite me . . . but, if you change your mind, I'll understand."

Walter was emphatic. "Oh, no. I would not change my mind. I would never make this offer and then rescind it." As I left the building, I heard Walter's phone ringing. Kahmel.

29 OCTOBER 1991

Went out for breakfast and browsed through some shops. I'm looking for a gift for Dan. Each time I come here, I try to find something special for Dan.

I phoned Walter. No answer. Now I'm thinking I do not really want to go stay with him, but I don't want to hurt his feelings. The invitation itself was a tonic for me; actually packing up my things and going out there seems like a nuisance. Something else I've learned about Walter is that he is a hypochondriac. Last night he revealed his history: spontaneous hair loss, bizarre temporary paralysis, depressions, tics. Everything was cured when Walter had all of the fillings in his teeth removed and replaced with porcelain. He claims he has never had a single health problem since he made that bold move. He is absolutely convinced

that he discovered the cause of his pain, and that now he's cured. In this way, he feels allied with me — that we are two medical adventurers, moving against the grain. I don't feel that alliance. I'm not convinced of anything.

Read through the afternoon. My true crime story is deliciously gruesome. Kept turning to the Yeats poem. How could he have written a poem about AIDS back in 1920? *The ceremony of innocence is drowned.* How did he know about the blood-dimmed tide? Well, he didn't, obviously. It's just that AIDS is not the first time, and will not be the last, that *mere anarchy is loosed upon the world.* I don't understand the poem, really. I get lost in its references and assumptions. But I am unaccountably moved, too. By that one line especially: *The falcon cannot hear the falconer.*

By supper, still no word from Walter. Odd predicament — I was figuring out how to decline his offer but, at the same time, resentful that he'd not called to confirm it. I dialed him again.

"Walter? Hi, it's Bo."

"Yes, hello Bo."

"How are you?"

"Thanks. And you?"

"I'm good. I've had a quiet day."

"Yes?"

"What have you been up to?"

"A lot of chaos has happened, Bo. Kahmel called me today because he was arrested by the authorities. I had to go down there to him. And he's been released over to me."

"I see."

"Yes, and he's listed that this is his home, and so he will be staying here now for a few weeks. This is a lot of chaos. But what could I do?"

I said nothing.

"So, I'm sorry to say I must rescind the offer to you to stay here with me your last night in Zurich."

Washed over with relief, and a second later with anger. "Well, that's okay, Walter. I told you to think it over."

"Yes, but I have really no choice. I'm very sorry."

"I understand. Really, don't worry about it. I'm fine here."

He asked when I would be leaving and if I needed a ride to the airport. I said I'd arranged for that. He said he would call me in the morning to wish me good-bye.

The best lack all conviction, while the worst
Are full of passionate intensity.

AROUND TEN O'CLOCK TONIGHT, I left the hotel. The streets and steps were crowded. I walked to the Apollo bathhouse and rang the bell to be let in. I handed the attendant fifteen francs and was given a locker key and a towel. Some very sexy posters urging safe sex practices were framed and hanging in the entryway, and there were boxes filled with condoms on the counter.

A maze of lounges with beat-up leather sofas. Men were stretched out naked, smoking or sleeping. At the back of the place were the steam and shower rooms. Red cellophane was taped over the lights, so the tile and the men were drowned in a pinkish color. Mostly older guys. A few young ones who seemed high on speed. Occasionally, low voices, speaking in German. Men looked me over. One followed me, but I did not encourage him. Another one I liked, but he did not seem interested.

I never have cared for the baths much, and in San Francisco they've all been closed down. I've always said I didn't like taking off my clothes. Here, though, the nakedness was neutral, neither inspiring nor terrifying. Maybe I mean natural. And I felt shot

through with an exciting, dangerous pulse because of my absolute anonymity here: No one knows me. No one's seen me before. I will not encounter any of them again. No one here trusts or distrusts me. I am unrelated to these people, don't even speak their language.

I sat on a bench, steam rising in the red-muted dimness. I closed my eyes. Huge beads of sweat coursed down my throat, chest, legs. My hair was soaked and stuck to my forehead. The motionless clouds of steam, the odor, signified that in this place anything was possible. My dick was stiffening; it rolled slowly against my thigh.

I opened my eyes when I felt my elbow brushed. Someone's knuckles. He was sitting on the bench beside me. I couldn't see him well, because of the steam. I put a hand on his shoulder. It was hard. His hand moved over me, to my chest, my arms. We embraced. We kissed. He had a small dick. We were jerking and tugging on each other. I touched his face. I pushed my fingers through his short, dark hair. His hand was wrapped around my dick. He could tell I was about to come, and he did not change the rhythm of his stroking, he stayed slow. When I did come, he pulled me close to him. Drenched, we held each other this way for a few seconds. Then he kissed my ear and walked away. I saw the door of the steam room open, and light came in, and his figure stepped out, and the door closed behind him.

30 OCTOBER 1991

Walter did not call today. I did not really expect he would.

Around eight a shuttle car picked me up at the hotel, to take me to the airport. For the first time, the sun was out, the sky was blue in patches. Our car sped, weaving from lane to lane. We came

over a rise, and suddenly Zurich was spread before us. Cathedrals and towers and balconies and gardens, shining and still, like an illustration of a fairy-tale kingdom . . .

What did I get here? An infusion. A friend? A vision, at once troubling and hopeful, that darkness drops, then lifts, then drops, then lifts. On everyone, not only me.

Is the value of my treatment not in the substance or method or in the doctor's sure hands, but in the experimenting itself . . . born into a hard life, where being saved must always be a hope. A shot can save me — for now. Maybe a pill will come along. A touch saved Walter one day . . .

During some hour, a long time from now, I will be liberated from the pervasive dream that I need liberation. I'll see that I'm already free.

JADE

Upon a plain of thought, a box,
Ornate as a medieval bodice.

Within the box, another box: the renaissance of jeweled boxes.

Dissecting the boxes with surgical gloves,
A blond and bright nothingness,
You watch the descent to smallness, once in love with
 diminutiveness.
Box within box within box within box . . .
Centuries stripped raw, poignantly.

In the very last box (if there is one), this century,
The root of the problem displayed upon velvet
Like the Nairobi diamond or Nairobi itself,
A Haitian pufferfish in its embalmed perfection;
Desire frozen with moribund deception. Oh so artfully.

Wrapped in plastic, the dormant heart,
"Ti bon ange" trapped in a jar,
Still feathers against what makes up the glass,
Your fear which makes it impenetrable,
Sentences me temporarily to a bell jar like Juliet.

In the very last box (if there is one), this evening,
Marbleized by the moonlight and vaulted like a ceiling.

You and I sit on a sofa, a turbulent dinghy.
You're afraid to kiss me, the plot of our first kiss,
The backdrop, foiling us.
"Do you think of me as contaminated?" I ask you finally.
"I think of you as a beautiful jeweled box," you reply very
 quietly,
"And inside you is a box even more beautiful."

But in your eyes I interface myself,
A photograph of a dead tree
Or a painting of a living tree.
That minute carnelian buds have begun there makes no
 difference.
One can easily turn away from a photograph or a painting.

I see the dirt pile up in the distance,
Dug up by the tiny spoon that doles out the pufferfish powder.
Someone left a jar of it outside my house.
And in the very last box (if there is one), inside me,
Lies the spoon raised on velvet, a corpse in its tomb.

It swallows up everything I am, this box.
This box a blood test, this box, an abstraction,
This box a coffin of sorts
That buries inside my body the antibody HIV;
My body's counterbody, the proof, nonproof,
A footprint, this root, merely a photograph of a root,
A photograph of a dead tree.
This origin, a nonorigin mistaken for the truth
Devours me almost cannibalistically
To a skeletal bride draped in desecrated chiffon, once white.
Coffin within coffin within coffin within coffin . . .

Within my body, a pilgrimage of candles floats.
Within my body, a coffin burns in the snow.
My soul, a firefly the witch doctor now owns,
A flaming boat, my sinewy hold on myself, a tiny angel,
Pinned like a collected butterfly,
Anesthetized by the powder mixed from pufferfish and skull
The Haitian witch doctor grinds to pharmaceutical dust.
Someone blew a cloud of it into my face,
A desert storm where your parents live.
The powdery sand seeps from my skin to my brain.
"They call it the Romeo and Juliet drug," you said,
Ordering all my orifices to be closed
By martial law your peers enforced,
My vital signs stopped by their hands, by yours,
Which lower the ropes eight feet deep into the earth.
I can hear the dirt shoveled on top until there is no sound.
The weight warps the wood closer to my face.

You hated to be the one to do that to me, you said,
Like there had to be someone.
I should have dropped a penny into your executioner's hand.
I should have said, "I forgive you."
There's freedom in feeling that there's no choice, I assume,
Freedom from the screams you hear from eight feet below;
Freedom from the pilgrims buried when they were comatose,
Dug up decades later to find their skeletons clawing to get out.
This freedom, I guess, makes you capable of what you do:
You spread the cold spoon like cold cream all over my body.
You enter it deep inside me like you.
You erase my name, banish me from your house like a
　　Montague.

My unborn children with O-shaped mouths press against your
 window.
I, their murderess mother, who loves them so,
Stare blankly back, mummified for all they know.
Yellow and red rain pours down on my boy and my girl,
Wets their clothes, beats their eyes shut
Against my extenuating scream, one note —
The rain, red and yellow, relentless in its waning
When you cross my hands across my chest,
When your fingers force my face into an expression of repose.
Perhaps you love me best now I've matched the dead,
Buried alive by your fear that I am.
Winter trees tarry against the winter sky like wet feathers.
And I, as resistant, cling to the debris,
To the edges of the sinking place you picture me in.

You visualize (wishfully?) a zombie
Who meanders through the same streets as you,
My silhouetted figure, the negative state of my positiveness,
Always with me, a dead twin.
With my lips zipped together, my tongue carved out,
I've become all eyes, and you cannot bring yourself to look into
 them.
For if you did,
You would hear my scream as just breathing, and you know it.
You would witness without surprise the green decumbence of
 my exile.
You expect the odor of putrefying flesh
But discover instead my body whole and pink,
Loyal to your touch, as you once did.
From the inverted mouth returns the bottomless kiss
From my hidden sex, a Buddha's smile,

My body, the beautiful box you fetishize
As if inside me there were a box even more beautiful.

Stripped of our clothes we go beyond the flesh through the
 flesh,
To the swelling within us we refer to as our souls.
Our flesh, a rope bridge to this, where trains pass beneath
In the night, in the philharmonic heat.
Where the red moon, inches above our heads,
Will exclude us from its light, apheliotropically, in the end.
And this is why we in our aphasia
Must kiss and kiss and kiss, in an effort
To include ourselves in the red moon and suffocating kudzu's
 eternity;
Which, if granted, we could not bear, we admit.
But equally we cannot bear its alternative, so we kiss
Flagrantly, tearing our shirts open
And eating from the other's mouth the other's mouth.
So we kiss, just once, a reminder, a glove, an interleaf
Of our aloneness spent together, for now.
So we kiss, cat and mouse, until our saliva becomes a kind of
 elixir,
Kissing insistently, petulantly, apologetically, tangentially,
 automatically,
Profanely our necks, our breasts, our sexes, our hands,
Our fingers in each other's mouths, our eyelids,
Until we kiss as if writing a beginning and a middle and an end
 to us
In the dilating myopia of our kiss.

And in the very last box (if there is one), a symbol
Offered up like a sacrifice, a sliver of jade.

Jade, the gemstone of prophetic dreams
Raised upon velvet, a yellow star, a pigmentation, the
 perpetrator of sin.

Raised upon velvet, it rises again in symbolic ascent.
The cremation dust of resurrection, lost as it nears the unifying
 sky.
Lost and scattered like snow flurry
Across the treeless plain where animal totems roam or graze.

Who sent the yellow star swimming in my veins?
Who plucked it out like an eye and painted it so painfully
 yellow to begin with?

Who stigmatized the pigmentation of my skin?
Who soaked me in blackness, rain of red and yellow, every
 inch?

Who shamed the muscular backs of two men
Making love in the privacy of their bedroom?
Outside, the purling insults deflect from their torsos.
And though six yods whirl, a natural pedestal at their feet,
Like a purdah, a curtain must be drawn in public;
A purdah of lamé, like the backs of two women
Making love in the privacy of their bedroom.

White bread, white collar, white shoe, white noise, tennis
 whites, Snow White,
White tails, white boy, white sale, white teeth, lily white,
 hospital white,
White night, white linen, white horse, White House, deathly
 white, white cloud,
White lie, white elephant, white wedding, bone white, soft
 white, semen white,

White wine, white rabbit, white glove, white Christmas, white
blood cells

I hang from hooks that pierce my chest,
From threads in a hole eight feet deep without food or water.
I hang as if on a vision quest,
A grizzly bear existing on its own fat like an oil lamp.
I hang until I gather the grotto around me as my coat,
The fur of my grizzly bear totem on earth.
And listen, floating within this black tank,
To the rain, red and yellow, pummel the surface above.

It pours down on those buried alive in Hades.
On all the angels, "Ti bon ange," trapped in their jars,
Music convexed inside tiny silver balls.
Boxes within boxes within boxes within boxes . . .
And in the very last box (if there is one), inside us:
There is no yellow star, only a virus of hatred.
There is no pigmentation, only ignominious discrimination.
There is no difference, only lynching, gassing, and burning,
Only the indifferent, contributing insidiously
Like the president of our country,
Only power thwarted and twisted as vegetation on Three Mile
Island,
Only fear that spills injections of interferon, upon the agnostic
cemetery,
Only fallout that pulverizes the monolithic granite,
Only tears precipitating on the multicolored florets
That appear more as if tossed than placed, like wedding
nosegays,
Before the engraved names and dates of the arbitrary lengths
of life —
Only the atrophied hearts of the living that look on.

While I, in a kind of sunk ship of my own, listen
To the falling of our love, flayed in its attempt to be shown.
Until burying what was left of our desire
Was all that was left,
Box within box, into the cold slid the black body bag.
I can hear the wings around me beat against their jars,
The frenetic angels fighting for air.
Their letters, conversations, monologues of defenses,
 possessions, mementos,
Telephones, typewriters, telegrams, sexual innuendos and actual
 gestures
Assimilate a soliloquy that has become an abyss.
Abysmally falling on the flavescent grass,
Falling and simultaneously bursting inside me,
Box within box within box within box. . . .
Violently, sequentially, the boxes spring open their lids.

And in the very last box (if there is one), inside me,
Lies the root laid upon velvet,
Simply a symbol like a sliver of Jade:
A cold spoon, an antibody, a yellow star, a pigmentation.
"What's Montague? It is nor hand, nor foot, nor arm, nor face."
The mythology of white weaves these threads from which I
 hang.
Jade, the gemstone of prophetic dreams,
Dissolves in my system like a pill.
I watch vigilantly while you take off your surgical gloves,
I watch you approach and drink from my cup,
For I've put no pufferfish powder in there, you finally trust.
Finally my healthy body that is my healthy body is given back
 to me.

Finally my rights that are my rights, as my tongue is mine, are
 regained.
Finally you touch me, and the finality explodes
Into plains of thought, layers of earth in an archaeological site,
Into the history of boxes,
Until finally they collapse within themselves
And vanish into extinction.

POEM FOR A POEM

for "Jade"

And the snow fell lightly in Cambridge
where I swallowed the lightning of you whole,
a bolt with such a hyperbolic zigzag to its edges
that it seemed cut out of cardboard for a school play.
It stayed that way, stuck inside me like a pipe,
a spine of bite-sized bones.
And the snow fell lightly in Cambridge
where I stood on the platform in public for you,
you placed precariously before me like sheet music,
just paper, I know,
but not outside of me as I had hoped,
as I wrote that winter in those black mornings.
And the snow fell lightly in Cambridge.
My lamp snowed whitely on my desk, a street of snow
where white mice multiply by the hundreds.
And everything was so cold, all my animate objects,
except for the lead of my pencil, a welding utensil
or flashlight to guide my exodus in the snow.
I wrote you, a wagon I pulled on the road

in the effort to leave you, to let you go.
Or maybe it was more the other way around,
the words, bread crumbs strewn to lead me back home.
Does it matter, really, which direction I desired?
I built, plank by plank, the rope bridge with so much purpose
that the purpose became the purpose in itself:
the relief of the labor of mindless work,
the stinging panic that brought lovely focus
to the next cliff. The next cliff
was all I thought about,
as if sailing in a ship at dawn.
And the snow fell lightly in Cambridge.
So whitely it put me back in my days,
the hotel decor as monochromatic as my thoughts
of you, you the poem, and the you in the poem,
the two merging together like a photograph
when a matte-finish snapshot is what I have left.
The landscape behind the amateur portrait
landscapes the landscape of my pain, rank with weeds,
outlasting of you, or me, as landscapes do;
though as a landscape of snow you'll always loom
where the lamplight on my desk whitely snows.
I thought because you were so complete,
because you came out whole like a baby
or twelve-foot snake yanked from my gullet,
great sword of Excalibur ripped from its stone,
that at last you were separate from me as a landscape.
But deeper you sank instead, absorbed into my liver
like a bottle of vodka I'd consumed.
Now there's no getting rid of you.
I could tear you up, burn you, stubbornly disown you,

sign a pen name in place of my own,
and still you'd roll through my head, a motion picture,
sway below me still the sturdy net I wove of you that winter.
I even feel guilty and somewhat fearful
as if you had the power to paralyze my hands,
break every bone in my fingers like a king,
draw and quarter me for my traitorousness;
then turn all my poems to mush, as if they be, by the grace
of god, not already that.
And with the spiteful vengeance of a jilted lover
ensure supernaturally that they never be read,
for they're not made of the pure substance of you,
like the real thing I shot up my veins,
and let the much-talked-about bliss run rampant,
not caring, not caring about anything.
Ironically I wrote you to make myself clean,
a thousand baths taken in the writing of you,
the symbolic cleansing of a baptismal crucifix.
Now you riddle me permanently, bodily, a body tattoo,
internally ruinous, a virus and not just deadly
but deadening to all other poems and men.
Everything breaks down to the denomination of you,
everything I write simply the dissemination of you,
replicating in my body. O my molecule.

WHAT SILENCE EQUALS

for André François Villon

Where the homogeneous wind beats the wild grass closer to
 the quiet ground,

Homogeneous, wild, quiet
Homogeny in a pretense of superiority
Beats wildness to wither into nothingness,
The quiet ground enveloping all that is askew, unorthodox,
The chaff of the world.
If we keep our heads bent in equal direction
Like plow horses pulling against the elements,
The plow will conform into manageability the unharrowed.

The plow will conform into manageability the unharrowed.
Plow, conform, unharrowed
Like strong men at the circus with handlebar mustaches
We hold up this principle while the applause meter goes
 berserk.
We watch mute and emotionless you pace in your cage,
Your frenzied wildness eating you up alive,
Giving back to the god-given earth what you took.
If we're not better than you, what are we better than?
Let the saber-toothed plow of silence reign.

Let the saber-toothed plow of silence reign.
Saber-toothed, silence, reign
We watch you rise fitfully with fever in your apartment,
Your eyelids bruised from crying.
Mute and emotionless we watch you make phone calls
And talk a steady stream of what you need and believe.
Your so-called "friends" sit paralyzed on the other end;
They've said they love you,
But what good can be done really for a drowning man?
In time your talk will collapse onto itself like a Chinese box.
They'll admire the inlay of pain on your face.
They just want to commute conscience-free to their jobs.

Like a Chinese box you'll be buried with all your secret
 drawers locked.

Like a Chinese box you'll be buried with all your secret
 drawers locked.
Box, buried, secret
Ugly angels like buzzards circle overhead.
Your prayers, their prey, they carry clenched between their
 teeth.
On the horizon we stand, appointed klansmen waiting,
Impatient for the riffraff around us to cancel itself out.
Our tuft heads in the distance project a cryptic kind of
 village —
We're just a discriminating denomination, folks.
You sink, rightly so, in the swamp of your made bed,
Far enough away so you can't infect the kids in our schools.
The sky cuts you off like a sunroof as it should.

The sky cuts you off like a sunroof as it should.
Cuts, off, should
Your screams billow up, clouding the glass.
We watch your face, contorted, shrink and whirl away
With a high-pitched cry like a helium balloon losing its air.
We watch several faces follow yours
As if severed from some grasp,
Each with that high-pitched ringing noise.
They shrink and whirl away behind the cloudy glass of the sky.
We watch until that irritating ring stops in our ears,
Comforted by the solid surface of the god-given earth
Where the homogeneous wind beats the wild grass closer to
 the quiet ground.

"PORTRAIT OF CHARLES" BY JEROME CAJA

JEROME HAD ME OVER not long after Charles died to look at the ashes. He inspected the chips of bone. "I wish they were larger," he said, "easier to paint on."

"Can I?" I asked.

He encouraged me, undoing the twist-tie that held Charles's ashes in a heavy plastic bag. I reached in, and the density surprised me, like shattered mortar.

"No urn?" I asked, a little disappointed.

"Just the box" — heavy like a hatbox, and oblong.

That had been two years before Jerome's exhibit, The Remains of the Day, opened at Southern Exposure Gallery and five years after Jerome met Charles Sexton at the San Francisco Art Institute. The Remains were a series of portraits of Charles, created by Jerome, over a surface of resin blended with Charles's ash. In other works, Jerome has included his own body: strands of his long, blond hair, the accumulated toenails on which the *Foot of Christ* is painted. There's no reverence in his use of the body. Jerome is a taskmaster and the body is forced to perform — in Charles's case, even after death.

"So here," showing a portrait, "the ash is mixed with a red resin with glitter in it. I mixed glitter with the ash because she was such a princess."

Admiration and vengeance both had their hand in that project, in the ennobling and satirizing portraits that Jerome later gave away to those closest to Charles.

"Before the show, I decided that those paintings were for his friends and his family, why else bother making them? They're a memento, they mean something to the people who knew him. They may be nice, and people who didn't know him might appreciate them, but not nearly as much as the people who knew him. I don't do stuff for the dead, but I do fulfill promises."

"So this was a promise you made?" I asked.

"Of course, well, we decided whoever died first, the loser would have to make paintings with the other's ashes. Charles really pushed the ashes idea. He loved the idea of being spread out around the country. So now, with the ashes I have left, I can sell her, make her work for a living."

When I asked if it was a great responsibility for Jerome to have agreed to, he responded without hesitation, "No. It's a fabulous surface to paint on. It's a wonderful experiment. The texture's gorgeous. I'm still making new ones." How, then, was Jerome evaluated as the loser? "I lost my place in the mortality line. Charles and I were going to the same place, but he got there sooner." So Jerome became the inheritor of this memorial project. His challenge: to make a phoenix of these ashes.

The Remains of the Day, for its material use of ash and bone, was noticeably lacking in sentimentality. The show was not about honored remembrance, but honest remembrance, and if Jerome had painted Charles as Saint Theresa in one piece, he'd also painted Charles as the devil in another.

He pulled out a painting, explaining, "And the *Happy Face* one, that's a very important one, too. Because that queen hated happy faces so much. I used to have these big, Happy Face earrings. She would not let me wear them in her house. I had to put them in my pocket. So I decided to make her into a Happy Face for eternity."

Painting as payback. But art is always a cannibalism of some sort, and Charles Sexton's work is also an unflinching testament to that idea. In *Dog Boy,* a body is viciously attacked and eaten by a ravenous blue God, which Charles saw as AIDS. It is one of many images in which Charles transformed his own illness into the raw materials of his art. Jerome, who was willed Charles's art supplies and had been using them in preparation for the show, also incorporated their mutual themes. Many of the images in the paintings were shared and developed while they worked together, which they did into the early stages of Charles's CMV retinitis, a complication of AIDS leading to blindness.

"My concept of him is the burning temple, the incinerator. It's one of his constant themes. Saturn eating his children is another theme. That's why I painted Charles eating himself. I love that concept of devouring, and for him, self-devouring. I think self-pity is a devouring thing, to feel sorry for yourself all the time. I always thought Charles was a little crybaby. But he was a noble man, too. He had an exquisite mind, brilliant talent."

For both painters, painting extended well beyond the work that would sell in galleries or hang on museum walls. Their inventiveness transformed their living environments. Both painters were collectors, admirers of the readymade, skillful with appropriation and recontextualization while happily avoiding the titles postmodern, or neo-geo — only to be placed in the dubious realms of "outsider art." Jerome, for example, who paints with make-ups and nail polish, is by virtue of his materials difficult for an art critic to categorize. He doesn't spend his time wracked by such considerations. Asked why he paints with nail polish, he answers without pretense, "Because it's easier to clean up. You never have to wash your brush, just put it back in the bottle."

This simplicity brings to mind a story Jerome once told me

of a visit by one of his ten brothers. They had gone to Golden Gate Park, to the Rose Garden, when they noticed a lesbian couple lying together on the grass, embracing and kissing. Jerome's brother bristled, and when Jerome inquired about his response, his brother used the classic line of those most removed from it, "It's unnatural." To which Jerome responded, "If it happens, it's natural." This philosophy, which implies that nature does not conform to our wishes, informs his work, and is apparent in its inclusive content, and its defiance. Jerome employs images canonized in art history, but they are either fetishized or playfully debunked. Often his use of Catholic imagery and saints is perceived as either academic or political, but, in fact, Jerome has had a brief but startlingly intense relationship with the Church. Not only was he "born again," but he also worked for the Church as an arts and crafts teacher for retired nuns.

Jerome knows his saints, and listening to him explaining their presence in his paintings and particularly, in his relaying the stories of their persecutions, it's easy to assume that his excitement is probably what passed as his conversion experience. Jerome has produced a number of shrouds, manufacturing histories that include *The Shroud of Buddha* and *The Shroud of Bozo;* he's preparing to market them with assurances of their genuineness.

Other images, equally important to Jerome, may not be as easily embraced by the museums, galleries, and arbiters of taste who often wind up on judges' panels and selection committees. I've seen Jerome make some genuine efforts at directing the "right" images to the "right" viewers, but he always seems, somehow, blinded by his adoration of his own work and oversteps the boundaries he attempted. Recently courted by the Institute for Contemporary Art in Boston for a show with drag as its theme, Jerome sent slides of some of what he must have deemed appro-

priate work, to have only one piece — the least offensive, *The Shroud of Glam-O-Rama* — settled upon for inclusion.

The last time my parents came to visit, Jerome brought along several miniatures for them to look at. I was looking over my father's shoulder when he came upon a glittery painting of an engorged penis. "That looks like mine," my father said, laughing with surprise and calling my mother over for a second opinion. Perhaps they should have curated the ICA show.

I mention these incidents to communicate the difficulty Jerome has in observing his work from anyone else's perspective. I think this is why he insists upon having his friends do regular "beauty contests" of his work, persuading them to identify the winner and runners-up from his stacks of paintings. No one is forced to justify their decision making, but I always have the sense that Jerome is deeply interested in how the people closest to him evaluate the work. As with Mapplethorpe, it is not un-common to go through a stack of dick paintings executed in make-ups on black velvet paper, and then be offered another stack of tenderly rendered still lifes of flowers. Jerome, however, docs not feel compelled to make elegant or formal paintings. Raunch also has a place in his heart and work. Sometimes it appears overtly, as in the painting I am the proud owner of, *Bozo Fucks Death,* in which Bozo is a middle-aged man engaging in anal sex with a masturbating skeleton, both figures wearing little boy's briefs around their ankles. Sometimes he is more sneaky, for example, his numerous Virgin Marys painted on used condoms (the shape works perfectly; the head is painted on the reservoir tip).

Jerome makes no attempt to self-censor or justify his process. One need only see his live-work space to understand why he paints primarily miniatures. His room, as well as the other rooms of the apartment, are like display cases created by overzealous

agoraphobics, laden with treasures found and created, constantly evolving environments. In Charles's apartment, too, one confronted the possibilities of an afterlife in hell in Day-Glo dioramas, a foreshadowing, and perhaps a preparation for the truly oppressive purgatory he was soon to enter.

"Hospitals leave a residue on your mind," Jerome explained. "Charles always hated it. She was always so grateful to see me, because I brought decorations for her room, like lights and pictures. No one can live in an empty room, how could you ever get better? So I would go decorate — that's how she got most of the paintings of mine. I said, 'Godammit girl, can't you just die, you keep getting sick and I'm losing all of my best paintings.' She was such a greedy cunt."

Charles's work began to reflect the cold procedural probings of the hospital in works like *Diagnosis,* a dark monoprint of a stigmatized patient either locked in an airless, pyramidal aquarium, or constrained inside a reliquary box. The Remains of the Day are reliquiae, though no longer protected or enshrined, but exposed to light and air, used, forced to work. Jerome muses over the tradition of reliquary boxes: "Some were made out of gold and gem-encrusted, with little windows through which you could see the decay." He seems delighted by the elegant intricacies of a box that makes us privy to our decay. "My favorite story is Saint Bernard's. He became a missionary when he saw some German boys and thought, God must really want them in heaven because they are so beautiful. He was attacked by thieves who wanted his box. Saint Bernard fought for it and was killed. The thieves got the reliquary, but when they opened it, there was nothing inside but hair and bones."

In contrast to this tradition of making the dead precious and preservable are Charles's images of voodoo and dolls, of replica

"DIAGNOSIS" BY CHARLES SEXTON

and symbol. Charles's painting *The Supplication* is full of a primitive and hypnotic power; priestess and supplicant are doll figures, their relationship an archetype between the protector and the vulnerable, the care-giver and the sick. Jerome's painting *Charles as King of the Broken Dolls* recasts these themes. Charles, portrayed as a crowned jack-in-the-box, looks out over the ruins of broken toys. The body is breakable, finite, simple. The doll, possessing Charles's face, is again imprisoned in a box, a toy that is toyed with and discarded. And though Jerome was never sentimental about the cruelty of Charles's illness — the opportunistic infections like vicious and individual brutes that form a gang — the jack-in-the-box conjures up an innocence, an innocence shared by anyone who suffers needlessly, anyone so brutalized.

The ugly irony of retinitis, for an artist who loved color and texture as much as Charles did, meant a fight to the end. Jerome remembered painting with Charles, after his roommate, Tina, went to bed. "We'd go into his room and start to work because there was a place where he took intravenous things. He had little ports everywhere, in his chest, because his veins were destroyed from needles. She had her own intravenous center, which she painted. She was taking medication for her eyes: Foscarnet. And she sat beneath her painting of Saint Lucy holding out her hands, and when the Foscarnet wasn't working, she took a hammer and smashed Saint Lucy's eyes. She had a temper, that girl."

Jerome commented on Charles's frustration, but he certainly had his own. Of Charles, he said, "She drove me out of her life for months at a time. We were like Baby Jane, playing both roles for each other." The image is painfully perfect; Charles once and for all had the terminal role, wheelchair bound, a role for which he'd been applying the makeup for years, that white-face he eventually did work into the grave only to have his roommate, Tina,

dig it back out, more deranged than ever, and wear it regularly wherever drinks are cheap.

Charles actually hated drag, on himself, that is. I think he preferred to be seen as a specter, not a grim but a seductive reaper. I remember him at a party I'd thrown for Valentine's Day, the living room converted into a fallopian fantasy, a soft, pink lining of fabric, floor to ceiling, and mischievous cherubs bathing and diapering guests. And there was Charles in white-face and black suit. In retrospect, Charles's vampire drag at a party celebrating infancy was probably a knee-jerk reaction to the innocence of the theme. Queers have become the snake in Eden, the corrupting influence. AIDS is exile and nudity. Charles came dressed in the theme ascribed to him: the mythic, romantic predator.

I remember, also, the first time I went to Charles and Tina's apartment. There was a large painting of Charles's lover, Adolfo Lopez Luna, whom he lost to AIDS. This painting is striking in its emotional use of color: Adolfo's sorrowful face painted blue and green and dropping from a red sky. Also falling from the sky are images of the virus, glowing red with green tentacles. The face is emptying into a pool of blue-and-green water. Adolfo introduced Charles to the color and symbolism that were so much a part of his Mexican background. Charles inherited these gifts after Adolfo's death, and since he was not a native of the culture and had received them through love, they remained, for him, a sensual mystery. Charles liked colors that resonated against each other and maintained their individual integrity when placed side by side. Painting was a way of conjuring Adolfo after his death; not only the portraits, but the whole language of Charles's painting bore his influence. Perhaps it was this inheritance that encouraged Charles to enter into a pact with Jerome.

Most of Charles's work came after his AIDS diagnosis. He

traveled to Mexico and Rome, two sites of inspiration for him, bringing back lurid posters of Catholic saints with wounds being licked by stray dogs, and 3-D Jesus postcards. His work habits, always a complaint of Jerome's, must have improved — at last he was finishing pieces. Over Charles and Tina's couch, a dark monoprint, *The Birth of Religion,* showed a primitive figure, a hermaphrodite with three breasts, a bonelike erection, and an infant emerging from the birth canal. The infant's face is Charles's. The whole image is lit by a fire under a large cauldron in the background. The hermaphrodite shakes a bone. The images are shamanistic and self-procreative, and like many of Charles's paintings, the suggestion of creativity and metaphysics is hard-edged, often violent and full of horror. He made AIDS a muse, so his metaphysics didn't offer promises — they were about transformations of the present.

Charles entrusted his assisted suicide to his longtime roommate, Tina — his closest friend since high school. Like so many people dealing with their test results, he had firmly decided not to live once the quality of his life became severely impacted and there no longer seemed any possibility of improvement. He respected suicide in the way he respected choice in every aspect of his life. Art is a series of choices, of decisions; he was prepared to exercise choice over fate. Tina, remembering the moment when Charles asked him to assist in the suicide, portrayed someone planning a no-hitch event: Charles's parents and brother were called; Jerome and Miss Daniel were also invited. The morphine was easily accessible. But Charles's mother, taking a seat amidst his paintings in the living room, would not witness his final struggle. And Jerome was in New Orleans.

"You know how she died?" Jerome began her telling of the event. "Well, Miss Tina had to kill her, because she was trying to

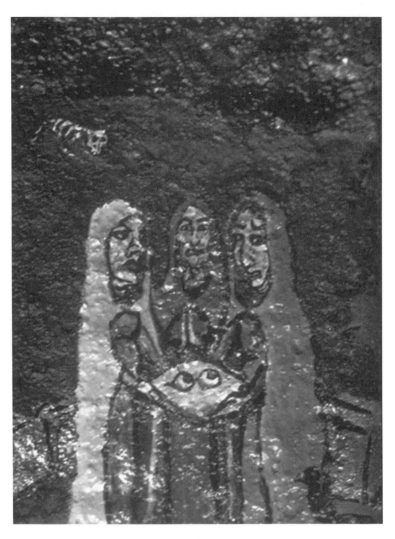

DETAIL FROM "THE THREE DISGRACES"
BY JEROME CAJA

poison herself and she was on these antibiotics, and this poison, this medication — I forget what it was. They had planned it, the whole family was there: his brother, his mother, his father, Miss Tina, Miss Daniel. That was a private little get-together, and he had decided that he wanted to go. They pumped in all that — whatever the drug was — but the antibiotics he was on neutralized the drug, so they had to order more drugs from the hospital, which they got right away. And they put more in, but it still didn't do the trick. So Tina's sitting there and she goes, 'You know, if she wakes up tomorrow, and she's still alive, she will be such a cunt, she just won't let me live in peace.' So she put the pillow over her head; she just had to put the pillow over her. She was so weak, she couldn't even move the pillow. So that's the painting I did of her, which Miss Tina now owns, *The Three Disgraces*. Do you remember that one? That's the one with Charles in the ashes burning, like the rising phoenix. The three disgraces are surrounded by toasters, that's the fire of the real world — it doesn't work too well — and Tina and Daniel, the murderers, are holding the pillow, and I'm praying because that was when I was in New Orleans. They kept begging me to call and I thought, I just can't. Well, she just wants to say good-bye. 'Bye!' I've been saying good-bye to her for years. But on the pillow are the new eyes, because I think that's what really terrified Charles the most, going blind. And the eyes are looking at Tina, and the Bird of Death is standing next to Tina, The Guilty One. And then, there's a dead cat beyond the toasters, because Charles loved cats and I just hate those things."

Charles died January 27, 1991. The Remains of the Day opened October 9, 1992. It marked the fulfillment of Jerome's promise, but it also satisfied another of Charles's greatest wishes — a show that brought both their work together. I remember Charles suggesting such a show, and Jerome's typically difficult

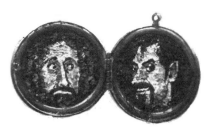

"TWO FACES OF CHARLES" BY JEROME CAJA

response that implied, If I had to work with you, we'd never get past our differences. Jerome was probably right — neither of them was a great organizer, both of them were opinionated, and the differences they chided in each other (differences that from outside looked more like a shared spinsterhood) would have had to be put aside for the larger project. Neither of them could be coerced to put personality aside, for unlike so many contemporary artists who regard personality as either illusory or untrustworthy, both Charles and Jerome, delighting in illusion and impermanence, had made personality the source of their work, complete with all its riddles, complexities, and imperfections. So the show, which brought the work of these two artists together, happily involved the aesthetic decision making of one only. Charles's wishes respected, he came in spirit and a new body that Jerome designed for him, exhibiting himself, once again, for our admiring eyes.

He burst into my home naked
and covered in Kaposi threw me on
the bed: "you would've thought I was
sexy if you saw me before I got sick."
I kissed him then pushed him off and
ran from the apartment. Woke up.

"UNTITLED" BY DAVID WOJNAROWICZ

SPIRAL

DAVID WOJNAROWICZ

ALL I CAN REMEMBER is the beautiful view and my over-
whelming urge to puke. I was visiting my friend in the hospital
and realizing he was lucky. Even though he was possibly going
blind he did get the only bed in the room that had a window and
a view. Sixteen floors up overlooking the southern skies as all the
world spins into late evening. It was a beautiful distance to drift
in but I still wanted to throw up. There among the red and yellow
clouds drifting behind the silhouettes of the skyline was the over-
whelming smell of human shit. It was the guy in the next bed; all
afternoon he'd been making honking sounds like a suffocating
goose. He was about ninety years old and I only got a glimpse of
him and saw that they'd strapped an oxygen mask over his
leathered face and when he screamed it sounded like a voice you'd
hear over a contraption made of two tin cans and a piece of wire.
Calling long distance trying to get the operator. Someone in
charge. Someone in authority. Someone who could make it all
stop with a pill, a knife, a needle, a word, a kiss, a smack, an
embrace. Someone to step in and erase the sliding world of fact.

THIS KID WALKS INTO MY SLEEP he's maybe seventeen
years old stretches out on a table says he's not feeling well. He
may be naked or else wearing no shirt his hands behind his head.
I can see a swollen lump pushing under the skin of his arm pit. I
place my hands on his stomach and chest and try to explain to

him that he needs to be looked at by a doctor. In the shadows of this room in the cool blue light the kid, a very beautiful boy, looks sad and shocked and closes his eyes like he doesn't want to know or like somehow he can shut it all out.

Later some guy appears in the place. He has an odd look about his face. He tries to make it known that he knows me or someone close to me. He leans in close has flat dull eyes like blue silvery coins behind his irises. I think it is the face of death. I get agitated and disturbed and want to be left alone with the kid. Try to steer him away to some other location. He disappears for a moment and then reappears in the distance but far away isn't far enough. I turn and look at the kid on the table he looks about ten years old and water is pouring from his face.

T W O B L O C K S S O U T H there is a twenty story building with at least three hundred visible windows behind which are three hundred tiny blue television screens operating simultaneously. Most of them are tuned to the same stations you can watch the patterns of fluctuating light pop out like in codes. Must be the war news. Twenty seconds of slow motion video frames broad-casting old glory drifting by in the bony hands of white zombies, and half the population ship their children out on the next tanker or jet to kill and be killed. My friend on the bed never watches his tv. It hangs anchored to the wall above his bed extended over his face and on the end of a gray robotic-looking arm. If he bothered to watch the tv he would see large groups of kids in the saudi desert yakking about how they were going to march straight through to baghdad, find a telephone booth and call home to mom and dad. Then he'd see them writing out their wills on the customary government-supplied short forms. Or maybe he'd

catch the video where the commanding instructor holds up a land mine the size of a frisbee and says, If you step on one of these there won't be nothing left of you to find . . . just red spray in the air. Or the fort dix drill sergeant out of view of the rolling cameras, When ya see those towel-heads . . .

But my friend is too weak to turn the channels on other people's deaths. There is also the question of dementia, an overload of the virus's activity in his brain short-circuiting the essentials and causing his brain to atrophy so that he ends up pissing into the telephone. He sees a visitor's face impaled with dozens of steel nails or crawling with flies and gets mildly concerned. Seeing dick cheney looming up on the television screen with that weird lust in his eyes and bits of brain matter in the cracks of his teeth might accidentally be diagnosed as dementia. I catch myself just as all this stomach acid floods up into my throat, run out to the hallway to the water fountain.

IT'S A DARK AND WET CONCRETE BUNKER, a basement that runs under the building from front to back. There is one other concrete staircase that is sealed off at the top by a street grate and you can hear the feet of pedestrians and spare parts of conversations floating down into the gloom. At a midpoint in the room you can do a 360 degree slow turn and see everything: the shaky alcoves built of cheap plywood, a long waist-high cement ledge where twenty-three guys could sit shoulder to shoulder if forced to, the darkened ledge in the back half hidden by pipes and architectural supports, and the giant television set. It's one of the latest inventions from japan, the largest video monitor available and it is hooked into the wall, then further encased in a large sheet of plexiglass in order to prevent the hands of some bored queen

from fucking with the dials and switching the sex scenes to Let's Make a Deal. The plexi is covered in scratches and handprints and smudges and discolored streaks of body fluids. At the moment the images fed from a vhs machine upstairs are a bit on the blink. When the original film was transferred it was jumping the sprockets of the projector and now I'm watching images that fluctuate strobically up and down but only by a single centimeter. Each body or object or vista or close-up of eye, tongue, stiff dick and asshole is doubled and vibrating. Kind of pretty and psychedelic and no one is watching it anyway. There is a clump of three guys entwined on the long ledge. One of them is lying down leaning on one elbow with his head cradled in another guy's hand. The second guy is feeding the first guy his dick while a third guy is crouching down behind him pulling open the cheeks of his ass and licking his finger and poking at its bull's-eye. The shadows cast by their bodies cancel out the details necessary for making the vision interesting or decipherable beyond the basics. One of the guys, the one who looks like he's praying at an altar, turns and opens his mouth wide and gestures towards it. He nods at me but I turn away. He wouldn't understand. Too bad he can't see the virus in me, maybe it would rearrange something in him. It certainly did in me. When I found out I felt this abstract sensation, something like pulling off your skin and turning it inside out and then rearranging it so that when you pull it back on it feels like what it felt like before, only it isn't and only you know it. It's something almost imperceptible. I mean the first minute after being diagnosed you are forever separated from what you had come to view as your life or living, the world outside the eyes. The calendar tracings of biographical continuity get kind of screwed up. It's like watching a movie suddenly and abruptly going in reverse a thousand miles a minute, like the entire landscape

and horizon is pulling away from you in reverse in order to spell out a psychic separation. Like I said, he wouldn't understand and besides his hunger is giant. I once came to this place fresh from visiting a friend in the hospital who was within a day or two of death and you wouldn't know there was an epidemic. At least forty people exploring every possible invention of sexual gesture and not a condom in sight. I had an idea that I would make a three minute super-8 film of my dying friend's face with all its lesions and sightlessness and then take a super-8 projector and hook it up with copper cables to a car battery slung in a bag over my shoulder and walk back in here and project the film onto the dark walls above their heads. I didn't want to ruin their evening, just wanted maybe to keep their temporary worlds from narrowing down too far.

THE OLD GUY IS STILL HONKING AWAY when I get back to the room. There are tiny colored lights wobbling through the red threads of dusk and I'm trying to concentrate on them in order to avoid bending over suddenly and emptying out. I've been trying to fight the urge to throw up for the last two weeks. At first I thought it was food poisoning but slowly realized it was civilization. Everything is stirring this feeling inside me, signs of physical distress, the evening news, all the flags in the streets and the zombie population going about its daily routines. I just want to puke it all out like an intense projectile. I sidetrack myself by concentrating on the little lights at dusk; imagining one of them developing a puff of smoke in its engines and plummeting to the earth among the canyon streets. Any event would help. The nurse finally shows up and behind the curtains I hear the sounds of a body thumping, the sounds of cloth being rolled up, of water

splashing and the covers being unfurled and tucked. Finally she leaves taking the smell of shit with her in a laundry cart. My friend wakes up and starts weeping; he's hallucinating that he can't find something that probably never existed. I understand the feeling just like I understand it when he sometimes screams that he hates healthy people. A senate group was in new york city recently collecting information on the extent of the epidemic and were told that in the next year and a half there will be thirty-three thousand homeless people with AIDS living in the streets and gutters of the city. A couple of people representing the policy of the city government assured the senators that these people were dying so fast from lack of health care that they were making room for the others coming up from behind; so there would be no visible increase of dying homeless on the streets. Oh I feel so sick. I feel like a human bomb tick tick tick.

I HAD AN ODD SLEEP LAST NIGHT. I felt like I was lying in a motel room for hours half-awake or maybe I was just dreaming that I was half-awake. In some part of my sleep I saw this fat little white worm, a grublike thing that was no bigger than a quarter of an inch. When I leaned very close to it, my eye just centimeters above it, I could see every detail of the ridges of its flesh. It was a meat eater. The worm had latched onto something that looked like a goat fetus. It had large looping horns protruding from its head. The whole thing was white, fetal in appearance, its horns were translucent like fingernails. The grub was beginning to eat it and I pulled it off. It became very agitated and angry and tried to eat my fingers. I threw it onto the ground but there was yet another one and it was crawling toward some other fetal-looking thing. I smacked it really hard. Picked it up and threw it

down but my actions didn't kill it. My location was a wet dark hillside around dawn or dusk with a little light drifting over the landscape. Looking around I realized that the entire contents of a biology lab or pet shop had been dumped on the ground. Maybe I had stolen everything. There were big black tarantulas, all sorts of lizards, some small mammals and bugs and frogs and snakes. At some point a big black tarantula was crawling around, blue-black and the size of a catcher's mitt. It made a little jump like it had seized something. I looked closely and saw it was eating an extraordinary beautiful monitor lizard, a baby one. The spider didn't scare me; my sense of anxiety came from mixing the species. They all seemed to have come from different countries and were now thrown accidentally together by research or something. I pushed at the spider, picked it up and tried to unfasten its mandibles from the belly of the lizard. Someone else was with me; I handed them the spider and said, Take it somewhere else or put it in something until I figure out what I'm doing. The person threw the spider on the ground in a rough manner. I said, Don't do that, you'll kill it. If you drop a tarantula from a height higher than five inches its abdomen will burst.

FEVERS. I wake up these mornings feeling wet like something from my soul, my memory is seeping out the back of my head onto the cloth of the pillows. I woke up earlier with intense nausea and headache. I turned on the television to try to get some focus outside my illness. Every station was filled with half-hour commercials disguised as talk shows in which low-grade tv actors and actresses talk about how to whiten your teeth or raise your investment earnings or shake the extra pounds from your bones. I am convinced I am from another planet. One station had a full

close-up of a woman's face, middle-aged, saying, People talk about a sensation they've experienced when they are close to death in which their entire lives pass before their eyes. Well, you experience a similar moment when you are about to kill someone. You look at that person and see something in the moment before you kill him. You see his home, his family, his childhood, his hopes and beliefs, his sorrows and joys; all this passes before you in a flash. I didn't know what she was making these references for.

The nausea comes back. I try a new position on the bed with some pillows and slip back into sleep. I'm walking through this city not really sure where or why. I've got to piss really bad and go down this staircase of a subway or a hotel. (Architecture grows around my moving body like stone vegetation.) I find this old bathroom, mostly metal stalls and shadows like the subway station toilets of my childhood. I could sense sex as soon as I walked in, the moist scent of it in the yellow light and wet tiles and concrete. I go into this stall and pull out my dick and start pissing into the toilet. A big section of the stall's divider is peeled away and I see this guy in his late teens early twenties jerking off watching me. When I finish I reach through the partition and feel his chest through his shirt. He zips up and comes around into my stall and closes the door and leans against it his hands on his thighs. I unzip his trousers and peel them down to his knees. I roll up his shirt so I can play with his belly. When his pants are down at his knees I notice a fairly large wound on one of his thighs, lots of scrapes and scratches on his body. The wound does something to me. I feel vaguely nauseous but he is sexy enough to dispel it. He pulls down his underwear and leans back again like he wants me to blow him. I crouch and slowly start licking under the base of his prick. The wound is close to my eye and I notice this series of red and green and yellow wires, miniature cables looping out of it.

There are two chrome cables with sectioned ribs pushing under the sides of flesh. Then this blue glow coloring the air above the wound. I stop licking and look closer and see it is a miniature monitor, a tiny black and white television screen with an even tinier figure gesticulating from a podium in a vast room. There is the current president, smiling like a corpse in a vigilante movie, addressing the nation on a live controlled broadcast; the occasion is an enormous banquet in washington, a cannibal banquet attended by heads of state and the usual cronies; kirkpatrick and her biological warfare husband. The pope is seated next to buckley and his sidekick buchanan. Oliver north is part of the entertainment and he squats naked in a spotlight in the center of the ballroom floor. A small egg pops out of his ass and breaks in two on the floor. A tiny american flag tumbles out of the egg waving mechanically. The crowd breaks into wild applause as whitney houston steps forward to lead a rousing rendition of the star spangled banner. I wake up in a fever so delirious I am in a patriotic panic. Where, where the fuck at five in the morning could I run and buy a big american flag. My head hurts so bad I have to get out of bed and stand upright in order to ease the pressure. I go to the bathroom and finally throw up. I come back into the room, yank open the window and lean out above the dark empty streets and scream: THERE IS SOMETHING IN MY BLOOD AND IT'S TRYING TO FUCKING KILL ME.

I STILL FIGHT THE URGE TO PUKE. I've been fighting it all week. Whenever I witness signs of physical distress I have to fight the urge to bend over at the waist and empty out. It can be anything. The bum on the corner with festering sores on his face. It could be the moving skeleton I pass in the hall on the way in.

Some guy with wasting syndrome and cmv blindness who is lean-
ing precariously out of his wheelchair in the unattended hallway
searching in sightlessness for something he's lost. He's making
braying sounds. What he's looking for is beneath the wheels of
his chair. A tiny teddy bear with a collegiate outfit sewn to its
body and a little flag glued to its paw. I pick it up and notice it
has saliva and food matter stuck in its fur and I wonder if this is
what civilization boils down to. I place it in the guy's hands and
he squeals at me, his eyes a dull gray like the bellies of small fish.
I have to resist that urge to puke. It's upsetting but I realize I'm
only nauseated by my own mortality.

My friend on the bed is waking. The hospital gown has pulled
up along his torso in the motions of sleep revealing a blobby
looking penis and schools of cancer lesions twisting around his
legs and abdomen. He opens his eyes too wide a couple of times
and I hand him a bunch of flowers. I see double, he says. Twice as
many flowers, I say.

SOMETIMES I COME TO HATE PEOPLE because they
can't see where I am. I've gone empty, completely empty and all
they see is the visual form; my arms and legs, my face, my height
and posture, the sounds that come from my throat. But I'm fuck-
ing empty. The person I was just one year ago no longer exists;
drifts spinning slowly into the ether somewhere way back there.
I'm a xerox of my former self. I can't abstract my own dying any
longer. I am a stranger to others and to myself and I refuse to
pretend that I am familiar or that I have history attached to my
heels. I am glass, clear empty glass. I see the world spinning behind
and through me. I see casualness and mundane effects of gesture
made by constant populations. I look familiar but I am a complete

stranger being mistaken for my former selves. I am a stranger and I am moving. I am moving on two legs soon to be on all fours. I am no longer animal vegetable or mineral. I am no longer made of circuits or disks. I am no longer coded and deciphered. I am all emptiness and futility. I am an empty stranger, a carbon copy of my form. I can no longer find what I'm looking for outside of myself. It doesn't exist out there. Maybe it's only in here, inside my head. But my head is glass and my eyes have stopped being cameras, the tape has run out and nobody's words can touch me. No gesture can touch me. I've been dropped into all this from another world and I can't speak your language any longer. See the signs I try to make with my hands and fingers. See the vague movements of my lips among the sheets. I'm a blank spot in a hectic civilization. I'm a dark smudge in the air that dissipates without notice. I feel like a window, maybe a broken window. I am a glass human. I am a glass human disappearing in rain. I am standing among all of you waving my invisible arms and hands. I am shouting my invisible words. I am getting so weary. I am growing tired. I am waving to you from here. I am crawling around looking for the aperture of complete and final emptiness. I am vibrating in isolation among you. I am screaming but it comes out like pieces of clear ice. I am signaling that the volume of all this is too high. I am waving. I am waving my hands. I am disappearing. I am disappearing but not fast enough.

"I'M A DRAGON TODAY," said Nan Goldin, when we finally met at her Manhattan photography studio near Canal Street. That week Goldin was to oversee her openings at the Whitney Bienniale and Pace MacGill, exhibiting many of the photographs of transsexual and transvestite subjects contained inside *The Other Side,* her latest book. In this work, Goldin explores "the varieties of desire that can't be compartmentalized." This exploration also encompasses the dangers of desire fulfilled: in 1992, she traveled to Asia with a German filmmaker to work on a documentary about male prostitutes and gay culture in Southeast Asia. There, she encountered widely divergent attitudes toward AIDS, from awareness and action to denial.

Despite her exhaustion, the creator of *The Ballad of Sexual Dependency* — the powerful, exquisite, and ongoing documentary of subjects comprising her "extended family" — was unfalteringly businesslike. The *New York Times* has described *The Ballad* as "an artistic masterwork that tells us not only about the attitudes of her generation, but also about the times in which we live." Goldin describes the work, made up of more than seven hundred slides with an accompanying soundtrack, as "the diary I let people read. My written diaries are private."

THOMAS AVENA: When you were curating the Artists Space exhibition, what were your intentions, and how difficult was it when

the National Endowment for the Arts became embroiled in first-amendment violations?

NAN GOLDIN: I was living in Boston; I'd left New York about a year before, to go to a drug treatment clinic. While I was there a number of my friends, who'd been sick when I left, died. I was living in a halfway house when Artists Space called me and asked me to curate a show. They didn't really tell me the parameters of what they wanted. I found out later they just wanted me to do a photo show, like Mapplethorpe had done for them. I felt the only thing I could do at that point was a show about AIDS. I had left my community — my community being my friends who are in the *Ballad [of Sexual Dependency]*, who are like an extended family. So many people were sick or dying, and there was no way for me to talk about my community or reenter it without dealing with that subject.

The curating came from a purely personal standpoint, it was a case of curating done by subjective emotion. Everyone looked for intellectual theories to back it up, but it wasn't about that. It was about how one community had been devastated. I asked artists who had been directly affected to be in the show: there were twenty-five people living with the effects of AIDS and four or five people who had died, including Mark Morrisroe and Peter Hujar, who was David Wojnarowicz's best friend and one of my close friends. Mark Morrisroe, a photographer, died between the time the show was initiated and the time it went up. A number of people were living HIV-positive, and others had lost their brothers or sisters or lovers or family. The power of the show was that it was so interrelated, as only a real community is. There were a lot of pictures people had taken of each other, like Peter Hujar's pictures of David Wojnarowicz; David Wojnarowicz's pictures of Peter, taken after he died; Philip Lorca DiCorcia's pictures of

Vittorio Scarpati, whose drawings were also in the show; and David Armstrong's pictures of Cookie Mueller. The people who were in the show were also in the pictures.

TA: A powerful sense of nontraditional family was communicated through all the representations?

NG: Yes. And people talked about their personal experiences with AIDS, either having contracted the virus themselves or having lost the people closest to them. It was one of the first shows in New York that came from such a personal view of the disease. Now there are a lot of shows like that, but in 1989 it wasn't being done in the same way.

A friend of mine had produced David Wojnarowicz's *Sounds in the Distance* as a play, and I had acted in it. So I later asked David to write the catalog text for this exhibition, and he composed this incredibly strong piece about living with AIDS, his anger at the government, and his anger at the Church. He named a lot of names. He talked about his fantasy of dousing Jesse Helms with gasoline ["I'm beginning to believe that one of the last frontiers left for radical gesture is the imagination. At least in my ungoverned imagination I can fuck somebody without a rubber or I can, in the privacy of my own skull, douse Helms with a bucket of gasoline and set his putrid ass on fire."] and about Cardinal O'Connor being a "fat fucking cannibal in black skirts." The last paragraph — it's become mythological about David — was his statement that when people die we should take their bodies and dump them on the White House steps instead of just having memorials.

TA: I remember a quote about his rage being "like a blood-filled egg" that he wants to hurl.

NG: Egg, yes, and it's cracking.

TA: His work always had that terrific edge to it.

NG: That insistency.

TA: Absolutely honest, which bureaucrats find beyond the pale.

NG: Such urgency. So the director of Artists Space, Susan Wyatt, freaked out when she saw the text. This was the time the NEA was dealing with the issue of Mapplethorpe and Serrano and censorship. She took the text to Frohnmayer. There's a really good rendition of this whole story in *Arresting Images* [Stephen C. Dubin]. Have you seen that book? There's a whole chapter about the Artists Space uproar. Anyway, Susan Wyatt asked David to censor some lines, and he refused. When she brought that to Frohnmayer's attention, he panicked and pulled the grant, the press got involved, and it became front-page news.

TA: Did David discuss with you the possibility of censoring?

NG: Yes, and he told me he wouldn't do it; it was an absolute for him. He had written this text. He took out one *fucking,* and I think that was a big deal for him.

TA: In your book *The Other Side* you write about David "teaching you the limits of moral integrity." Did this derive in part from his refusal to back down on that issue?

NG: Well, that was only one issue. That was probably the beginning of what became an extremely intense relationship between us during the last few years of his life. Basically, he was my moral litmus test, he was the standard by which I tested a lot of decisions. I had enormous respect for his integrity. He was uncompromis-

ing; he saw things with a hyperclarity that was almost impossible to live with. He cut through all the bullshit. It was very pure.

TA: When did you start photographing Wojnarowicz?

NG: Unlike many of my relationships, photographing him wasn't a big part of our friendship. I only did it a few times. When Peter Hujar died, I photographed him at his grave. Then I did a shooting of him for *Village Voice,* and they lost all the originals, almost one hundred originals, and never found them, including the picture of David at Peter's grave. It *was* a big crisis for me. But then *Interview* hired me to photograph him.

TA: That's a powerful portrait of him hanging at the Whitney. Did he determine there would be the red-tissue backing behind the black blazer and the skull, or was it happenstance?

NG: That's exactly the way the place looked. He wanted to wear makeup in order to hide somewhat. He was wearing a lot of makeup in that shooting.

TA: In your photos there's almost always a certain awareness the subject has of the camera. The photograph of the Asian woman who's looking into the mirror applying makeup is different tonally because the colors are so soft, but also she's completely unaware of the camera.

NG: The day that I photographed the Asian queen, I didn't know her. That was the start of our friendship, that day. Most of the people I photograph I've known for a long time, and I have a deep emotional relationship with them; so they really are much more participatory. She knew I was there photographing her, but she didn't know me; she was shy, and basically involved in what she was doing, not really speaking to me, communicating with me through the picture.

TA: Are there particular qualities that draw you to a subject?

NG: It's a visual obsession that I develop for people. Although the visual doesn't last unless it becomes emotional. I don't remain attracted to people I don't feel a deep connection to.

TA: You've been photographing drag queens and transsexuals for a long time now. Were you drawn to them as subjects or were you just living amongst them?

NG: I lived that life completely when I was eighteen, nineteen, twenty. I met the queens, I fell in love with one of them, I was completely absorbed in their lifestyle. I had no real sense of myself as a woman; I wanted to be a queen. They were my whole life context at that point.

TA: Was it because of the creation and exaltation of glamour?

NG: And because of what I felt they had achieved. I had this enormous respect for them and I still do. I felt that it was an incredible act of courage and self-determination and autonomy. I came from a culture where so many things were dictated. In my family there was a high premium on being a male, so as a result I think I've always been attracted to men who became women. I left home when I was fourteen, and the saying that I lived by was Oscar Wilde's "You are who you pretend to be." I was interested in people who were re-creating themselves, as I was trying to do by leaving home. They had achieved some kind of liberation. I worshiped them.

TA: Here, the whole notion of self-creation is involved in defying gender expectations.

NG: Well, these were people living totally that way. They weren't doing drag for shows. It was *their lives.* They couldn't walk down

the street in the daytime; their lives were completely outside any mainstream at all. I felt at home there.

TA: You've written that attitudes have shifted: "The previous glorification of the glamour of self-destruction and substance abuse has been replaced with the will to survive." What forms has that survival taken?

NG: In 1987, a friend of mine said, "It's ridiculous watching you trying to kill yourself on drugs when all our friends are trying to stay alive with AIDS." It took me a while, but that had a big effect on me. I think that notion affected everyone — people among us were dying, they were fighting really hard to stay alive, and the rest of us were involved in this kind of spiraling self-destruction. Death became real, and the "live fast, die young, leave a beautiful corpse" feeling of the seventies and early eighties, this glamourization of self-destruction and flipness about it all wore thin when people around us started dying.

TA: When did you first meet Cookie Mueller?

NG: I lived in Provincetown, and she was living there. I met her at a yard sale she was having on her front porch. I already knew John Waters's movies, so I knew her from those, and then she started coming over to our house. I lived with two gay male friends, one of whom I still live with, and she was lovers with a woman named Sharon, who is one of my closest friends still. They would come over, and we would do these slide shows and show them Super-8 movies. We started becoming good friends. That was about '76.

TA: What first drew you to her? She was a very powerful presence, so was it a visual obsession?

NG: She was also just fabulous. This kind of underground star; this

light for a whole community. And tough, but gentle and lovely. She was a very loving person and really funny.

TA: Did she confide in you about her diagnosis, when she first learned of it?

NG: We talked about it in the early eighties, '83, '84, somewhere around then. She talked about it, but it wasn't a diagnosis. I think when she was diagnosed with ARC, we didn't really know much about the disease. There was still a lot of ignorance, a lot of denial that it was really happening, and that it was a fatal illness — for her. There was denial that this was something she needed to treat. Sporadically, she would medicate herself with various herbs. She didn't really go under a doctor's care; she didn't follow through with any treatment. She used to write a column called "Ask Dr. Mueller" for *High Times* magazine as a home-remedy doctor; so I think she knew a little bit about that stuff, but I don't think she really researched it enough to get the benefits. I know other people have used herbs very well, but sometimes she wouldn't take anything, sometimes she'd take too much of something, like St. John's wort. I don't think she was really in touch with the whole treatment underground.

TA: May I ask you what form her illness took?

NG: She had CMV [cytomegalovirus]. She couldn't walk; she was paralyzed on one side. The last few months she couldn't really talk, she lost the ability to write, and she had these growths on her face.

TA: What kind of support did she receive from her community? Did she lose friends because of having ARC, did people turn away from her?

NG: When she was really sick — in the fall of '89 — a few people

didn't know how to deal with it, but that often happens. Maybe some people don't show up as much as they could, maybe they think that they have less to give, that they might drain the person. She was very sick, and a lot of people didn't really know how to handle it, but I think that's always true.

TA: Did you photograph her at that point?

NG: There are photographs of her. But she doesn't look sick. People have said there are no pictures of Cookie sick in the catalog [Pace MacGill's], but there are a lot of pictures. She still shines through in such a powerful way that you can't tell.

TA: That photograph of Cookie being x-rayed? It's a stark portrait. She's centered in a black box, with rays gathering around her impassive face. She seems almost peaceful, was she well then?

NG: No, very, very sick. And in other pictures, like at Vittorio Scarpati's funeral and with her son after the funeral, she's very sick in all those pictures.

TA: In New York City are people open about being seropositive or having AIDS?

NG: A lot of people are. I see people at the gym who obviously have AIDS. A friend of mine who just died who was covered with Kaposi's was going out right up until he went into the hospital. But I think there are still many people who don't want to talk about their own diagnoses. It's strange to me, having been so close to David Wojnarowicz and to other people who were open about their diagnoses; it's strange to see this, but I guess some people feel they'll just become defined by it or be treated differently in the world.

TA: One of the things that happens is you're written off. It's an issue for the elderly, but also for anyone undergoing critical illness, who's still striving to work.

NG: I think that's not necessarily true in the art community. There's an interest in people with AIDS.

TA: Interest in a person with AIDS as a subject, perhaps, but less so as a person still capable of creating? For example, Harold Schmidt, the literary agent, has just sold a book for one of his clients. Earlier he had sent it to European publishers, where the recurring response was, "Your client's not going to have another book after this, so we're not taking this book."

NG: The attitude in Europe is very different. I know because I lived there for the past few years, and I have friends who are sick there. My closest friend in Berlin has been in and out of the hospital for several years. There are pictures of him in the Whitney; he's in a triptych in the hospital. The transsexual in the show at Pace MacGill who's naked in profile, looking in a mirror, getting dressed — she just died. She never told anybody she was sick. Even our friend in Paris who was close to her since she was a boy. We only found out after she died, from the newspapers. People aren't open about being HIV-positive, even to their friends. Generally, people talk more to their New York friends about it than to their European friends, because they feel that there's some context and understanding here.

TA: I keep thinking of the German *Deutscher Blick,* the type of 'regard' that masks indifference, as a metaphor for world attitudes towards PWAs.

NG: There *is* a certain general lack of compassion. But Germany

has the best AIDS hospitals in the world; at the hospital where my friend has been off and on for the past few years, most of the staff are gay, men and women, and they're trained in sensitivity. It's an incredibly different experience than visiting David at Cabrini Medical Center. That's like a nightmare.

TA: He was not treated well there?

NG: It's like the ninth circle of hell. There are people smoking crack in the halls, people coming off the elevators at night and robbing the patients, religious groups coming around trying to convert people. It's incredible. Nobody could ever get well in a place like that. It makes you really sick.

In Europe, I lectured a lot, talking about my relationship with AIDS and art, how important it was for artists to be dealing with it, and that it's like a holocaust. In Europe, they often say, "Well, it's not the same problem here because we have good medical treatment, so we don't have so much to fight against." But there's a lot of AIDS-phobia in Europe, too. People are afraid to be open about it. My friend Alf told me about somebody he grew up with who's living in his home town in Bavaria who has full-blown AIDS. People actually pick on him and do all kinds of ugly things to him on the street in this small town in Germany. In the big cities maybe you wouldn't find that, but there just seems to be a neglect of the problem, or a denial of the problem. "It's a New York problem, it's not our problem."

I was asked to help curate and then ended up just being in this show in Hamburg about AIDS. A very good show, but when the guy called me up and asked me to help him select artists for it, I said, "There have to be some German artists in it, so it will really resonate here." He said, "AIDS is a New York problem; it's not a German problem." Well, Simon Watson was in the show,

and a number of activists were in the show, and I think by the time the show was finished, he understood it wasn't true. But that was his initial reaction: it's not a German problem. At the press conference for the opening of that show in Hamburg, one of the journalists asked, "Do you think AIDS is more of a New York issue or an L.A. issue?" And Simon Watson said, "I think it's an international issue." That's the way they're thinking there. There's a lot of gossip in Paris, for instance, about who has AIDS, and what artists have AIDS, and will their work be worth more after they die. There's a lot of cynical bullshit around it. I think it's worse there than it is here. I think there's much more open support here.

TA: Is there an underground AIDS community in Berlin?

NG: There's some ACT UP. There are people trying to get alternative treatments. It's been established for a few years, but it's small. In Paris also. But it's definitely growing.

TA: You have traveled and photographed in Thailand and the Philippines. Is there an awareness of AIDS there? Are the prostitutes protecting themselves? Do they use condoms?

NG: Not in Manila. That's because it's a Catholic country. They're very controlled by the Catholic church. The queens I know there say "Jesus loves you" in their letters to me. The male hustlers that I hung out with didn't use condoms either. When I discussed that with them they were actually insulted. They said, "What do you think we are?" They consider themselves straight. They think and they say "What do you think I look like, the kind of person who would get AIDS?" That to them is a real insult. There's no AIDS education that I could find in Manila. I don't think they're truly aware of the danger, or they weren't a year ago. They feel they're not "homosexual," they just let people touch them for the money,

so they're not in danger. The whole gay culture is very different in Asia — straight men are with gay men — you don't often find two gay men together, that's not understood as an option. There's an effeminate man, and that effeminate man will sometimes be able to have sex with a straight man. There aren't open gay relationships in the same way as here. With the inception of a gay community in the Western sense, it's beginning to change, so now there's more discussion of AIDS.

Thailand is completely different, there's a lot of frank discussion of AIDS. From what I could tell, the sex workers were aware of it. We met radical AIDS activists who have a theater group that combines traditional Thai dancing and AIDS information. They tell stories, they give out condoms. They perform in the malls, in the department stores, they do it in the bars, they do it in the sex clubs. I went around with them and watched them perform. They get the boy hustlers to come up, and they have this condom contest — who can put a condom on a vegetable fastest — and they make sure the boys know how to use a condom, and they give out condoms all over the bars.

TA: That sounds like a good start.

MICHAEL FLANAGAN

> Thanks to the descriptions in Homer and tragedy, we can re-
> construct the course of an ordinary Greek sacrifice to the
> Olympian gods almost in its entirety.... Generally it is hoped
> that the animal will follow the procession compliantly or even
> willingly. Legends often tell of animals that offered themselves
> up for sacrifice, apparent evidence of a higher will that com-
> mands assent.... Now comes the death blow. The women raise
> a piercing scream: whether in fear or triumph or both at once,
> the "Greek custom of the sacrificial scream" marks the emo-
> tional climax of the event, drowning out the death-rattle.
>
> — Walter Burkert, *Homo Necans:*
> *The Anthropology of Ancient Greek Sacrificial Ritual and Myth*

Diamanda Galás's music is by its very nature political. Whether addressing issues of torture (as in "Eyes Without Blood" or *Insekta*), the homicidal rage of the betrayed (*Wild Women with Steak Knives*), or the AIDS epidemic (*Masque of the Red Death* trilogy and *Plague Mass*), her music is both challenging and obstreperous. This is not the nice music of a person who wants to play fairly with the forces against which she aims her sonic assault. This is terrorism, pure and simple.

It is odd, but the most eloquent praise of Galás's work is often found in reviews by people who find it nearly impossible to listen to her. Critics have referred to her as being "louder than heavy metal bands" and "a weapon to use against your worst enemies." This is, of course, as it should be. Schoenberg was not concerned

about whether his music sounded pretty — he was depicting the life of refugees escaping Hitler. Diamanda Galás should be proud to be causing such foment at the end of the twentieth century, much as Stravinsky's *Firebird* caused riots at its beginning.

Songs as commodities are a part of modern living; it was not until the phonograph that songs became things to buy and play. Before that time, producing music (outside of folk and indigenous traditions) required sheet music and a musician or musicians. It has only been in the past half-century that the business of music has been concerned with how many units of product are sold and how soon the next unit of product can be released to build upon the artist's upward market curve. Galás's work stands apart from, and in opposition to, this trend. She has given many marketing and accounting personnel in the recording industry insomnia with her single-minded insistence on pursuing themes both controversial and unpleasant. One can almost hear them say, "How dare she dedicate a decade of her life to a despised minority?"

One often reads of Galás's incredible (3.5) octave range. There is no doubt that she possesses a tremendous instrument. I have often felt, however, that it is wrongheaded to make too much of this. After all, pianists at the piano are presented with 7.5 octaves. It is not so much the range of the instrument as its use that deserves comment. Diamanda could probably have had a successful career in the mainstream of classical music, but she, like many other singers, would have had little impact outside of that cloistered world. Instead, she has taken her instrument and challenged the boundaries of both the musical world and her listeners.

Even when compared with her contemporaries in classical and avant-garde music (forms exempt from the assembly-line ethic of pop music), Galás stands out. For example, minimalism has often seemed minimal not only in its form, but also in its

content. Music inspired by tribal and native form usually pales in comparison with the original. Neither a minimalist nor an ethnomusicologist, Galás exists separate from these forms, creating powerful music spanning the two worlds of politics and art.

GALÁS'S MUSIC has been called satanic, particularly by biblical literalists from the Christian Right. Her video for "Double-Barrel Prayer" found its way into rotation on the Christian Broadcasting Network. Her *The Litanies of Satan* appears as background music in Reel to Real Ministries' video "Hells Bells" (1989); the narrator explains the blasphemy in her music:

> The eighties have seen the emergence of a macabre brand of rock that combines elements of punk, new wave, and even classical music. . . . The occult elements within this new genre are even more disturbing than those in heavy metal, because they are combined with an intelligence and poetic passion rarely found in the latter. For example, Diamanda Galás, whose voice was used to suggest the sounds of demonic possession in the movie *The Serpent and the Rainbow*, closes out her *The Litanies of Satan* with these words:
>
> > To thee o Satan, glory be, and praise.
> > Grant that my soul, one day, beneath the Tree
> > Of Knowledge may rest near thee.
>
> *Divine Punishment* . . . is an eerie recitation of Old Testament scripture with one exception: Galás's 'Sono L'Antichristo' (I am the Antichrist). . . . The message is married to the most dangerous catalyst for satanic insurrection: a

sense of religious and poetic transcendence. In this the devil may lose an occasional human sacrifice, but he gains something that from his perspective is of much greater value: a multitude who is willing to sacrifice hope in life's meaning and faith in God's love.

Of course *The Litanies of Satan* was written by Charles Baudelaire well over a century ago, but it would do little good to point this out (and just as pointless to tell a literalist that this is a symbolic work — one can only wonder what the speaker makes of authors such as L. Frank Baum). Galás seems to be of two minds concerning this identification with satanism. With regard to the more pedestrian view of ritual, she says in *Re\Search Publications #13: Angry Women:*

> I was in Berlin and some girls came up to me and said, "Oh, you are Diamanda — please do another record for us soon. We have witchcraft rituals and shoot up speed and chant to the Devil and listen to your music." I thought, Oh, fuck — you could get a Julie Andrews record and do this kind of stupid shit.

However, concerning the view of Satan as accuser, avenger of the oppressed, and anathema, she also says in the same interview:

> When a witch is about to be burned on a ladder in flames, who can she call upon? I call that person "Satan." . . . It's that subversive voice that can keep you alive in the face of adversity. . . . I have this text "You call me the shit of God? I am the shit of God! You call me the Antichrist? I am the Antichrist." . . . So you say, "Yes, I am the Antichrist . . . I am all these things you are afraid of."

The spirit of the satanist in Galás's music could also be called the spirit of the terrorist or the spirit of the warrior. Unlike those who sit back and wait for the mercy of the Church, Galás is willing to defend her polemic.

AMONG WORKS CONCERNING AIDS, Galás's *Plague Mass* and her *Masque of the Red Death* trilogy (*The Divine Punishment, Saint of the Pit,* and *You Must Be Certain of the Devil*) have a particularly important place. She began them very early in the epidemic and has continued to perform them with fervor (some would say obsession). *Masque* and *Plague Mass* were not her first political works. In the interview in *Angry Women,* Galás explained:

> Oriana Fallaci said, "Life is war!" . . . Ever since I com-posed *Panoptikon* . . . my work is always preoccupied with freedom. . . . [In *Wild Women with Steak Knives*] I wanted to produce an immediate extroversion of sound, to deliver a pointed, focused message — like a gun.

Even before her first recording in 1981 (*Litanies of Satan,* which included *Wild Women with Steak Knives*), Galás was con-cerned with freedom in extreme situations. Luke Theodore (Liv-ing Theatre), upon seeing her work in 1976, had suggested that she perform in mental institutions with her back to the audience. These performances led to her role as the lead in Vinko Globokar's *Un Jour Comme Une Autre,* a work based on Amnesty Interna-tional's documentation of a Turkish woman's arrest and death by torture for treason in 1979.

Galás began the *Masque of the Red Death* trilogy in 1984. In an interview with Robert Hilferty (he and his lover, Tom

Hopkins, had attended Galás's performance at the New Horizons festival of the New York Philharmonic) she commented that she was planning a piece based upon Poe's "Masque of the Red Death" and that it would have metaphorical implications about AIDS. In the fall of 1984, while visiting a friend in San Francisco, Galás opened a Bible and read the first thing she saw, Psalm 88, which is the supplication of a man in mortal illness:

> Oh Lord God of my salvation,
> I have cried day and night before thee.
> Let my prayer come before thee;
> incline thine ear unto my cry.
> For my soul is full of troubles,
> and my life draweth nigh unto the grave.
> I am counted with them that go down into the pit.
> I am as a man that hath no strength.
> Free among the dead, like the slain that lie in the grave,
> whom thou rememberest no more;
> and they are cut off from thy hand.

Immediately after reading this passage she went into the studio and recorded "Free among the Dead," which became the first piece of *The Divine Punishment*. Galás had been directed toward the first part of the *Masque* by an act of bibliomancy, a form of divination in which a person takes guidance from written material, particularly the Bible. This tradition traces its roots to Saint Augustine, who, in the fourth century, recommended taking omens from the Bible "in all cases of spiritual difficulty." Bibliomancy was a common practice among kings, bishops, and saints searching for signs and solutions to problems.

"Free among the Dead" was produced during the first Ameri-

can presidential election year of the AIDS crisis, and yet AIDS was not addressed in this election by either party. *"Like the slain that lie in the grave, whom thou rememberest no more,"* indeed. The work was dedicated to Tom Hopkins, who had developed full-blown AIDS in June 1985 and was the first person whom Diamanda knew personally who had developed AIDS. With Tom, she witnessed firsthand the moral ostracism related to AIDS. On one visit, Tom told her (through a device that amplified his single functioning vocal cord) that his family had disowned and abandoned him; they felt his illness was a punishment from God for his homosexuality. Tom had been raised in a strict Baptist environment full of hellfire and speaking in tongues. He and Diamanda discussed how the ranting of Baptist preachers was similar to the glossolalia she practiced. Tom died in November 1985. Echoes of his whispers (as well as the whispers of many other friends) can be heard throughout her work. Already the *Masque* was becoming elegiac as well as metaphoric.

In 1985 Diamanda received her first grant to create what would become the *Masque* trilogy. At that point, she decided that it was inappropriate, in the face of AIDS, to do a work based on the bubonic plague. She wrote the grant sponsors and informed them that the work would now deal specifically with AIDS. To deal with AIDS only metaphorically seemed inappropriate to her in the face of such a catastrophe. In the fall and winter of 1985 she went to London to finish recording *The Divine Punishment* ("This Is the Law of the Plague," "Deliver Me from Mine Enemies," "Lamentations," "Sono L'Antichristo").

The Divine Punishment is the most biblical of the *Masque* trilogy; most of the works derive their texts from Leviticus, Psalms, and Lamentations. It can be divided into works that deal with legal sanctions and approbations concerning illness, pleas and

supplication for protection, and laments at abandonment and punishment. As much of the literature of popular culture was intent on blaming the victims of this disease, *The Divine Punishment* can be seen as a parable illustrating the desire of the pious to look for proof of their own blamelessness. *The Divine Punishment* was first performed at the ARS Electronica Festival (at the Osweg Shipyards in Linz, Austria) on June 23, 1986.

When Galás returned from recording *The Divine Punishment,* her brother, Philip, playwright of *Mona Rogers* fame, had taken ill. In May 1986, Philip was diagnosed with AIDS. He died shortly thereafter. In a strange twist of fate, Diamanda found she had been a Cassandra. What had started as a work of tragedy that concerned others, including friends, had now touched her family. She told Hilferty (in 1990), "The horror of his death and departure from my life do not diminish — they increase like the nightmares of anyone who has witnessed a homicide."

TWO WEEKS BEFORE PHILIP DIED, he gave Diamanda a book of poems that included Gérard de Nerval's "Artemis" and Tristan Corbière's *Cris d'aveugle* (Blind Man's Cry). These works, as well as Baudelaire's *Heauton Timoroumenos* (Self-Tormentor), "Deliver Me," and *La Treizième Revient* (The Thirteen Returns), make up *Saint of the Pit,* the second work of the *Masque of the Red Death* trilogy. It is in *Saint of the Pit* that the Moirologia tradition of Greek funerary music finds its most eloquent expression. This tradition of singing is notable not only for its beauty, but also for the messages it transmits. *Moirologia* is the attempt of those left behind to stand bravely and face their grief and mourning. It is also a call for revenge against those responsible for the death. "Deliver Me" in particular evokes the emotions of those who are mourning fallen sons and heroes. Moirologia music is usually

associated with "other" states of consciousness (states that in our modern medically oriented societies would be thought excessive, erratic, and abnormal), and is accompanied by the rending of garments and hair. In Orthodox countries this type of music was outlawed and considered profane, as it relates to a heritage that predates Christianity.

In *Saint of the Pit* (released in 1986) we hear the depth of depression that has become all too familiar to those of us enveloped by the AIDS crisis. There is also, however, an undercurrent of rage here, which predates the coming of militant advocacy. Galás's work was again visionary.

I FIRST MET DIAMANDA GALÁS in August 1987, when she was preparing to record *You Must Be Certain of the Devil*. She requested information on specific cases of hatred, oppression, and discrimination from the AIDS information organization I work with. She was intending to use this material not literally, but as a matrix on which to base her work. I particularly remember providing her with information about a young Mormon who was excommunicated by his church as he lay dying of AIDS. Even though I knew of many horrors of this kind, I was amazed by the ferocity of *You Must Be Certain of the Devil* when it was released in 1988. Here was a frontal assault on the forces of bigotry. This work was a call to arms (literally) for those faced with quarantine, a call to face the clerical hypocrisy with a forty-five-caliber indulgence. Witness the lyrics to "Double-Barrel Prayer":

> The dogs have come today
> The dogs have come to stay
> It's time to get your gun out
> And drive the dogs away

And if the faithful were not frightened off by the call to arms, a "Malediction," or curse, was included for good measure. It is, however, the haunting "Let My People Go" that has attained the stature of an anthem. It compares the government (whether through volition or lack of attention) to a poisonous arachnid that sucks the life and hope out of an oppressed people:

> The devil has designed my death
> and he's waiting to be sure
> that plenty of his black sheep die
> before he finds a cure
>
> O Lord Jesus, do you think I've served my time?
> The eight legs of the devil now are crawling up my spine . . .
>
> I go to sleep each evening now
> dreaming of the grave
> and see the friends I used to know
> calling out my name . . .
>
> O Lord Jesus, here's the news from those below:
> The eight legs of the devil will not let my people go.

You Must Be Certain of the Devil was released in 1988. In July that year Galás delivered a talk about the piece to the New Music Seminar (an annual orgy of self-congratulation for being "cutting edge" held by music industry insiders in New York), which she later titled "New Correlations in Male Heterosexual Impotence and Homophobia":

> I've just completed a trilogy that is dedicated to my broth-
> ers and sisters, persons with AIDS who are now living and
> dying in Cadillacs, in hotel rooms, crucified in hospitals,

and everywhere you don't think they are. And let me tell you something else . . . while you're sitting here having a good time, think about somebody who's lying in vomit bags, lying in perspiration and in dirty old sheets . . . and when you aren't too busy eating pussy and getting autographs, you might go to an ACT UP meeting tomorrow night. There's a little bit of education for all you impotents, for all of you cowards, for all of you ass-lickers, for all of you motherfuckers — but that would be too nice for you.

Galás — nemesis of the record promoter — had struck again. Upon completion of the trilogy, Mute released the works packaged together. She toured to support the completed work in Dallas and San Francisco and also in Australia, Sweden, Yugoslavia, the Netherlands, Italy, Spain, and Germany. In Bavaria, where a quarantine was in effect, she turned to the cameras during a talk show and began shouting "Forced quarantine is homicide."

In 1989 *Masque of the Red Death* was performed at Queen Elizabeth Hall, in London, and at the Lincoln Center. On December 10 that year Galás participated in the Stop the Church action at St. Patrick's Cathedral. In response to Cardinal John O'Connor's fight against the distribution of condoms and threats to excommunicate Catholic politicians who supported abortion, ACT UP and WAC (Women's Action Coalition) disrupted a mass and picketed outside. In one of the more memorable moments at the trial of the protesters, Diamanda was asked by the prosecutor (Dan Rather's son) if she would scream the way that she had at the cathedral. She responded: "I usually get paid for my performances."

PLAGUE MASS EVOLVED from parts of *Masque of the Red Death*: "This Is the Law of the Plague," "Sono L'Antichristo," "Cris d'aveugle," and "Let My People Go." To these pieces, Galás added "There Are No More Tickets to the Funeral," "I Wake Up and I See the Face of the Devil," "Confessional (Give Me Sodomy or Give Me Death)," "How Shall Our Judgment Be Carried Out upon the Wicked?" "Let Us Now Praise the Masters of Slow Death," and "Consecration." The work was performed in the form of a mass in Europe (Berlin, Basel, Barcelona, and Helsinki). It was sufficiently recognizable as a mass to be considered blasphemy by members of the Italian government when it was performed at the *Festival delle Colline* at the Villa Medicea De Poggio a Cainao. Parts of *Plague Mass* were performed for the Coalition for Freedom of Expression at the VII International AIDS Conference in San Francisco. The first complete performance of the mass was at the Cathedral of St. John the Divine in New York on October 12–13, 1990. This performance was committed to disc, and released by Mute in 1991.

As the current title *Plague Mass (1984–End of the Epidemic)* implies, the work has not ended. Much as *"Tragouthia apo to Amia Exoun Fonos"* begat *The Divine Punishment* and *Masque of the Red Death* begat *Plague Mass, Plague Mass* begat *Vena Cava. Vena Cava* originates in the clinical setting of "I Wake Up and I See the Face of the Devil" from *Plague Mass.* It premiered at The Kitchen (in New York) in February 1992 and was described in the introduction to the piece as

> A set of sonic incantations which return to the themes of claustrophobia, schizophrenia, stigma, extremity, cathartic obsession, and psychic violence. . . . Drawing on a personal understanding of — and medical studies concerning

— the relationship between the dementia of severe depression and what is referred to as AIDS dementia . . . *Vena Cava* is centered around the character of the depressed and isolated individual, suspended within the institutional void of the modern hospital. . . . The work explores the destruction of the mind in extreme isolation.

In this phase of her work, Galás has moved from the external political and medical aspects of the epidemic to the personal, mental effects. Here, distinctions between AIDS and other types of illness become less significant, for though only some people face AIDS, everyone faces mortality, which is difficult to do calmly. At this, perhaps the darkest, point in the work, there is a great equalizing message: You too will face death.

IT WOULD BE EASY to view *The Singer* (released after *Vena Cava* was performed) as something separate from the tradition of the *Plague Mass*. However, *The Singer* works as *Plague Mass*'s voodoo hymnal. It takes traditional forms, the spiritual and the blues (both associated with oppression), and turns them on their head: encouraging endurance, penetration, and overthrow of the oppressor. *The Singer* has the familiarity of an old church hymnal, and yet it is somehow *other* — as if Paul Robeson has been transported to the theater of Dionysus and is performing tragedy. Calling this work a voodoo hymnal is not hyperbole. Much as voodoo hides within the form of Christianity, *The Singer* takes the form of Christian music and puts it to its own end: the desire to subvert and overthrow the judging pharisees. Songs like "Were You There When They Crucified My Lord?" and "Balm in Gilead" succeed because they challenge (through inference) the

meaning and context of the original works. Since the emphasis here is on voice and piano, *The Singer* delivers the message to the listener on an almost subconscious level. Songs like "My Love Will Never Die" and "Gloomy Sunday" use the original form of the blues and delivers it into the world of biohazard. The work gives tribute to the talent of the writers and yet transmits Galás's message in a hidden, almost retroviral, way. "Judgement Day," the video of this work, which premiered at the 1993 San Francisco Lesbian and Gay Film Festival, is a visual record of how this message is conveyed. The work can be taken at face value, or the viewer can be caught sub rosa in the undertow.

ON JULY 8–9, 1993, GALÁS opened the Serious Fun! festival at Alice Tully Hall of the Lincoln Center with a performance of *Insekta*. Surrounded by razor wire, on what appears to be a battlefield, Galás opens this work with the beautiful "Sanctus" of Charles Gounod. Then she descends into a cage (quite literally) of torture (both physical and mental) of apocalyptic proportions. The piece and the main character are described in this manner in the program:

> *Insekta:* the survivor of repeated trauma within an enclosed space preventing escape or opportunity for impacting stressors themselves — in torture and other attacks which may be randomly delivered such as rape and other physiological/psychological experimentation, the ensuing anxiety disorders, and splitting into many different mental states or comfort/discomfort zones, *Insekta:* nameless, contemptible or dishonored — in reference to human populations whose anonymity and/or perceived power-

lessness makes them practical for the advancement of research.

Does the artist see reflections of herself, or parts of her personality, in this work? That is possible, but what is certain is that in her exploration of persons in hospitals (mental and general care) and victims of torture she has found a common psychology.

IN THE YEARS that I have known Diamanda and done research for her, my awe and respect have grown. I have seen her work encompass more and more of the world — here dealing with death, there with madness — until she seems less like a person and more like a cosmological entity, a black hole that absorbs and consumes more and more matter into her own dark universe. She is difficult to discuss without engaging in what must sound like hyperbole to someone unfamiliar with her work. In the end, the only thing left to do is to listen.

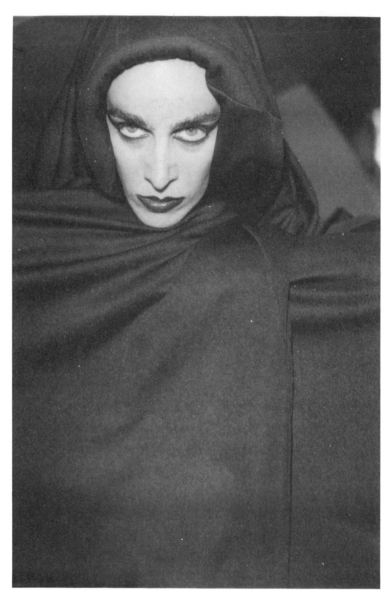

DIAMANDA GALÁS

And on that holy day
And on that bloody day
There are no more tickets to the funeral
There are no more tickets to the funeral
The funeral is crowded.

— "Were You a Witness" from *Plague Mass*

IN MAY 1993, I met with Diamanda Galás in her black-and-white solarium apartment in the East Village. The vocalist and composer of *Plague Mass,* the oratorio described by the *New York Times* as a "powerful indictment of people who regard AIDS as divine retribution," and by the *Observer* as "the most profound musical contribution yet made to the support of the AIDS community," was exhausted from weeks of rehearsal on *Insekta,* which she was preparing at The Kitchen for its premiere at Lincoln Center. Yet she was warm and gracious. *Interview* magazine has called Galás "the closest equivalent we have to Maria Callas," and the vocal and visual resemblances are unmistakable. But more interesting is the way in which Galás departs from the tradition of the classical: "I don't think I could survive if the work I was doing was detached from the time in which I was living, and that time includes AIDS. That's why I'm not going on stage and singing *Tosca* and *Norma,* with all due respect to those works and as much as I love them. My imperative . . . is linked to the

current moment." Scattered throughout her living room were sketches for the costume of *Insekta* — a cocoon of leather — and source materials on schizophrenic and aphasiac speech. Also overwhelming boxes were articles on substances like glycyrrhiza (an extract of licorice root), and other alternative immuno-stimulants. During our interview, Diamanda and I lapsed into a fevered discussion of such substances and unorthodox treatments — none of it academic. I have included a small portion of this to indicate how such an exchange is a constant for people struggling to survive critical illness.

THOMAS AVENA: You've been chronicling the AIDS epidemic since 1983. How has your artistic approach to AIDS changed over time?

DIAMANDA GALÁS: *Plague Mass* deals with an individual speaking in the context of the larger society for groups of people, many of whom can no longer speak. It also involves the individual speaking in opposition against other groups of people. *Vena Cava*, by contrast, deals with a person in isolation — in a kind of solitary confinement. Here, the vocal gestures are more subtle, the text is more introverted, the voice more stream-of-consciousness. In *Plague Mass*, the texts are declaimed. I employ Psalms and Leviticus — the books of laws that detail the quarantine procedure traditionally referred to in the clerical condemnation of homosexuality. For example, Psalm 88: "O Lord God of my salvation, I have cried day and night before thee . . . incline thy ear unto my cry." This is a completely different way of speaking than the internalized voice in *Vena Cava*. The vocal treatment is again different in *Insekta*, which reveals the view from both inside and

outside the cage of the individual in isolation (in my perform-
ance at Lincoln Center, the cage is suspended by hooks from the
ceiling). It is a torture piece about the treatment of anonymous
populations — for example, what happens to people who are in-
stitutionalized, lost populations whose families cannot or will not
save them. *Insekta* gives voice to the type of situation where pa-
tients are raped and beaten in the middle of the night. For these
people, the only freedom they have is their thoughts. In this way
they are similar to people with dementia, aphasia, or Alzheimer's
disease.

TA: Do you occasionally wish yourself free of the need to repre-
sent the seropositive, the dying, and the dead? If AIDS hadn't
happened, what subjects might you be exploring?

DG: Separation and death are subjects that I have been exploring
since the beginning of my career. *"Tragouthia apo to Aima Exoun
Fonos"* [Song from the Blood of Those Murdered] deals with the
torture of political prisoners by the Greek junta; *"Panoptikon,"*
meaning "many eyes, surrounded at all times," portrays models
of claustrophobia and paranoia. All of my work has to do with
the position of a person in isolation, whether that isolation is
enforced from without, or it is isolation from a biochemical or
developmental perspective — such as the biologically or develop-
mentally induced isolation of schizophrenia. People who are in-
stitutionalized end up behaving in very similar ways, and a lot of
the behavior will be seen as schizophrenic, depending on how
bad the situation is. These subjects are part of my work, and would
have been regardless of the existence of AIDS.

TA: The people you explore in your work — schizophrenics,
aphasiacs, those who have dementia — do you ever view their

behavior as an almost rational reaction to situations of isolation that are intolerable, even irrational?

DG: Yes, I see it in terms of a personal catharsis. My brother and I were Greek American children coming up in a city where we worked in isolation, he in the attic and I down at the piano. We worked and lived in a very private way. So it makes sense that I would understand this type of behavior, or understand what it feels like. Actually, at this point in my life I choose to be alone quite often.

TA: Could you comment on the extreme vocal technique that you developed working in mental institutions?

DG: Some of my earliest performances were in mental institutions in San Diego. The idea was suggested by Luke Theodore from the Living Theatre, and a couple of his friends who had been doing performances in mental institutions. The response I got was very positive; it was very much a shared kind of community expression. A lot of women in particular were interested in the way I was using my voice — extroversion of the soul through the voice, so to speak.

TA: When did you find that you could let yourself, your voice, move into the realms of cacophony and extreme heights and extreme lows? At some points in *Plague Mass,* for instance, you seem to be speaking in tongues. It's an extraordinary manifestation. Did this result from your working in mental institutions, or singing there? Was there a break, when suddenly you were free to excavate the voice?

DG: *My* break happened shortly after living and working in a situation that had very little to do with art. It had to do with

distrusting everything, distrusting every means of expression I had learned, so that all the means of my previous expression became too facile, like gestures. I started to do performances dressed in black with my back to the audience. I wouldn't make a sound for maybe ten minutes. I wouldn't make a sound until I felt I was supposed to make a sound. I think those performances were pretty primitive at first — without saying primitive in necessarily a complimentary sense. I would have trouble explaining what the performances were about or justifying them, but I felt that I was in search of a new vocabulary of expression. By no means was I unique in doing that. Certainly, in the past, very intelligent people have made explorations of the voice. For example, Julius Eastman created a great piece called *Evil Nigger Faggot,* which shocked the classical music community in the early eighties. He was a radical composer, a brilliant singer, and a very early inspiration along with Roy Hart, who influenced us both.

Immediately before I began my exploration of the voice, I was introduced to Artaud, through my brother. It all made a lot of sense in terms of breaking with the pre-established language of "music." I had been trained as a classical and jazz pianist; later I became involved in the music of Albert Ayler, Ornette Coleman, and John Coltrane. Through my piano facility I found that the sound was going in the direction of the most visceral response of the body, past what the horn instruments were doing, because what the horn instruments were doing was essentially instrumental, a vocally inspired instrumental performance. The exception was Coltrane, because his work was so technical that most people couldn't hear that it was vocally inspired. As I said, when I started the work in mental hospitals, the visceral and emotional acceptance I got there was quite interesting. I was asked to continue to work there, but since I didn't see myself as qualified to be a thera-

pist, I didn't continue. This was between 1975 and 1977. In 1974, I had done a lot of things unrelated to music: street stuff, et cetera. It made me question everything I'd done before. I was living and working with a bunch of transvestites in Oakland. I often sang while working on the street; as a matter of fact, I discovered my voice. There I was with these queen sisters — in particular Miss Gina — saying, "Do you know that you have a lovely voice, Miss Thing?" "Oh, why thank-you."

TA: You were talking about work concerning agitated mental states. Are there similarities in the way medical communities approach AIDS and mental illness?

DG: Certainly. The most dangerous thing about the AIDS epidemic is the way we are conditioned to think about it, which encourages the sense of isolation that people end up with, a suicidal prognosis. Michael Flanagan says it best: Death by media. I mean every aspect of the media against which a person has to operate in a completely defensive position all the time. Even some gay newspapers that are supposed to be useful are just advertising monkey drugs, confusing everyone. In working with illness on a personal level, I've had problems dealing with much of the research on the hepatitis C virus, trying to find buyer's clubs and people who understand that I shouldn't render myself up to a liver biopsy and alpha-interferon immediately or accept a diagnosis of cirrhosis of the liver or liver cancer as inevitable.[1]

TA: Does working on restoring and maintaining your health demand a great investment of time?

DG: I've had hepatitis for four years, but until recently, I didn't even know it as hepatitis C; initially it was called non-A non-B. Hepatitis C is supposed to be spread almost exclusively through

needles. When I went to a doctor, he said, "Well, we find this primarily in gay communities." I said, "That's interesting, I thought you said it was spread through needles." This was right after hepatitis C had been identified as a potentially lethal virus. So I had to ask: "How old is the research on alpha-interferon and hepatitis C when you've just identified this virus as so lethal? Why do you suggest alpha-interferon treatment when, while improving the immune system, it has a 50 percent relapse status with the virus? Why do you believe, regardless of alternative therapies and diet, that hepatitis C inevitably leads to cirrhosis and liver cancer?" This is the kind of thinking we saw with AZT. It is very dangerous. I told the doctor that before I started taking alpha-interferon, I'd be much more interested in stimulating my own production of interferon through C-drip and through combination therapies.

TA: The medical community often makes proclamations when they have very little information. It's an obsessive need to provide answers, to be in control, rather than to simply admit "We don't know how to answer that." We seldom hear: "I don't know anything about alternative therapies. I don't know anything about the use of high-dose vitamin C. I've never researched it myself, and I can't possibly hope to keep up with new research on subjects outside of my field." Rather, we're given the dismissive "That doesn't work."

DG: One thing that is not encouraged by much of the medical community, either for HIV, AIDS, hepatitis, or any kind of immune-compromised condition, is a patient-doctor collaboration in the research of alternative treatments and experimental therapies. We are presented with this black-and-white thinking: if you have one of these viruses, start to make your fucking funeral plans. If you don't, it's not your problem — within the straight

population that is a popular fiction, never any discussion that we're now living in an age of science fiction, where everybody, sooner or later, will be stricken with some virus. You rise to the occasion or you don't rise to the occasion . . . Why *aren't* people talking about stimulating the immune system? Why aren't we talking in those terms? That's our biggest challenge. It's not that viruses aren't going to exist, that we're not going to be exposed to them or contract illnesses, or have antibodies to viruses, but that we have to be able to develop a strong body to deal with these conditions. That's how we will survive as humans, and how we will evolve as a human race, theoretically.

TA: There's a stance one takes. Some people seem predisposed toward survival; others, perhaps, can develop that trait. It involves building the will to live and doing research in medical journals, talking with other survivors, investigating their methods, investigating the body. When I see that, I know that a person has a much better chance of surviving critical illness.

DG: I talk to everyone about these issues, to people who had liver cancer thirty years ago and who are looking beautiful now, and others who got insane prognoses and still recovered. I've discovered that I can choose any level of knowledge I want — that's up to me. I'm not saying that I can choose to live as long as I want, because I don't know exactly how the body works, but I can certainly improve the probabilities.

TA: I'm interested in the nature of fury in your performances. In *Plague Mass* you seem to embody the complementary functions of priestess and Fury; I'm speaking of Fury in the chthonic sense, the cave-dwelling female deities who pursued Orestes, avengers

who punished the transgressor of sacred laws. What is the effect on your body and your emotions, your psyche, of this embodying and releasing of fury?

DG: Physically, I have to be very strong to do what I'm doing. Just on the level of stamina, in terms of my heart, this kind of work is exhausting. Like any good musician, I have to be equal to what I am hearing by exercising a certain kind of technical discipline. However, the technical discipline for a vocalist who does what I do demands a very strong body, a strong cardiovascular and diaphragmatic system. You have to be a healthy medium. My ideas about the epidemic are not passive ideas. My way of approaching my subjects is not passive; so naturally anger — even fury — is going to be part of my art, the textual information that I write or find elsewhere and use. And I have to be physically strong to convey such powerful emotions. The delivery of any material on AIDS or viruses or mental illness or germ warfare has to be as powerful as the material itself.

TA: What is your physical response to performance?

DG: If I'm doing what I'm supposed to be doing, I'm energized. That is a basic premise of good singing, in any case. And I want to be doing my work. If I no longer had any interest in remaining healthy for myself — and that could happen — I'm always going to want to remain healthy because I have more ideas that I want to get out. That's my blessing. Whether it's an illusion or a delusion, or a grandiosity on my part, it sustains my reason for existing.

TA: I don't think it's a grandiosity. In some ways it seems humble because you are in service of your art.

DG: Because my work is so athletic, I have to be as single-minded

in preserving my health as a person with critical illness. I wasn't trained in the compositional sense; I could not easily write my work for someone else to perform. In any case, I don't know how many people would be able to, or would want to, perform what I do anyway, so ultimately the work dies with me. That's something I've known for a long time. I've been asked, "Aren't you going to change professions in five years? You aren't going to be able to do this in five years." And I reply, "Why am I not going to be able to do this in five years? Why can't I do that?" They say, "Oh, you'll have a heart attack, or you won't be able to do it physically," and I say, "Then that's my challenge, and aren't I lucky?" I have to figure out a way to keep this body functioning at its most primary level so I don't have to feel like an old dancer.

TA: Even writers with AIDS fear a failing of the body — like dementia. They fear it terribly. The diminishing of the power of concentration is a very frightening thing. In performance, you seem to embody energy at its most visceral, something different than the merely athletic or intellectual. I've wondered, what must it mean, to embody this? What happens to Galás? How, for instance, do you rehearse?

DG: The best way for me to rehearse is to keep the technique going, either by myself or with my teacher, but that's only the beginning. It's like an alignment exercise, aligning the projection of sound with the bones of the face and resonance areas. There are many sound initiation sites in the body. To produce the highest notes, the resonance areas need to come over the scalp this way [Gestures], and I need to work from a grounded center, just as in t'ai chi or martial arts. To perform this kind of material — let's say for an hour and a half — I have to work, prepare, and rehearse continually. For example, with *Insekta,* I rehearsed at The Kitchen

four or five days a week. I have to build up my stamina, at the same time also aligning a kind of improvisational facility and the body: a body/intellect combination. Every day that I work I'm aligning the body and the intellect. I must memorize the work on a physical, rather than just an intellectual, level so that I can push it further and expand it through the adrenalin that I get from a performance.

TA: You are a seronegative woman, yet you have involved yourself with the epidemic as few others have. I feel you have taken the implications of the virus into your body during your performances, and outside of performance you have literally tattooed yourself seropositive. This is a ferociously courageous act of empathy — artistry combining the willingness to risk everything: ostracism, misunderstanding, insanity. What do you think are your primary and ultimate motivations for becoming involved with AIDS?

DG: I began the work in 1984. I was living in San Francisco and San Diego. I started to work at Hunter's Point [in San Francisco]. This was before I knew — or my brother knew, for that matter — that he was infected with the virus. I can't really explain exactly why or how I started to work on the *Plague Mass*, but I started it then. At that time I was hearing from people in the art world that it was a really bad idea. I found the reaction very, very curious. I continued the work in London, and from then on I was just seen as a freak — though that assessment was hardly new. In 1986 my brother was diagnosed with AIDS. It is bizarre that I was working on this two years before Philip was diagnosed, but that is how things are. Unfortunately, people tend to want to sentimentalize the work, to see it as a reaction to my brother's illness. In a way, besides explaining it for themselves, they are trivializing the work:

"Oh, she's mourning the death of her brother from AIDS!" This is seen as a sufficient explanation. It is also used by idiots and misogynists as a deprecation of the work, as if it is some pathetic female sentimentality, a silly notion. My vision is as cold as any man's. [Laughs] I can take a situation and look at it as dispassionately as anyone. On the other hand, who is anyone to be able to say that he or she can look at a situation dispassionately, especially when attempting to be most dispassionate? So what the fuck does that mean?

TA: But doesn't your art require that element of dispassion — to look at it objectively, to see if it's working, to see if it is truly communicating? I've found that the needs of the work and our emotional needs in creating it may be quite different. The focus of the work as it matures is ultimately what predominates.

DG: Thank-you. Exactly. People have said, "Don't you think some of the work you do would shock people who have HIV?" I would have to answer yes, and that is something that hurts me. If I were performing and looked out into the audience and felt there was someone there who had come to get a different kind of experience, I would think, oh, this is so aggressive and angry that it is hurting someone. I would feel terrible. I do wonder about that sort of thing. But it's then that I realize that, unfortunately, I'm just an artist. I'm just an artist; it's what I do best. I do this work. I'm not confused; I don't think that I'm a therapist. In any case, if there is any therapeutic aspect to the work, it would have to lie alongside its quality as an art–making entity. It could not be the predominant purpose of the work. If it were, I would *never* go up on stage and put blood on myself and scream; I would do what I do when I go to the hospitals. I go to the hospitals to sing Christmas carols or to play old standards on the piano, and if someone wants me to, I sing "Amazing Grace."

TA: As a seronegative woman, have you ever been pushed out of the community of people with AIDS?

DG: Yes, I have. And *certainly* a person who doesn't have the virus can't possibly understand what it is like to have the virus. But on the other hand, people who are seropositive each have different understandings. If I am coming from an absolute certainty that the concept of compassion (rather than sympathy) is something that has not been conditioned out of the human race completely, then I would have to be victorious in my assumption that people outside of the seropositive community are going to be able to contribute, and *have* to contribute. Whether they're accepted is incidental; they should consider themselves part of something that is much larger than the opinions of a few people. The distinction that I make concerning sympathy is that it can be the sort of bathos that motivates some stranger to say, "Oh, I'm so sorry about your brother." This always makes me want to say, "Oh, my brother called me from hell the other day to say he's never been fucked so good in his life; how are *you* doing?" Philip did not operate on that kind of pathetic level, nor do I.

TA: Can we talk about Philip?

DG: My brother is a brilliant playwright and performer.

TA: I often think *Mona Rogers in Person* couldn't be improved upon. It was a complete experience. I saw Helen Shumaker's performance; I didn't see Philip's.

DG: She was fantastic doing *Mona Rogers*. She's not a careerist per se, so she didn't advertise herself the way a lot of New York performers advertise themselves. Those careerists have much less talent than Helen; they just have a lust for a career — before they have anything interesting or important to say. So I've seen a lot

of formidably uninteresting things . . . Philip was phenomenal. He supported his work through Galás Exotic Cards, his business, which he began in San Francisco in 1978.

TA: How did Philip react to learning about having AIDS?

DG: I know that during the last year of my brother's life, actually the last two years, he was working extremely hard all around the clock, wanting to make sure that his work was completed. He was very happy because Helen Shumaker was performing *Mona Rogers* and another performer [Sean Sullivan] was performing *Baby Red Boots Revenge.* He had moved at this point from being a performer of his work to being a director of his work — perhaps so that it would survive him. I think he was trying to generate as much work as possible, and it's very hard to do that when you're performing a work all over the place. Also, a lot of writers aren't going to want to be stopped performing their work, the same work over and over again.

TA: Was he becoming more objective about the material, working with Helen Shumaker?

DG: That might be true. You may be right about the objectivity. As I've said, Helen certainly is a brilliant performer. She worked with Charles Ludlum and Ethyl Eichelberger as well as Philip. That's a pretty unhappy history when you consider the talents she has worked with who have died.

My brother was certainly my biggest inspiration when I was growing up. The two of us shared so much. Musically, my interest lay more in the free-jazz area; whereas he became interested in cabaret music. As far as writers go, he turned me on to Artaud, Gore Vidal, Baudelaire, Lautreamont, Nerval, and even little Truman's vicious interviews. We shared so much. I was impressed with

my brother and remain impressed with him, as one is in the presence of a sort of deity. I know it may sound extreme, but quite honestly that's the way it was. He was an incredible person. He would wake up every morning very early; I would be asleep and I'd hear these footsteps upstairs in the attic. I'd think, God dammit, can't I take a vacation once in a while! [Laughs] I'd come back from Europe really tired from my work, and I would hear him working early in the morning. He was working on all these things at the same time: the postcard business, writing, and performing. During the last two years of his life, the work was mounted in San Francisco.

TA: The Marine's Memorial, and Climate. I saw *Mona Rogers* performed in both places.

DG: Did you see him? He went on stage after the performance to take a bow.

TA: Yes, he got up on stage at Marine's Memorial.

DG: He wasn't at all well then. I don't know if you noticed that?

TA: He seemed very happy. He got a standing ovation.

DG: He seemed very happy? That makes me feel good.

TA: People were spontaneously roaring. They were stunned.

DG: People spontaneously roared?

TA: I did. We were stunned by the performance. Marine's was full.

DG: Yes!!! How many people were there?

TA: It was packed as I remember.

DG: Six hundred?

TA: More than six hundred. He looked shy when he appeared on stage; he had a very shy smile on his face and he looked around, and you could tell the audience and their appreciation of his work definitely got to him. There were scenes from *Avante Vaudeville,* the complete *Mona Rogers in Person*. It was Shumaker at her best. She hit every note. She hit everything that night.

TA: Many artists have been accused recently of being obscene or pornographic. You're one of the few contemporary artists to be accused of blasphemy. How did you react to that charge?

DG: It happened when I was performing *Plague Mass* in Italy, near Florence. I definitely felt that something very, very strange was going down that evening. Parts of the performance were in Italian, because the *Mass* includes biblical pieces sung and spoken in Italian [*The Divine Punishment*]. So it wasn't as if it were an abstract performance work from someone from New York coming to show them American ideas of blasphemy. It was actually something easily understood there, which translated into its perception as a mass, per se: a blasphemous mass. It wasn't as if I assaulted or shocked everyone; my supporters included a lot of people who had heard about the performance from *Babilonia* magazine, a gay magazine in Florence. They were standing there cheering. At the same time you could feel the disapproval and the horror at the performance — the town council was there. The meaning of my performance was thrust into the context of my being a somewhat respected avant-garde operatic performer and artist. I performed the evening after Luciano Berio. This was very shocking for the bourgeoisie of the community and their supporters. Many articles

came out, for example, showing pictures of the district commissioner and the building in which the performance occurred and headlines like *"Galás: voce, sesso e sacrilegio"* (Galás: Voice, Sex and Sacrilege), *"Infuria la polemica per l'artista 'maledetta'"* (Furious Controversy Surrounds "Cursed" Artist); *"Diamanda, all'inferno e ritorno"* (Diamanda, to Hell and Back), et cetera. The politicians in the Christian Democratic party were incensed. There was a great deal of national press; it kept coming out for weeks. I didn't know about it at the time because I had taken a plane out of Italy the morning after the performance to continue my tour.

There was a strong feeling that the people who had presented me there were being persecuted. I felt very sad about that; it wasn't my point to go and offend people in Italy. It wasn't my point as a New Yorker to go scandalize Florence. I'd had such great conversations with people from the burgeoning AIDS organizations there, and the next thing I knew I was offending all of the people in their city . . . I was simply performing the mourning rituals of the old women from the south of Italy and Greece. In Greece the ritualistic keening over the dead is called the *Moirologia,* and there are similar keening rituals in Italy and Sicily. I don't think these old women would have been shocked at all by what I was doing. Perhaps they would have been offended by some of the words, but not the emotion behind them.

TA: They would have understood the body of the performance — its emotional integrity?

DG: Yes, they would understand. When someone's son is killed, they sacrifice everything in their homes. Traditionally, there was a sacrifice of everything to avenge that person's death. So sacrificing one's public image, or sacrificing the intelligibility of one's performance, when confounded by this intense emotional expe-

rience, is a small price to pay by comparison. Except in the province of the small minds that make up a town council. Certainly not in the greater body of humanity, and certainly not in the great body of Italian female humanity! [Laughs][2]

TA: Since you began *Plague Mass,* many people have dealt with AIDS in various formats. What contemporary artists do you take seriously?

DG: After my brother, David Wojnarowicz. I felt such a kindred spirit from him. I've heard great things about Bill T. Jones, but I haven't seen his performances. I loved Essex Hemphill's work in *Tongues Untied;* I was crazy about him. I saw that film and just screamed.

TA: Essex wrote the poetry and performed, in collaboration with filmmaker Marlon Riggs — they've collaborated on several projects. Marlon has been terribly ill lately.

DG: I'm sad to hear that. I have tremendous respect for him; I loved that film so much.

TA: *The Divine Punishment* is dedicated to Tom Hopkins, who died in 1985. Since then you have lost your brother, close friends, and you still have close friends with AIDS. How do you maintain courage and strength, and how do all of these losses affect your creative process?

DG: I would have to ask you the same question. It's different for both of us, as it's different for everyone. I couldn't possibly separate my work from my life, so it's hard to answer that question. I'm not detached enough for that kind of introspection. However, I don't think that I could survive if the work I was doing was detached from the time in which I was living, and that time in-

cludes AIDS. That's why I'm not going on stage and singing *Tosca* or *Norma,* with all due respect to those works and as much as I love them. I do sing those works, but not on stage, because that is not the direction of my art. They don't really explore the nature of the time we are living in — the very visceral nature of it. Even working within another form, say within Coltrane's tradition, wouldn't make any sense now. My imperative is different from his, and it is linked to the current moment. I don't know if that means that I have a different cultural or artistic imperative than my predecessors. I probably do, because they were relating to their own time. At any rate, with regard to maintaining strength, I have to stay strong so that I can be equal to whatever blazing energy the work requires. That includes overcoming the insanity of attempting to live as a sane, functioning human being in an irrational time.

TA: What are the most outraging aspects of AIDS, or of reaction to AIDS by the larger community?

DG: The most outraging aspect is that the primary question for most people is whether the larger community is in danger of contracting the disease. The perceived risk to the "larger" community takes up so much of the dialogue that everything else is trivialized. It's not only cowardly, but also a symptom of a societal mental dis-order. So many in the heterosexual community are approaching this subject with their minds acting back-asswards. This fear reflects a simpleton's conception of the world; it seems quite bizarre to me.

TA: Much of your work has focused on what would be considered the darker side of the human persona. What lessons do we take from focusing on this side of the psyche?

DG: I suppose that if you focus on that side of the psyche you are prepared. When events that take place at dark knock on your door, you are prepared rather than unprepared, which gives you a better chance to be equal to them. There would certainly be no point conjecturing about things that you believe yourself unequal to.

NOTES

I am deeply indebted to Michael Flanagan, the president of DAIR (Documentation of AIDS Issues and Research) and Ms. Galás's principal research associate, for his assistance in editing this interview and for the following notes.

1. Diamanda's work points out that the kind of misinformation that produces this isolation and confusion is also present in the research on mental illness. Indeed her recent work portrays just how disempowered are people with mental disorders; everything they say concerning their own illness is considered suspect.

2. Defenders of the status quo come from the most unexpected places. Diamanda was recently denied permission to include background material from the book on tape version of *Final Exit* in *Vena Cava,* as the authors decided that her work was satanic. In one instance she was accused by supporters of the Church and in another refused permission by supporters of euthanasia.

SEVERO SARDUY

I

THE SENSES TRANSCENDED, *obscured*. Also understanding: "All that the imagination can imagine and the understanding can receive and understand in this life is not, nor cannot serve as a means of union with God."

By blinding myself to all paths can I more nearly approach the *ray of darkness*. The subject doesn't realize that he himself is illuminated by this ray. "And thus it is that contemplation, whereby the understanding has the loftiest knowledge of God, is called mystical theology, which signifies secret wisdom of God; for it is secret *even to the understanding that receives it*. For that reason Saint Dionysius calls it a *ray of darkness*. Of this the prophet Baruch says (3.23): *There is none that knoweth its way, nor any that can think of its paths*. It is clear, then, that the understanding must be blind to all the paths that are open to it in order that it may be united with God." (*Ascent of Mount Carmel,* Chapter 8, paragraph 6.)

II

Written in exile, when I can't sleep: so many books that nobody has read, so many meticulous paintings — bringing me to the edge of blindness — that no collector has bought nor any museum sought; so much ardor that no body has calmed.

"My life" — I tell myself, deliberating pre-posthumously —

has had no *telos*. No purpose nor destiny has unfolded in its passing."

But immediately I correct myself: "Yes it has. How can I not see in this succession of frustrations, failures, illnesses and abandonments, the repeated blow of God's hand."

III

We pray simple-minded and stubbornly to the gods to abandon their detachment and to reveal themselves. We long for miracles, ecstasy, the gift of inexplicable objects, fragrances, resurrections, a sense of His presence. Or simply a harmony, a reason.

Naive mysticism. The divinity's being is precisely what is not manifest, what does not have access to the world of phenomena or to perception. Not even as an immaterial presence or "intuition" of the mystical. We ask them, finally, to renounce their essence and to *be* in ours, which is the gaze.

But it's useless.

They never abandon that night, that black hole that devoured them forever.

IV

Despite everything, I still believe in God. Whom can we ask, if not, to curse our enemies? Even though God is so indifferent to human language that he can give me only a generic Blessing.

V

Morandi: those whitewashed bottles, those mute vases reach us, fall, from the night of the non-manifest. They have put aside for

a moment their firm reticence toward the visible, their absolute principle: not to appear.

Soon they return to their chaos, mistreated by that brief residence in the gaze, refracting the screeching glare of the day, the definition of every line, the explosion of color. The light.

VI

The work of art, exceptional or not, requires brilliant adjectives, syntactical surprises, the invention or play of words: a whole technical display whose finality is to dazzle the reader.

The sublime work — which does not grant the *night* one instant but rather leaves the trace of its long sojourn in non-being — is rudimentary, incompetent, streaked with rough spots, faded, always flat.

Thus San Juan's *Spiritual Canticle* contains the most repellent cacophony in the history of the Spanish language, *un no sé qué que quedan balbuciendo,* or a stammering stuttering God knows what.

It doesn't matter. God, who dictated the other verses, erased that babble. And with one blow.

VII

Marcel Duchamp, John Cage, Octavio Paz: we're dealing with the imitation of nature. But of course not of its appearance — realism's naive project — but rather of its *functioning,* using chaos, invoking chance, insisting on the imperceptible, privileging the unfinished. Alternating the strong, continuous and virile with the interrupted and the feminine. Dramatizing the unity of all phenomena.

Forget the rest. But there is nothing else.

199

VIII

Cioran — we must recognize — is disillusioned with everything. Disenchanted. Back from it all. Fed up with Man and his criminal initiatives, with Literature and its tricks, with the Parisian crowd and its intrigues.

He lives alone. He never sees anyone nor gives interviews. He publishes very little. When he is spoken to he's very friendly but never eloquent.

There is, nevertheless, when you read him attentively, something that is unequivocally evident: the quality and propriety of his style, the elegance — inspired by the French eighteenth century — of his sentences, as if those brief aphorisms that constitute his work were carved out of insomnia and out of the perfection emanating so frequently from him, refined time and again. There is, then, beyond total despair, something that persists, a faith. In language and its faculties, in the word.

We need to interpret, in light of the preceding, the final silence of the Buddha.

IX

When the sun returned, it was already late. Late in the day though not in his life, he managed to see that light he had desired so much. And the sea. And the unadorned castles. And perhaps in Collioure, an open window.

X

Defended, walled up by solitude and silence. Last hope: not to embitter myself with remorse, desires for revenge, yearnings for survival or annihilation, recapitulations, fears.

Take the step without a stage set, without pathos. In the most neutral way. Almost calmly.

XI

Lamps of fire in San Juan. Perhaps death is that: burning, calcinating in those flames, remaining blinded by the sparks of that light. As if someone stirred them both within and outside of our body, until consuming it.

Burning. Ardor.

To come out to another light, to become that light. An immaterial light, not pierced by any vibration, weightless, colorless, alien to the sun and to the iris. Uncreated, without edges, with neither beginning nor end.

Light: San Juan (Book II, Chapter IX) quotes David (*Sal,* 17, 10)

He set darkness under His feet. And He rose upon the cherubim, and flew upon the wings of the wind. And He made darkness, and the dark water, His hiding-place.

He points out, some paragraphs later, that among the fantasies or imaginings to which the understanding lends credence is *considering or imagining glory as a beautiful light.*

XII

Radically conclusive, extreme negativity. Fog closing in. The senses and the understanding blockaded against everything that can deviate from the road — unknown, unrepresentable, alien to all enunciations or glimmers of anything else — leading to the inconceivable, exempt from all attributes, what language's vulgarity might call *Union.*

Unknown then the final goal and the path: "In order to arrive at that which thou knowest not, Thou must go by a way that thou knowest not." (*Ascent of Mount Carmel,* Chapter 13, 11).

The *Ascent* can thus be read as an obstinate repetition of recommendations, warnings, advice, precautions and even alerts against any and all distractions:

> It now remains, then, to be pointed out that the soul must not allow its eyes to rest upon that outer husk — namely, figures and objects set before it supernaturally. These may be presented to the exterior senses, as are locutions and words audible to the ear; or, to the eyes, visions of saints, and of beauteous radiance; or perfumes to the sense of smell; or tastes and sweetnesses to the palate; or other delights to the touch, which are wont to proceed from the spirit, a thing that very commonly happens to spiritual persons. Or the soul may have to avert its eyes from visions of interior sense, such as imaginary visions, *all of which it must renounce entirely.* (*Ascent,* Book II, Chapter 17, 9. The italics are mine.)

XIII

He had already had to eat all of his papers as fast as he could so that they wouldn't be read by his harassing inquisitors.

They locked him up for nine months in Toledo, in a cell six feet by ten. Without water, without light: to read the Gospels he had to climb up to a tiny skylight in the wall near the ceiling.

On bread and water and an occasional sardine. His back rots, festers, lashed by the whips of the Carmelites, to make him renounce the Reform.

He's forced to cohabit with the pail of his own excrement. He's overcome by vomiting, dysentery and even perhaps regrets and guilt.

In that hell he conceives, learns by heart, and on his knees he sings and even shouts the first verses of the *Canticle*.

As if to ascend to the absolute and to know dissolution in the One it were necessary to descend to putrefaction, touch the most foul, lose himself in revulsion and corruption. [San Juan de la Cruz, *Complete Works* (I) Alianza Editorial, ed. Luce Lopez-Baralt and Eulogio Pacho.]

XIV

One day I say to Gombrowicz — I think it was in Royaumont, in any case we were under a tree — "I am lost and alone, I write in Spanish, or rather in Cuban, in a country not interested in anything that isn't its own culture and traditions; and what is no longer noteworthy, or perhaps completely accepted, is that the author leaves no trace of a past identity, as if he didn't exist."

With his usual touch of irony, his discreet but sarcastic smile, and that asthmatic panting that interrupted his sentences, he comes back with a cutting reply:

"And what would you say, my dear boy, about a Pole in Buenos Aires?"

XV

All that has a form is disconnected and dispersed, all that is gathered together dissolves, all that is created disappears. The body and its components — hair, skin, blood, semen . . . — the mind and its will, projections, memories, regrets, loves and rejections.

What is called *I* or *being* is merely a conglomeration, an ensemble of physical and mental elements that appear to act as one though in an interdependent manner, in a flux of momentary changes, subject to the laws of cause and effect, in which there is nothing permanent, nor eternal, nor exempt from change in the totality of universal existence.

There is no subject, individual soul, consciousness of oneself or an I. There is thought but no thinker. Neither is there — if we believe in the categorical responses of Milinda to Nagasena — a cosmic consciousness, a universal being.

If there is no *atman* — being, I, subject, soul — what can be reincarnated after death?

If there is no *brahman* — universal soul, cosmic consciousness — into what do we dissolve?

Given the leap, how can we hear the *explosion of emptiness?*

XVI

Paris, May, Montparnasse
I get up very early and open wide all the windows.

The transparent light of day flashes upon me. Barely blue. How far from the blue of Matisse — a butterfly's wings — which nevertheless he painted near here!

It's possible, I say to myself, submerged in contemplation, as if I were attending a miracle, that everything can be reduced to and formulated as a function of vibrating phenomena, as adaptations to the human iris, etc.

It's also conceivable that this light is the reverse, the residue, the double, the "fall" of another light.

Or its distant metaphor, as if alien.

Or a brutal *epiphany*, but of what?

XVII

Even knowing perfectly well that his commentaries on readings
— or his pretentious aphorisms — will remain unpublished, or
will be published under the sinister rubric of *posthumous,* a *real*
writer continues writing them.

Very early in the morning he gets up and, beside the window,
with day's first light he writes down some lines.

Why? What for?

Perhaps because the only way of responding to an absurd —
and death is the absurd par excellence — is an even greater absurd:
writing *for nothing,* with neither motive nor goal, without theo-
retical proofs, plots, fictions, readers, or aesthetic or literary efforts.

In the supreme freedom of *total gratuity.*

XVIII

Solitude, sickness, depression, silence.

Wherever the gaze rests it discovers dust, larval filth, sloven-
liness, stains.

The protocol of everyday life starts turning into a constant
vigilance, at times into a mitigated hell. Accepting the degrada-
tion of things, the relentless progress of disorder, would be like
one more invitation to death.

But after all, it is normal for everything to collapse, down to
the very last detail . . .

If life, which is the essential, the most precious, has been
taken away, how could I think that there wouldn't be bread-
crumbs on the floor?

XIX

Indifference, provincial aggressivity, collective rejection and mockery finally chip away at a writer's work. Also flattery, excessive praise, exaggerated eulogies expressed to his face, promoting him to the status of hero.

The former undermines his confidence in himself, makes him doubt what he's creating, the usefulness — or transcendence — of all possible creation.

The latter's explicitly fictitious nature is also destructive. No one believes in those apotheoses, neither the one who utters them — and who knows very well what the appropriate criteria are — nor the one who receives them — who immediately detects the emphatic emptiness, the total or at least banal gratuity of these inopportune inventions.

Backbiters and backslappers: equally ominous for an author.

What would be the *moral position* of a true reader? Where is the threshold of discretion that he mustn't cross?

The true reading — discreet, ideally silent — is as far from the sting, the insult, as it is from blatant frivolity.

(I suffered these two vilifications, which I shall never forget.)

XX

He abandons his native country and adopts another, faraway, whose sky is always gray and whose people are harsh.

In exile he constructs laborious fictions whose chiseled sentences and skillfully wrought Baroque volutes are seductive, though, when the end is reached, it all dissolves into oblivion.

These models of perseverance are published and tolerated by readers, ignored somewhat sarcastically by the multitudes, and

suspended in that respectful limbo of university dissertations and translations into unfathomable languages.

He then projects the summary, the final cycle of his inventions when he's struck down by a strange irreversible disease.

He shields himself with converging manias: morning readings of the mystics, a need for emptiness and the project of finishing paintings that are detailed down to the last millimeter, with the final strokes of red calligraphy, emphatic though discreet, ostensibly Eastern.

He divests himself of dusty books, summer clothes, accumulated letters, faded drawings, and paintings.

He surrenders, as if to a drug, to solitude and silence.

In that domestic peace he awaits death. With his library in order.

Translated by Suzanne Jill Levine (1993)

SEVERO SARDUY

I got to S.'s studio early in the morning so that I could see his
latest work before it went off to Los Angeles. He opened the gate
for me fully dressed; he was even wearing a shirt and tie at that
hour, his blond hair shining as if he had just oiled it. I knew
immediately that something was wrong. Gesturing impatiently,
he shooed away a menacing dog that seemed about to take a bite
out of me.

"I'm fine," he said right away, his tone that of someone en-
gaged in an extended conversation. "C.'s the one who's in bad
shape. His friend G. has been on an IV for a week."

Affecting an assurance contradicted by something in his voice,
he walked toward the studio like an actor who has finished his
lines.

The human body is a machine held upright by a system of
hinges. My hinges opened and broke apart. I stood there rigidly,
leaning against a radiator, as if the heat could keep me standing,
strengthen my spine. I fixed my gaze on S.'s paintings as if they
were a bull's-eye; there, in fact, the human body is trapped in an
irregular oval, where it tries to put itself back together, to mag-
netize the fragments dislocated and dispersed by the flash of color.
Parkinsoned by the chromatic discharge, those huge Gardelian
dolls shake and take flight toward a charcoal sky.

As I looked at them, I understood my reaction. I understood
what my body was telling me: AIDS is a stalking. It feels as if
someone, at any moment, under any pretext at all, could knock

on the door and carry you off forever; as if an unrecognizable danger hovered in the air and could solidify, jell, in the space of an instant. Who will be next? How long will you escape? Everything gets heavy, like a threat. The Jews, it seems, know that feeling very well.

AFTER A QUICK GLANCE the nonchalant nurse who was attending to me said the best thing would be to remove the wart surgically, because it had grown so large and so deep, even though it was barely visible on the sole of my foot.

A few hours later I was on the table and the doctor was taking my blood pressure, asking me if I'd had any anesthetic yet, giving me an injection, making the first incisions.

"Do you feel anything?" he said.

"Nothing," I replied, with the certainty that managing the microphones has taught me to feign.

"Or, yes," I added immediately, "I do have a feeling that . . . but this has nothing to do with what's going on here. That there's something burning in the neighborhood outside. Smells like burnt rubber."

"It's not in the neighborhood outside," he answered, but without looking at me, concentrating on his meticulous task, "and it's not rubber. I've already removed the wart and now I'm cauterizing your skin. What you smell is singed human flesh."

"We Jews," he added without the slightest change in his expression, "are very familiar with that smell."

Translated by Carol Maier

PART IV

EDMUND WHITE had just finished *Genet,* his encompassing
biography of the great French author and criminal, when we
shared lunch to discuss the proposed themes of our interview. The
author of eleven books, including the novels *A Boy's Own Story,*
The Beautiful Room Is Empty, and *Caracole,* was looking strong,
even serene; this visit to San Francisco for a speaking engagement
at Stanford was a vacation from "all the little problems with re-
visions, rights (which I foolishly forgot to keep track of)" related
to the extensively and scrupulously annotated *Genet,* and also a
respite from the difficult work of caregiving for his lover at their
home in Paris. Mr. White has been praised as "the most accom-
plished American author since Henry James" *(Le Monde)* and is
widely regarded as a gay author whose work crosses over to a
larger, more general audience, despite the explicit and luxuriously
rendered scenes of sexuality and decadence of his novels.
Christopher Lehmann-Haupt noted in the *New York Times* that *A*
Boy's Own Story "is not exclusively a homosexual boy's story. It is
any boy's story, to the marvelous degree that it evokes the inchoate
longing of late childhood and early adolescence." Mr. White is
also regarded as a writer's writer — Vladimir Nabokov cited his
first novel, *Forgetting Elena,* as the American novel he most ad-
mired. James Merrill has written that White's "style can take your
breath away." Charm, and a quicksilver mentality are perhaps part
of his Proustian sensibility, but Edmund White has lately found

that his relationship to the life and work of Genet has profoundly affected his personality; he has become "more severe, less charming as a person, more uncompromising. I think it's a salutary impulse."

> Now I sometimes feel I don't feel enough . . .
> perhaps because I know myself too well.
>
> — Edmund White, *The Beautiful Room Is Empty*

THOMAS AVENA: To me, it seems that AIDS makes the body foreign, that one encounters the body in a different way. Have you discovered that yourself and if so, how does it affect your work?

EDMUND WHITE: I'm trying right now to write a novel, and it's hard to find the appetite for narration that I had before. I don't know whether it's because I finished this long biography [*Genet*] in which I totally suppressed myself for six years — I immersed myself in the life of somebody else — or, more likely, it's because so much has happened to me that the chance of ever really rendering it on the page seems remote, almost Sisyphean. Something about being seropositive gives you this slightly ghostlike feeling toward the world and toward the reader, and toward your own experience even. I feel sometimes like a ghost revisiting the sites of my own life, with a slightly feeble grasp on my own memories and on my own experience. It's as though there's already a kind of weakening of attachment to the world — which is a very dangerous thing for a writer. Yesterday, on the plane, I was reading A. S. Byatt's short stories; this woman has an amazing zest for details, a kind of relish for every tiny thing that ever happened to her characters, and a fascination with places, with smells, with every-

thing, and I envied that and thought I've got somehow to find this same enthusiasm. But one of the things she does in her book, which I'm considering doing in mine, is to talk frankly to the reader about the problems of writing. It seems to me that after all the writer's real job is to render his present state of mind — that's one of his jobs at least. And if you feel baffled by the very specificity of writing because of this detachment from the world that one gets through being seropositive, and through having lost most of one's friends to AIDS, that seems a very interesting problem, probably similar to what most people feel in old age.

TA: So, it's really a question of having to fight this detachment we come to feel toward the sensual world?

EW: One becomes shell-shocked. Numb.

TA: There are whole armies of people wandering around numb. What effect has AIDS had upon the representation of sexuality in your writing?

EW: I am opposed to those people who feel it is dangerous to represent sexy unsafe sex scenes. In the novel I'm writing, I go back and forth from the period in the early seventies to the present. It seems to me that a book that was only about the early seventies, when everybody was having a great deal of unsafe sex, would be intolerable to read now. On the other hand, a book that was only about the agonies of our lives now would also be intolerable to read. Something about the juxtaposition of the two is a winning combination, I'm hoping. In what I've written up to this point — which is only about fifty pages — I find there's a certain loathing of the body *now* and a kind of adulation of the body *then*.

TA: Which leads me to this quote: that you "love Nabokov be-

cause of his passion, his sensual detail, the rendering of the physical, visual world around us, and that literature should be a gift to the reader and that gift is an idealization." I'm interested in reconciling that ideal with the physical realities of AIDS: how the sensual world might encompass the grim realities of physical deterioration.

EW: There's another element we haven't mentioned present in Nabokov — comedy. In Shakespeare's comedies, there is always something comic about the deterioration of the aging body, when there's a mismatch between desire and what the body is capable of performing. That's why Falstaff is a humorous figure, because he's still as lusty as a young man but he's grotesquely fat and old. This kind of mismatch is a source of humor that seems cruel to us. But if the object of the humor is not someone else but oneself, it might still be acceptable: the longing of the spirit outstrips the limitation of matter. What you long to do, whom you long to be, is always slightly at odds with the restraint imposed upon you by your body, but in this disequilibrium there's something that is warm and funny and entertaining for the reader, or at least for a certain kind of very special reader.

When I wrote those words about Nabokov, I still believed in not sharing the writer's problems with the reader. One of the things that is remarkable about, let's say, Proust is that he complains about absolutely everything except the one thing that was probably uppermost in his mind, which is how horribly lonely it is to write a two-thousand-page book and how desperately boring it is always to be alone writing. All that frustration, the fear that one has chosen the wrong direction, the fear that the design is not a good one, that everything is aborted and wrong — those are the fears that constantly haunt a writer, especially when he's

involved in such a mammoth project. Although he talks about everything else, he never talks about that. And I used to think of that as "Proust's gift," that he didn't bore the reader with the actual problems of composition. But my new goal is different: to confide everything, to say everything, including the drudgery, the fear of failure. I believe in a total transparence now.

TA: That's something really difficult to achieve, because a different kind of risk is involved. To explore all of the risks a writer takes, including the personal ones . . .

EW: I always thought that I needed to normalize my life. For instance, readers assume *A Boy's Own Story* is autobiographical and of course it is — kind of — but in another very important way it is not, because I made the boy much more ordinary than I actually was, since I was compulsively sexual from age twelve on. By the time I was sixteen, I'd probably been to bed with several hundred people.

TA: Which is why I never identified that narrator with you.

EW: But I thought if I make the boy the way I really was, it will freak everybody out, and nobody will be able to identify with him except a few sickos like me.

TA: That's perhaps the ultimate taboo — child sexuality.

EW: When I was a boy, I was a minor sort of prodigy. I published in school magazines, got the best grades, won all the prizes; the boy in *A Boy's Own Story* is not at all like that. The ways in which I was exceptional, either in being compulsively sexual or in being bright, I suppressed in order to produce a figure who would be more appealing to more readers. Maybe I was taking up an age-old gay genre: the apology.

TA: It seems like fiction is always reduced from our experiences, real experience being too fantastical.

EW: Right. A. S. Byatt again — one of the most extraordinary things she does is to present characters who are as intelligent and freaky as she must be herself, and who are prodigies. She has a wonderful story in which there is a little girl who says that she knew her classmates would begin to hate her as soon as her grades began to come in — all straight A's. She confides really all of the freakiness of her own situation, which is very appealing. She's given me the courage — at least in this volume, which is to be called *The Farewell Symphony* — to try to take my present situation, a very unusual one, and confide that to the reader. I mean, after all, I live in Paris; I don't work a regular job. I've lived in the Palazzo Barbaro. I've lived an extremely privileged, if precarious, existence. Most writers who lead that kind of life play it down because they don't want to waken the envy of readers or alienate them by creating characters you could never identify with. On the other hand, I feel I've had my share of agony too . . . as anybody has who is gay and has the AIDS virus.

TA: When did you first learn you were HIV-positive?

EW: I always suspected I must be, and then, somewhat like a character in the story I call "Palace Days" I had a Swiss lover (not a German lover as in the story), and he had had only one lover before me, to whom he had been faithful for ten years. So when the test became available he insisted we take it. I said, exactly as in the story, "I'm a good enough novelist to know how this is going to come out" — this is in 1985 — "I know that I'll be positive, you'll be negative. You'll be terribly decent about it, but you'll be afraid of me, and at the end of the year you'll break up

with me or we'll drift apart." That's exactly what happened. Just as in that story, as soon as we had the results, which we received in Zurich, we went to Vienna for a holiday. We stayed in this very beautiful hotel, The King of Hungary, and I remember getting up and going down the hall to the bathroom and just sobbing, sobbing, sobbing. I didn't want to awaken him or bother him with it, but finally he realized what was going on, and he was extremely kind, but a year later we did break up.

TA: Was it his terror of the body?

EW: We'd always had safe sex, and when he was tested after our affair he was still negative, of course. But just as in that story, the decisive point was when he saw me scraping potatoes and cutting my thumb just slightly — a nick. That night when I was touching his sex with my hand, he said, "Not that hand, the other one." I suddenly felt such a pariah that I couldn't go on with it.

TA: I remember that scene from "Palace Days." Something we've all been through, always inspecting our hands for cuts and nicks. At one point, people would run cut lemons all over their hands, and if it stung they wouldn't even engage in masturbatory sex with another person.

EW: I live in a country where nobody thinks about any of this stuff. One of the funny things that probably will infuriate Americans about my book is that I'm sure I'll be seen as very low-conscious politically. I *am* very low-conscious politically, because I haven't lived in America for so many years, and in France there's not a real gay community. People don't talk to each other; everyone lives in a kind of isolation. You're alone with your AIDS. You talk about it to yourself, that's it. There are no opinions, no codes of behavior, no etiquette around AIDS: what you should do in

bed, whether you should tell your partner if you're positive, whether you should make sure he uses a rubber or not. None of that's ever, ever, ever discussed.

TA: Is this because, as you've said, European gays are more assimilated into the larger culture? Or is it because they're not looking at AIDS in the same way?

EW: I think it's a series of things. There is no strong gay ghetto there, as here; there's no part of Paris that is specifically the gay area. And then the French people are fatalistic. Americans are considered puritanical and hysterical (two words that are always applied to Americans by the French), whereas the French consider themselves gallant and fatalistic. Those are all important differences. One of the things that makes us hysterical is that we see so many of our friends who are dying and dead. Whereas there, when people become ill they no longer go out. They go back to their villages and die quietly, unseen by everyone. Here, you can dine next to someone who is covered by Kaposi's sarcoma; we have support groups.

TA: How has AIDS changed the American gay community's relationship to aesthetics or a gay artist's representation of beauty?

EW: In the seventies, the real gay aesthetic was what I used to call the "pleasure machine." It was the idea that the creative or artistic impulse didn't exist so much in traditional works of art as it did in things like sculpting your own body, creating a beautiful environment in your own apartment, concocting drug combinations and sequences of drugs that would be highly aesthetic. It was a shaping of the immediate environment and experience, whether through flowers or costumes or makeup or gems or discos. All those things were ways of programming experiences that would then result in very particular aesthetic responses.

AIDS has done away with that. That kind of conspicuous consumption and emphasis on pure sensation has vanished. Maybe it's just that I'm getting older. AIDS is a frightening experience that is isolating. Even if you do have friends around you, there's that moment at three in the morning when you wake up and you're all alone with this terror. We're brought back to some of the anguish involved in the gay man's adolescence. Most of us didn't grow up in a gay family or in a gay environment; we grew up in a rather hostile family or neighborhood, where we felt like weirdos: alone and anguished and awkward. The body was something we didn't quite trust, although it was very thrilling because obviously you have to be sensual, very motivated physically, to overcome all the stigmas of this society in order to become gay.

TA: So the seventies were really about encountering the body physically and aesthetically and taking it to its limits?

EW: It was a very strange period: all day long you would go to the gym and pump yourself full of vitamins and fruit juices, and all night long you'd take drugs. You were constantly building up this machine that you were then destroying or tampering with. Today this "body art" is suspect, and the traditional high arts are important again — especially literature, but also painting, poetry. The whole Dionysian aspect of the gay experience in the seventies has been replaced by a kind of Apollonian solitude and meditation.

TA: But the younger culture in San Francisco seems revitalized. After an absence of years, that culture has appeared again, but in new forms, maybe more responsible ways?

EW: Sure it has. But there was a triumphant spirit about clone culture that was broken by the eighties and that will never be quite the same.

TA: How has your own relationship to AIDS changed over time?

EW: When I first found out about AIDS, I wanted to deny it because I felt it would be used by straight people or the religious right or by regressive elements in the gay community as a way of reducing our freedoms, which I perceived then to be mainly sexual freedoms. The idea of closing the baths or enforcing safe sex seemed to me hideously repressive and against everything we'd struggled for in the sixties and seventies. That was my first response. But very quickly I began to realize that AIDS was a major health problem, and that it was going to get bigger, and we had to do something about it. So, I was one of the five people who founded the Gay Men's Health Crisis in 1981 (I was the first president of the GMHC). After that, on a subjective level, I think I went into my elegiac period. I felt that we were all blasted and doomed, and every time I saw a friend I would have tears in my eyes. It was all nostalgia, Strauss's "Four Last Songs" . . .

TA: A very seductive period that I went through myself — so different from Kübler-Ross's notions on death and dying, where there are distinct stages. Does it seem heretical to talk about the beauty and seduction inherent in the experience of leaving life in the context of a critical, lingering illness?

EW: Well, I got bored with that because I kept on living much longer than I thought I would. I thought, wait a minute I can't go around with tears in my eyes for the next twenty years if I'm going to go on living and living. So I've recently tried to be more stoic and strong and humorous and upbeat about things, even tragedies. Things that before struck me as totally appalling and unacceptable, through the force of time I've been obliged to accept. I suppose it's like living in a concentration camp for several years.

TA: You've explained this partly, but how do you maintain courage and strength amidst all of the losses you've experienced?

EW: One way is by being a kind of ostrich. I've avoided a lot of deathbeds and illnesses by living abroad. I'll fly in for the memorial ceremony, or the deathbed scene, but I haven't had to live it all out. In some part of me, I knew that I would have to live it out with somebody or other and that one can't go through such pain too many times. Now I'm living out every moment with my lover. It's ironic because when I met him he was married and appeared to be in completely good health. In fact, soon after he left his wife for me I made him go for the test, and he found out that he was not only seropositive but had only one hundred T cells; he'd probably been positive for at least five years. So now I'm going through all of those stages that are so well known to gay people: waking up five times a night to change the sheets, holding his hand while he's vomiting or shitting, plugging in the catheter, and all that stuff. Leading a very, very reduced life. We don't see anyone, we don't go out, we don't do anything. We have a dog, and I take the dog for walks. I buy more food, and he can't eat it, and I try to find something he can eat. We go to one doctor after another. I suppose I was always holding myself in reserve for this; I always knew that it would come my way some day: first with him, and then later with me. So, now it's come.

TA: Amidst that, you maintain the determination to write, and to meet deadlines?

EW: Yes, I always had that quality. I'm a Capricorn, and we're supposed to be law-abiding, good citizens. But when I was a young adolescent I was really threatened with going insane. My mental health was very fragile, and there were several psychiatrists who said to my mother, "You should put him in a hospital."

TA: I remember that terrifying part of *The Beautiful Room Is Empty* where your mother suggests you undergo surgical estrogen implants and you realize the power she could wield over you, not only to destroy your physical body, but to start to change your sex against your will.

EW: But even when I was younger I went to a psychiatrist — I was fourteen or fifteen — and he said to my mother, "This boy's unsalvageable. Put him in a mental hospital and throw the key away." I think I actually was kind of loony, but perhaps it was just the result of being gay and very driven to express my sexuality in the 1950s in the Midwest.

TA: Maybe a sane response to the insanity of this oppression?

EW: Perhaps. Because of that rough patch I developed certain strengths, which included always leading, always doing my work. For instance, even back then, when I was hysterical and crazy and sobbing all the time and biting my nails to the quick, I was still getting straight A's.

TA: You've said that in *The Beautiful Room Is Empty* your intent was to show the puritanical oppression of sexual freedom.

EW: When I was growing up, I felt I was a totally freaky person, as I've suggested, and then later I came to realize that my life, which I had thought was the most *exceptional* imaginable, was actually the most *representative*. All I needed to do was to say what I went through in order to say what gay people went through in their evolution toward freedom. I lived in the fifties and was very oppressed and considered insane because I wanted to be gay. Later I was excessively psychoanalyzed for many years by several different doctors. Then — actually, purely by accident — I partici-

pated in the Stonewall uprising. In the aftermath, in the 1970s, I joined several consciousness-raising groups that were sort of Maoist, as was the style then, and I was active in the early gay literary movement, publishing *Forgetting Elena* and *Nocturnes for the King of Naples*. In the eighties, as I mentioned before, I became involved in the Gay Men's Health Crisis.

As for that remark about puritanism, I wanted to show the effect of growing up sexual, whether homosexual or heterosexual, in a highly repressive, puritanical society. I think that in my writing, just by reporting my life and my experience, I managed to do that without being very polemical.

TA: You have talked about how gays in the fifties were constantly threatened with the charge of insanity. Do you think that people with AIDS are being castigated in the same way?

EW: I think the minute people know that you're a goner, that you're not going to be around much longer, they lose interest in you. Particularly in America, where everyone is grasping his or her way to the top, and friendships are cultivated mainly as a way of social climbing or networking. Especially in cities like New York. I've spent a large part of my life among extremely ambitious people who regarded their social life as an extension of their ambition. And I think once people know you're HIV-positive, they shun you. It's not just a question of gays — old people know the same feeling; they get shunted off to the side.

TA: Especially older women. Look at the novels of Jean Rhys and her exploration of that invisibility, craving it and hating it at the same time: the final anonymity.

EW: I saw a lot of parallels between my mother's experience and mine. My mother died last year; she was eighty-eight. She was losing all of her friends, and I was losing all of mine. She was a

lot less strong than she had been, and though she had very intense periods during the day when she could concentrate, they didn't last long. She had once been a prominent psychologist and researcher into mental retardation, and suddenly she was forgotten, nobody cared about her research, it was all superseded anyway. She had less money, she was not going to be around anymore, she wasn't grist for anyone's mill. Although that hasn't quite happened to me yet, I can imagine it happening. If it hasn't really happened to me, it's because I've continued to write, I've continued to make my mark in the world; but I've seen it happen to a lot of my friends. For instance, my lover, who was an architect and had to give up a career that was just beginning, because he's only thirty-one.

TA: Is he embittered?

EW: I don't think so much embittered as disappointed. It's easier to give up life if you feel you've made your mark. He has been doing comic strips for adults, but very artistic ones that are his memoirs. People we meet and things we do go into this comic strip.

TA: What about the risks that a young seropositive writer faces? Do you feel there are increased risks to taking on a writer's life, in addition to, say, the financial ones?

EW: One of the saddest things I've seen as a teacher — when I was teaching at Brown these last two years — is a brilliant student who had AIDS, who wrote a remarkable novel, and who now is dead. I sent it to everyone I could think of, but it didn't get published. That is a painful scenario: you have very little time to live, you want to consecrate that time to writing a book, you finish the book — then you see that it's not going to get publish-

ed. There's something very harrowing and ultimately tragic about
that. It's as though you're being stifled. Each person has a story to
tell, and if you have AIDS you've got to tell it quickly and now.
And if you do tell it and nobody wants to hear it — because they
say we've already had too many AIDS novels, just look at the
piles of remaindered AIDS novels — that's tragic. It's a danger if
as a young writer you stake everything on that, if you feel publi-
cation is going to justify your whole life, then you live long
enough to see that, in fact, your book is not going to get publish-
ed. I assured my student that his book affected his immediate
circle and the other students who read it. As long as *we* live —
which might not be very long — *we'll* remember that book.

TA: Has AIDS been a major force in late-twentieth-century art?
If so, will it continue to be, or are we going to see more piles of
remaindered AIDS novels in bookstores and publishing houses
saying there's no market for this?

EW: The market is a very strange thing. When black people
wrote in the twenties — there's a book about that called *All
Dressed Up with No Place to Go* — there was the Harlem Renais-
sance, but very few black people were rich enough to buy the
books being written by black writers, and so the whole move-
ment foundered after the collapse of the stock market. When
blacks began to write again and become prominent, in the sixties
and seventies, there was a fear that the same thing would happen,
but it didn't happen. It took a long time to launch all of those
black writers, to create the audience for them, but it happened.
There were enough editors, who (either because they were black
themselves, or because they were committed to the idea of a
black literature) were willing to go on and on publishing the
books, even though they were selling only two or three thousand

copies. They were willing to wait until an audience developed. And I think the same thing has happened with gay literature in general and AIDS literature in particular. There are just too many AIDS deaths to ignore. In New York, every straight or gay person who works in an office or is involved in the arts has had dozens of close gay friends die. It's really affected everybody. I wrote for *House and Garden,* for instance, and the former editor, Nancy Novogrod, is very conscious of AIDS. She's a major consumer of AIDS books because of what her friends have gone through and what she's gone through with them. AIDS won't go away. Just by dint of its sheer oppressiveness, the immense dimensions it's come to assume in people's lives, it will generate an artistic movement.

TA: Are there artists dealing with AIDS whose work particularly speaks to you?

EW: I like Ross Bleckner's paintings very much; I find him a powerful painter. Dale Peck's book, *Martin and John,* is about a young couple who have AIDS and who imagine all kinds of other lives for themselves, and the same themes keep coming up, no matter how fantastical the variations on their lives become. It is a very densely written, powerful book, published by Farrar Straus and Giroux. *Eighty-sixed* was a novel I envied; I wished I had thought of the form of it. There are some funny treatments of AIDS I don't take to: there's a wry, deep humor and then there's a kind of shticky, New York humor, and I like the first kind, not the second. I like the humor of situations and not the humor of wisecracks.

TA: A bitchy, campy humor versus a gallows humor?

EW: I like the gallows humor. I like the humor that, let's say,

would translate into any language, that you wouldn't actually have to know Bette Midler personally in order to get. I don't like the kind that depends on endless references to contemporary humorous figures in the New York mythology.

TA: What issues are you concentrating on in your upcoming novel on AIDS?

EW: I'm trying not to just concentrate on sex. One of the lies of my previous novels is that I've concentrated too much on sex and underreported my own cultural and intellectual life. I want my new novel to be more comprehensive. I want to give a fuller picture of all the jarring contradictions: I can go to the Institute of Contemporary Art in London and give a speech, invited by Her Majesty's government, and then immediately afterwards, in the evening, go out and walk in St. James's park with a boy, hand in hand, and be arrested — which happened to me — by the very same government that had just invited me.

TA: That's outrageous.

EW: For just walking hand in hand, that's all. No kissing, no nothing, no "fondling," as they say. We were simply walking hand in hand. I was with Neil Bartlett, a very wonderful writer. He wrote a book called *Ready to Catch Him Should He Fall,* which was an excellent novel, and he wrote a book about Oscar Wilde, called *Who Is That Man?* He's a young English writer, who was a lover of mine, a well-known actor whose translations of Marivaux are being done at the National Theatre right now. We were walking in the park, hand in hand, two old lovers, now old friends — and we're arrested!

TA: What was the charge?

EW: Holding hands.

TA: Holding hands!

EW: Two men. The policeman said, "If you're capable of that, you're capable of blowing up Buckingham Palace," which was right next to where we were. See, what I might have put in my other books would have been the business about being arrested but not about talking at the ICA, just before. Now I want to put in both, because I want to show what it's like to be this man in his fifties, who on the one hand is beginning to receive more honors than he deserves, but on the other hand is still being oppressed for being gay, by the very society that's honoring him.

Of course, artistically, you worry about whether you're going to sink the whole ship by including too much stuff. As a writer you'll understand what I'm talking about — that one of the problems of being inclusive in your writing is not honesty, because you can always be honest; it's not that hard to be honest. What's hard is to be honest and also give some momentum to what you're saying and not just sink under a plethora of distracting details.

TA: That's what Genet said: "To write is to choose from one of twelve sets of materials offered to you." Because a person's life is so much larger and stranger than fiction. What motivated you to take on a figure as complex as Genet?

EW: Bill Whitehead was my favorite editor; he'd published *A Boy's Own Story* and, before that, *States of Desire,* and later *Caracole.* Anyway, he commissioned me to do it. Then he died of AIDS. The book is dedicated to him. He died almost immediately after he commissioned me to do it. Well, he didn't really commission me — I think he was being discreet, but maybe he didn't even have me in mind. One time when he was visiting me

in Paris he said, "Can you think of anybody to write a biography of Genet?" I said *me,* and I think he was pleased. So, he gave me a contract, and then he died soon afterwards. I see the book as a monument to him, and I've also seen it as part of my AIDS work in a way that would surprise somebody like Larry Kramer. Larry Kramer recently criticized me in the *Advocate* for wasting all these years on Jean Genet, "of all things" (as he put it), when I should be writing about AIDS. His notion is that if you're HIV-positive or if you're just gay or if you're concerned in any way politically, or humanly, you should be bearing endless testimony to your AIDS experiences. And my feeling is that he's right, but only half right. The other danger is that gays, even in their own eyes, get reduced to a single issue, which is after all a medical one; there is a kind of "remedicalization" of homosexuality going on, which I find very dangerous. A book like Richard Ellman's *Oscar Wilde* came out at a very important time for most gay people, because it reminded us of this towering, martyred figure who had nothing to do with AIDS, but who was one of the great forgers of the modern consciousness, and who was gay. I feel that Genet is another one of those figures, and though I could never hope to write such an interesting book as Ellman's, nevertheless, that was my model and that was my goal.

TA: What constitutes your workday? How does your writing develop?

EW: I try to write in the morning, as soon as I wake up. I go and pee, get back in bed with a cup of coffee, and write longhand in very beautiful notebooks. I only do it for about half an hour or an hour, and then I'm finished. The rest of the day I devote to

taking care of my boyfriend, walking the dog, and endless journalism, which I do to make a living. This week, I wrote four articles. I wrote a review of a new novel based on Tintin, for the *New York Times;* I wrote a review of four books, one of them a two-thousand-page book called *The Fifties,* by David Halberstam, part of an omnibus article on the 1950s for *Vogue;* I wrote an article about Genet and Giacometti to be timed with an exhibition at the Tate for the *Evening Standard* in London; and I wrote an article about a lady's house for *House and Garden.* I wrote a new article every day, actually.

TA: It's just one take; you're not doing a lot of revision of the material. No second guesses, no post mortems?

EW: Oh, no. I don't take journalism that seriously, I just sort of do it. Fiction I do take very seriously. Of course, I've been very, very occupied with the Genet book for an endless amount of time, and all the little problems of revision, rights. The notes, which are extensive, took me a year to do, just searching out all the original French sources, which I very carelessly didn't keep track of the first time around. I'm doing an anthology, a Jean Genet reader, for Ecco Press. And I'm translating a long poem by Genet into English; I'm trying to make an English poem out of it. That's taking a lot of time.

TA: What do you imagine Genet's reaction would have been had he lived through the eighties?

EW: He lived until 1986, and he was slightly aware of AIDS as a problem, but it wasn't a major interest of his. He was not very identified with the gay community, though he felt that homosexuality was one of the great jewels in his crown, the other two being thieving and betrayal. Betrayal, thieving, and homosexuality

were his three cardinal virtues. He felt that homosexuality had led him into fascinating experiences, into contacts with people whom he would never have known ordinarily; that it revealed a whole world to him, and taught him a sensibility he thought was crucial to his work. But, despite that, he wasn't very interested in the gay community; firstly, because he only liked to go to bed with straight men, so he didn't know very many gays; secondly, because he didn't like white middle-class people, who were usually the ones most out as gays, at least in France; and thirdly, because the obsessive cause during the late years of his life was the Palestinians. To him, questions like the rights of immigrants, the rights of workers, the rights of Palestinians or the Black Panthers in America, were far more burning issues than homosexuality.

In the recent past, there were these great gay figures like Genet, like Pasolini — and there's still one living, the Spanish novelist Juan Goytisolo — who are remarkable because they stand for a pre-ghetto culture, before homosexuality became such an important culture in and of itself. Though all three of these men were openly gay, they were very interested in issues like the third world, workers' rights; they all had communist or leftist leanings. They felt that they were a kind of conscience for Europe in general, not just for the gay part of Europe. Although they occasionally spoke on gay issues, that was a minor part of their agenda. I think that that has completely vanished, partly the result of the ghettoization of gays *and* the emphasis upon gay culture, and typical of the whole American notion of identity politics. Now black leaders hesitate to speak about Mexican problems, and Chicano leaders hesitate to talk about gay problems, and if they do talk about it, they're usually repulsed by the very community they're addressing.

TA: The focus is extraordinarily narrowed.

EW: Which has hurt the Left. If the Right had tried to think up a way of destroying the power of the Left, they couldn't have come up with a better solution than identity politics. When I attended a gay and lesbian writers' conference here in San Francisco a few years ago, I was talking about something or other and this woman raised her hand and said, "Mr. White, I'm appalled that you haven't yet addressed the question of the lesbian Jew in Mexico," which was what she was, she was a lesbian Jew living in Mexico. And I said, "You're quite right, I haven't hit that subject yet." [Laughs] This proliferation of ghettos obeys a centripetal force at the very moment when the Left in general is in danger of extinction in America.

One of the things I admire about Genet and feel is a lesson for us is his deep concern for oppression, no matter where it was taking place in the world. And his wasn't a bossy or patronizing Sartrean kind of concern. Sartre would sign any kind of manifesto that was handed to him, whether he understood the problem or not. Genet was not a fashionable Left Bank intellectual. Unlike the Left Bank intellectuals in France, who spent five or six days amongst the Palestinians, Genet spent two years with them, living in the camps, learning their language, speaking with the soldiers, immersing himself in their culture over a period of thirteen years before he dared to write about them. This is very different than a superficial espousal of alien causes. Genet had a sense that humanity finally is one large group that suffers and lives together on an increasingly smaller and smaller planet. That's something we're losing and that we need to think about again.

TA: I'm remembering *Funeral Rights,* the deterioration of the young communist Jean Decarnin in his coffin in the refrigerator, and how Genet struggles to keep Jean, or Jean's essence, alive; he

won't even bathe because he has a crab louse on his body that they probably shared. The whole notion of deterioration is invested with incredible nostalgia and passion.

EW: The whole book can be seen as a kind of ritual . . .

TA: To resuscitate, to reanimate him. An incredible act of empathy.

EW: Even to the point of going to bed with the enemy. In other words, whether a militiaman, the French police who were working with the Nazis, or a Nazi killed him — he wasn't sure who killed Jean Decarnin — Genet wants to embrace that person, the murderer. At the beginning of the book, Genet is watching a movie, a newsreel of a young militiaman whom he names in his mind Riton. And he imagines kissing Riton, becoming his lover. He says to Riton, "I give you my Jean!" The idea of embracing the enemy of your lover, the very person who killed your lover, is an idea that would make sense only to somebody living in a traditional, preliterate society, someone who believes in magic. Genet was returning to the very roots of poetry, which is a kind of ritual; he was acting as cannibals do when they eat the noble organs of their enemies in order to steal their virtues. You eat the heart of your enemy in order to get his strength; you eat the sex of your enemy in order to get his virility. Just as cannibals understand that, in the same way Genet understood that you must eat your beloved and you must eat his enemy in order to embody within yourself the whole drama that has befallen you. It's a very passionate and savage kind of art that he practiced.

TA: Except in your recent short stories, those in *The Darker Proof,* I find less of a sense of impending doom in your writing than in,

say, Paul Monette's work, and less of a need to respond to irrevocable change in one's world. With your impending novel, are you moving fully into that territory?

EW: You're absolutely right. It was just a question of time. While I was working on the Genet, I only had time to write occasional short stories, and I found that my short stories were like mini-novels. They were like speeded-up novels or compressed novels rather than traditional short stories, which explore a very small space. Because I'm only really a novelist, I wanted to tell a whole long story, but speeded-up and condensed. These are the stories that I wrote for *Darker Proof,* and which I've continued to write since then. I had one in *Granta* called "Skinned Alive" that was later anthologized in *Men on Men.* Another one, "Reprise," is in a recent number of *Grand Street* magazine. Those stories are probably a foretaste of the kind of thing I hope to do with the novel, although the novel may be a little less good-natured, a little less charming than those stories. One of my fatal gifts as a writer is charm, as it's one of my fatal gifts as a person. And I have found that in the last few years, I've become more severe, less charming as a person, more uncompromising. Perhaps it's Genet's influence — I hope. I think it's a salutary impulse. In my writing now I want to be more uncompromising, to put in things that maybe the reader won't like, and even to be a person whom the reader won't like. I've always been attracted by that possibility. For instance, at the end of *A Boy's Own Story,* which is a novel of great charm, the boy does betray the one person who's been kind to him . . .

TA: A hideous betrayal.

EW: A hideous betrayal.

TA: A very discomforting betrayal for me as a reader.

EW: Good. That's always attracted me as a writer — to lead the reader out onto a limb and then saw it off. It was very necessary to put that incident in there. It was a terrible thing I actually did in real life, betraying that man, and it's always haunted me. All the while I was writing *A Boy's Own Story*, I kept saying to myself, I wonder if I'll have the courage to put in some truth here, I mean, the really horrible truth of what I actually did. I was quite pleased that I managed to do it, although it's a shock for many readers.

TA: I can't point to specific examples, but I found in your work, or perhaps I've read it elsewhere, the notion that sex is worth dying for, sex may in fact be the only thing worth dying for. Perhaps that's an inaccurate reading?

EW: I belonged to a writer's group called the Violet Quill. Of that group, I think five of the original eight members are now dead. One of them, Michael Grumley, was a writer for whom I wrote the introduction to his posthumous novel, and in that introduction I said this writer shows us that sex is sometimes worth dying for; that was the opening line of the introduction. It evoked a lot of anger from some gay readers. I think it was another one of my politically incorrect moves. Two of the many ways in which I'm politically incorrect are that I'm supposed to be a looksist — that is, I talk about people's looks all the time, and that's considered very bad — and I'm supposed to be sex-obsessed, which supposedly objectifies people. Oh, and recently *Ten Percent* (or should we call it *One Percent* after the new census?) accused me of being male-oriented, which I cheerfully admit.

TA: We're coming out of a period during which we've been very much defined by our sexual behavior, as opposed to any other sense of identity.

EW: People who know me always tease me because they say I find everybody handsome. The truth is I'm besotted by male beauty, which I discover in almost every man I see. So, despite the glowing descriptions I give of the gorgeous men in my life, when people know the originals they always laugh at me and say, "But there's nothing attractive about that person. He's perfectly banal. How could you possibly think he's so gorgeous?" My main feeling in sex and in love is gratitude, because I always feel that it's some miraculous thing that somebody's bestowed upon me — a gift, to go to bed with me. In any event, I do think that sex is something worth dying for. I believe what art is primarily about is beauty, and what beauty is about is death.

TA: Has AIDS shifted the focus from sexual behavior toward sexual identity, creating a more cohesive identity for homosexuals?

EW: We used to say, well, we'll call ourselves *gay* because the word *homosexual* has the word *sex* in it, and that's not so good. We don't want to emphasize the sexual part because after all it's mainly an affectional tie, nobody spends that much time actually having sex, and so on. I agree, though, with Felice Picano, who feels there's a dangerous opposite impulse now in younger gay writers to deny sexuality. He calls them writers without dicks, who won't write enough really about sexuality. He feels that, after all, if anybody bothers to become gay, it's usually because they have very strong sexual impulses, and that the gay community still is not a community; it's an extremely diverse collection of people, and one thing they all have in common is this strong sexual urge, so it seems idiotic to deny that. But I do agree with you in general; political activism — AIDS activism — has welded a different kind of community.

TA: Do you see this ultimately as a benefit?

EW: Very mixed. The positive part is there's a cohesive community, which is capable of having a culture and institutions and a sense of continuity and a respectable place in the American political system, and that's all to the good. The negative part is political correctness, which I think is very disagreeable, because it's a way of censoring impulses, passions, half-thoughts — especially dangerous for an artist, since all an artist has to go on is his or her own vision, which is quirky, incorrigible, and irresponsible. There's no way that a sensibility can be disciplined into an uplifting social program. It will always be regressive, infantile, recalcitrant, adversarial, dangerous, subversive.

TA: Or it becomes state art?

EW: Or it becomes Stalinist art. And the Stalinizing aspect of gay society today I find very dangerous and a fatal blow to the arts.

TA: Can you give me specific examples of that?

EW: I saw it, for instance, at Brown, a school that is a bastion of political correctness. Even raising certain questions, for example, I would say to my students: "Do you think gay men are more oppressed in our society than lesbians? It would seem reasonable to think that, because if women are more oppressed than men and if gay men are perceived by society as being more feminine and lesbians are perceived as being more masculine, then you would expect a corresponding upscaling in the status of lesbians and downscaling for gay men." I added, "Now I'm sure there are a lot of ways in which this is not true; this is really a question, it's not an answer. I have nothing in the back of my mind. I just want to know what you all think." And I'd have students, men and women, who would get up and leave in a rage, slamming the door behind them, and denounce me. So that when a poet came to the campus and denounced me, there was a standing ovation from

my students, who sheepishly came to me the next day and explained what had happened. I found it all discouraging. It made me feel kind of grumpy, because I felt that the primary goal of education was to develop skepticism.

TA: Radical skepticism. I cultivate that in dealing with my health; it's what Michael Callen talks about in *Surviving AIDS*. I think it's essential for navigating the difficulties of looking at this possible alternative treatment or that allopathic treatment, and you're applying it to art.

EW: That's right, or to intellectual life in general. A student who has received a successful education has successively embraced Catholicism, existentialism, communism, many other philosophies, and come out doubting them all. That student has learned to think for himself. I feel political correctness is just another orthodoxy that jeopardizes this kind of radical skepticism, which to me is the sign of a civilized person.

TA: Twelve years into the epidemic, which questions haven't been brought up, what remains to be said?

EW: I think part of what remains to be said is to give a sense of how there's a constant, which is the threat of AIDS or the reality of AIDS, and then there's a varying response to it, whether it's from the medical community or from oneself emotionally. One's always trying to come up with an answer or a solution to what is basically, up to now at least, an insoluble problem. We're trying to imagine changing the inevitable. I have been with my lover to so many doctors, and we've pursued so many "miraculous" cures that have then fallen through. We've had so many hopes. A

French friend called me up and said, "There's a doctor in Montpellier who has just cured a friend of mine. You must go see him." We spent quite a bit of money getting a series of round-trip plane tickets from Paris to Montpellier, and the doctor finally said to him, "I can cure you of your disease — your homosexuality, I mean — through acupuncture." Then he said, "White people are superior to blacks and yellows, and the whole race is degenerating. Eventually we'll become green, which is what happened to the dinosaurs and that's why they became extinct." We met with a Chinese doctor in the middle of the night who promised to give us miraculous injections. Then he had to leave us because he was running off to give some countess's horses the *same* injection. [Laughs] This person was presented to us by a research biologist at one of the major laboratories. The amount of charlatanism that has been solicited by this malady is extraordinary.

TA: Perhaps on both sides, on the side of traditional medicine as well.

EW: Oh, yes. Oh, of course. Not just the alternative therapies — no, both. And in a way, with traditional medicine it's more dangerous, because it's harder to call into question an orthodoxy. Even if a doctor suspects that another doctor is full of shit, he won't say it. They won't testify against each other in court or anything.

TA: Some of us call them the "medical Mafia."

EW: The "medical Mafia" needs to be written about. There are also philosophical things that need to be written about, like an entirely altered sense of values and of time. Our way of experiencing time is different from the way ordinary people experience

it. Most people have a scenario of their life that involves a begin-
ning, middle, and end, and they have a chart in the back of their
mind that takes them up to age eighty. If you are HIV-positive,
you have a very different chart in your mind.

Somebody once said no one could go on living if he knew
the moment of his death. We *do* know the moment of our death,
but we go on living anyway. That's another thing that would be
worth writing about: we're always being told how courageous we
are, yet we have no choice. We couldn't act otherwise. We're forced
to live through all these things. Circumstances have thrust them
upon us, and we must be courageous. We do a very good job of
it, but it's not exactly the same as courage, which is usually some-
thing voluntary, something chosen that you could have run away
from, which would have been cowardice. We can't run away from
it — it's there.

TA: Well, events tend to be thrust upon people. I'm thinking of
war for instance, of the French collaborators versus the French
resistance. We have to be accountable for our behavior when cir-
cumstances are thrust upon us.

TA: To what do you attribute your health? You seem incredibly
vibrant, healthy, and strong.

EW: I don't know. I just don't know. I try not to psychologize or
moralize it, because I think the opposite side of that would be
blaming the victim. If there's some marvelous thing that I'm do-
ing, then there's some deplorable things that other people who
are getting sick are doing, and I don't like that idea. I know plenty
of people who have great attitudes and perfect mental health and
who are more moral and more alert and more disciplined than

me — who have died. So, I want neither to blame the victim nor to praise the survivor. It could even turn out to be something paradoxical. Maybe it'll turn out that I had a more sluggish and not particularly efficient immunity system, and that's why I've lived as long as I have, that my system didn't respond in an alert way.

TA: Some people believe that AIDS, in part, involves a hyperactivated, or misfiring, immune system, so that's a possibility.

EW: Everyone has his superstitions. Mine are that I'm fat, which protects me, that I sleep a lot, which protects me, and that I'm very calm. Of course, my other superstition is that I have a mission in life — I feel that I must write. First I had to finish the Genet book, and now I have to finish this novel. I think when I finish that, then I'll die. Maybe it's one reason I have trouble writing it, because I feel it's almost like a curse. It's like some fairy tale: when the princess finally finishes weaving the cloth, then she must die.

TA: Some survivors speak of their sense of guilt for continuing while others die. Do you feel guilt associated with surviving AIDS?

EW: No, I don't have survivor guilt. I asked a psychiatrist friend of mine why, and he said, "It's because you're positive." He said negative people who survive have survivor guilt, but very few people who are positive do, because they know that they haven't really survived; it may strike them at any moment.

TA: We've all imagined the magic bullet, the magic cure; some talk of a vaccine. Imagine, tomorrow AIDS vanishes. What sort of changes would you envision?

EW: There *could* be a certain disappointment among even the

people who are HIV-positive. In other words, we have now chosen this alternative. We see this as an inevitable process. Many of us have given up our careers; I recently gave up my professorship in order to concentrate on my writing. If suddenly this awkward thing were to happen, that I was now going to go on to live to be eighty, I would find myself without a pension and without a future in the ordinary bourgeois sense of that word. Many people have so accepted the Holocaust mentality, and have learned to live with it and girded their loins, that if suddenly there were a cure, it would take several years to reorient a life toward positive goals. Mind you, I'm only talking about a very special situation. Basically, the response throughout the world would be one of great joy among the victims of this disease. Nevertheless, speaking privately amongst ourselves about the way artists in particular would respond, we must admit AIDS has become our great subject. It's become something that we think about day and night. And suddenly we would lose this lens through which to perceive our experience. It would require a radical reorientation.

TA: What interests you most about this disease?

EW: There are very interesting things — relationships among siblings, for instance, when there's one member of the family who has AIDS and the others are normal siblings, either gay or straight. I have a lesbian sister who's a therapist who works with many people who have AIDS. She works with gay and lesbian people, so she's up to her eyeballs in the whole disease. But I find her sympathy alarming; it's as though she's longing for me to get ill and wants to rush to my side and take care of me. There's a part of me that's rather cold about all that, that doesn't want to be taken care of by, or reabsorbed into, the family — not even by a very understanding and liberal and lesbian member of that family,

who's the only remaining member of my family alive.

TA: I have the same sense. When I was going through chemo-therapy, many people wanted more emotional contact with me, so that they could go through the process of leaving me. However, I was focused only on survival; I understood afterwards that I did not give them any satisfaction; I gave them no release.

EW: They want a star turn, for themselves and for you. I was interviewed by a woman on the BBC about AIDS and art, and finally at the end of it all, I could see she was quite exasperated by me. She said, "Well, you're awfully calm and cool and collected. Isn't there anything that can break through that veneer of yours?" I said, "It's not a veneer. It's a genuine equilibrium I've achieved. I'm not going to weep for you on television so you can attract more spectators."

TA: A similar thing happened to me on a network television show. I was talking about the work I do with other people who have cancer — this was about three years ago — and I took their film crew to Healing Alternative Buyer's Center in San Francisco, to do some research and to show them that people with AIDS were doing research on survival. Eventually, they took me to a room, put a spotlight over my head, and began this sort of chant: "Your friends have died, how does it feel to know you're going to die?" I wasn't going to break for them, I didn't feel like it. They were frustrated that they weren't getting another victim on the screen, and they seemed to want one badly — that was their agenda. It was bizarre. I suddenly understood that I was really just an unpaid character actor in a cheap melodrama that passes for news and I wasn't acting as they wanted.

EW: Straight people have decided that we are victims, and they

want us to behave accordingly. When we don't, when we write eight-hundred-page books about Jean Genet or we manage to go on living after our fatal diseases or we publish our poems — and they're not all about AIDS — or we have lives or we receive medals or we do things like other people, they hate that. If society is suddenly so open and compassionate to us, it's because we are back in the position of being sick, which is what they wanted from the very beginning. I remember in the sixties a girl who worked with me would plead with me to talk about my homosexuality, and when I did she would get this sort of Madonna look of compassion on her face. I finally realized there was something that made me intensely uncomfortable about these conversations. Although I enjoyed her compassion and her interest, finally I felt that compassion wasn't quite the response I wanted to what was simply another way of living. Having a sex life and having lovers and having adventures didn't require compassion from anyone. In the same way I think we're back now in that position of being victims who require compassion from everybody, and it's one more way of assimilating us, even dismissing, certainly *consuming*, us. It's very interesting — when Genet was writing his novels, there were only three possible ways for homosexuals to think of their homosexuality: either as a sin or as a crime or as a sickness. Most middle-class writers chose the sickness model, because it required compassion from the reader. But Genet saw the trap in that and chose the other two: sin and crime. It's a much stronger position. Once you're willing to accept the idea that you'll be alienated from society by making that choice, you're in a stronger position.

TA: You're freed.

EW: You're freed.

THE SECOND MONTH OF MOURNING

TONY KUSHNER

I

I had to, I felt it
necessary to, meaning no
disrespect out of love only
out of love
only I felt it needed
to be done that I had to
necessary this remove this
stone, this barring rock.

Boulder heavy dispatching the duty of
obstructing I had to
for the free flow

for the free flow again
of the air.

Naught else, otherwise.

2

You, or
the loss of you.

You, or
the loss of you.

Now what

Now what kind of a choice
you
or the loss of you
is
that?

Now you, or
rather, the loss of you
is all the you there is,
and so,
now,
you *are* the loss of you.

Or, rather . . .

No way to say this I can't
no way to say
no way

3

Human beings are
human beings are funny animals when
confronted with the loss of
with loss, they
make sounds of distress
they make sounds of distress comical

when viewed
objectively.
Catalogue:

4

Transparent liquid seepage
from mucous membrane,
duct, gland.
General leaking from facial holes.
Dissolved saline, saltwater,
a bathing of the epiduris with
fever-water warmed in fur-lined caves,
cavities deep within
the cranium tucked
up near the blood-fueled furnace,
the blood-driven engine of grief,
the organ of mourning,
the body part
whose job it is
to order up, to distill
in the visceral alembic the biochemical
perfumes of what it is
to grieve.

To grieve the loss of . . .

5

And that's why
it's all grey matter upstairs where
the Court of Mourning is held,

its courtiers ashen in mourning-wear grey,
and the lights along the passageways
are dim or all
extinguished.

And every door is carpeted and locked.

And every port and portal, blocked.

And time
is held immobile in the uncirculating air.
It's an airless old archive upstairs where
grey documents are stored important to
an obscure discipline
whose disciples' numbers dwindle:
now less-by-one, by you.

By the subtraction, or
rather by the loss of . . .

6

. . . The hooting noises and the drowning sounds,
the ferocious sucking in of air against
the inner onrush of some acidic fluid filling up
the passageways water ballooning the lungs
the submarined larynx going
glub
glub
glub
the

strangulated hee-hee-hee bursting into
the mighty BAWL, or
the keen, the trill, the bark,
the wobble, the silly fluting cry,
signaling distress to indifference,
calling loss to absence,
to you or rather
to the loss of you.

Silent, too. How they cry.
Open-mouthed,
contorted,
eyes screwed shut,
hiss of air escaping as whistle
the corkscrewed, shuttered-up throat;
or no hiss at all, no air,
purpura, black spots,
the extravasation of blood,
asphyxiation . . . and their little hands
make little . . . (gestures)
in the cold air, little . . . (gestures)
their little hands reach up
toward nothing there in the dis-spirited air
and they go . . . (gestures)
a little.

It's a gesture
it's a gesture they learned
from the dying.

7

If the stone

If the rock cannot be moved it can at least
be described.

Soft, grey, spherical, a dead little planet.
Dusty, so it must be
old. It dropped
from the moon.

It should have landed
sploosh into some choppy lead-black icy
deep January sea somewhere far
in the Northern Hemisphere far
from land but instead
the damned thing's dropped
with a placid, almost genial
absolute immobility
an incontrovertible here–ness
right here entirely obstructing
my view of . . .
my view of . . .
Well whatever's on the other side.
I don't
I don't remember what was there.
Who or what
there was to see before
the replacement of that with this
blank, thought-stopping rockface filling
the field of sight.

I don't remember what.

Oh yes. Now. You, or
the loss of you. Now,
I remember.

8

Perhaps patience and time will trace
a transubstantial evolving: a change
of no-hope mineral permanence into
something if not green then at least
vegetable, which withers, or perhaps
animal, which dies:
rock acquiring a kind of lumbering organicity,
bursitic, deliberate,
elephantine, ox-ponderous,
an obedient beast
of a nearly insupportable
burden,
some kind of gentle, domesticated animal that,
when prodded, lopes, and
moos

and waves its head like a conductor's hand
in slow graceful arcs,
down beat, from side to side
metronome mapping of a largo-land,
a broad terrain where activity
tends toward halting, rocks
toward cessation
between breath and breath.

9

In August
I saw the deathroom angels at their work,
intent over your body, dismantling.
With their tin pails and brushes,
rusty tools,
with creaking joists and pulleys,
with thick braided rope, in the silent hum
of their serious industry,
bathed in the shadowless chemical light of extraction
the deathroom angels plied their trade,
standing like tombstones, in pools of tears.

And for this once they were efficient,
and though hardly merciful they were
mercifully brief.

Watching them
in the industrial cold
in the death-bed room:
their grey intelligent faces,
their nimble, practiced fingers,
their terrible strong hands,
the stained canvas of their stiff grey gowns,
bowed under in the vascular pulse of the fluorescent lamps,
their song . . .
gleaned from the hum of their serious industry:
Intent over you . . .

Oh but stay.
Oh but stay.

Oh but stay . . . away from that.
Oh but stay away from
that.
Draw down the heavy shade
to shield that scene.

10

A scaly talon sinks its
sixteenpenny galvanized iron
nails into the soft and bloody
tissue of my all-but-unresisting heart.
Pain feels like a blow
at first — Whose fist is it —
till nerves vivify and start to scream to
Life.
Eventually,
an accommodation of sorts.
Not
now.

11

A rose for the rose quarter.
You were desperate
to say something or write
something and you went . . . (*gestures*)
but when finally with pen in hand you
or the pain or the fear or the medication wrote
only poetry:

As the deathroom angels sang all about you,
plying their trade, those grim professionals:

You wrote:
A rose for the rose quarter
and said:
It would be nice
to be able to say
enough.

And anyone watching would have to agree.

And on the sleepless night
after the service
when a semitropical cloudburst broke
drowning the impossible day,

I saw you
atop that bare little hill,
hospital gown for a winding sheet,
knees drawn up,
arms on knees, head
in hands and the rain
beat down and you,
confused,
asked this question:
"What is this?
What's this?"
and I still have no way
no way to answer you, or
rather, to answer
the loss of you.

12

Enough.

No way to end this,
no way to make an end.

You, or
the loss of you.

Now what kind of a choice
is that?

You, or
the loss of you.

And what if the rock can't be budged?
And what if never again the free flow of the air?

And now you are the loss of you.

In a cold dead August down in the infernal south,
we blinked dry bloody eyes against
the cinder-wind,
watching
while fire ants threaded tunnels,
red veins through the earth of your grave.

IT WAS DIFFICULT to arrange an interview with Marlon Riggs. The Emmy Award-winning filmmaker (of *Ethnic Notions*) had been critically ill for months. We finally did meet in Mr. Riggs's home in Oakland, amidst his preparations for another sequence of filming on his feature-length documentary *Black Is . . . Black Ain't*. Much of the final text for this film was developed one night in his hospital room. "It was as if the film were rolling before me," he said, "and I was just transcribing; I almost couldn't keep up."

At first glance, Marlon, always gentle, very dark (dressed in blue denim and a blue shirt), looked well, but when he sat down I noticed the thinness of his legs. A friend hovered, wanting to take a photograph:

"Of what? My skinny butt?"

"You don't look too bad. Your face is full."

"Then do a close-up."

Outside, near a date palm, the two posed, and I shot two photos.

"Would one of you please get me some of those yellow fruit?"

Being the taller, I complied.

"You're going to get them . . ."

I stood on tiptoe. Marlon pulled at the branch, and I plucked off, one by one, these tiny, smooth, yellow fruits.

"Are these loquats?" I asked.

"Something from nature," Marlon said, in his rumbling priestly voice. "Plums. I just call them plums."

We met once again at his Berkeley office to finish our work. Marlon Riggs's struggle to survive the many deprivations of his illness, and his uncovering of a clear space in which to create, embody much of the difficult subject matter of the interview that follows.

THOMAS AVENA: In the past few months, you have faced enormous difficulty with your health. I'm wondering if this experience is entirely negative, or whether you have found any value in it?

MARLON RIGGS: Audre Lorde writes about pain in *The Cancer Journals*. I didn't read the book until fairly late, that is, after my hospitalization. A friend had brought it to me, but I kept it at a distance because I thought it was going to be morbid. Even though I knew she was a survivor at the time of the writing, still I didn't see much to be gained from reading diary notes of experiencing breast cancer. It was "a woman's disease," so it seemed it wasn't that urgent for me to find out about her experience. But then later, after I left the hospital, I read the journals and was struck by how she described pain, which is the way I experienced it. It was all-consuming. The agony of being weak, of vomiting, of nausea, of fever, of blood coming out of all of my orifices, of being disoriented, drugged, having nightmarish dreams because of the drugs. It was a feeling of utter loss of control. And I can't say that there was much valuable in those experiences and feelings as such. But what was helpful — more than that, what was

even at times virtuous — was what I discovered about myself, which was the capacity to transcend each crisis: to be mired within pain and yet at the same time to pass through it, so that there was something else that endured beyond pain, and beyond a sense of total loss, which of course was not total, because I still endured. I was still alive.

TA: Were you focusing on some particular goal, beyond pain, or was basic survival the only thing you could experience?

MR: I wasn't thinking about art; I was driven down too far into the basic consciousness of just staying alive.

TA: Moment-to-moment survival?

MR: Breathing, at times. I would have difficulty breathing.

TA: Second-to-second survival.

MR: It wasn't as if I could think about creative issues, when my very life was at stake. I went from second to second, step by step, and I didn't necessarily envision a light at the end of the tunnel. I didn't think of light or any of those metaphors. I concentrated on my heartbeat. I would simply rest there, with the pulse, and both try to maintain and sustain it, but at the same time, flow with it.

TA: I had a similar experience of flowing during some of my chemotherapy. Did you find that your body had become foreign to you — that you had to encounter it again, but differently?

MR: Oh, definitely. Still now — when I walk, when I breathe, when I sleep, when I get up in the morning, when I eat — everything that was routine and trivial in my life in terms of my body and how I moved is changed. Now I have to encounter this new

entity, and I have to work with it, very consciously work with it, to make it work, to make myself work. But there was a period when I couldn't move. Especially when you still possess a cognitive mind, you're very conscious of the things around you, you're thinking clearly — you say to yourself, I want to move my leg over here, or I'm tired of this position that I've been lying in for several hours, I want to move my head or neck — and you issue out those little internal commands, and nothing happens. You remain inert. And that's scary, because for so long you've taken for granted the ability to alter your circumstances, to manipulate your person without even thinking about it. Suddenly, you're reduced again to the point of inertia, and acute self-consciousness.

TA: Mentally, you were unimpaired during this process?

MR: I was alert for most of the process of being sick; however, later when I talked with my family, with my lover, Jack, and my mother, I discovered there were blackout periods in which I remember nothing. And in many ways I'm glad I don't, after they told me what I was going through.

TA: How did the way you thought of your body change? And did you see these changes as an almost willful separation from the mind's control?

MR: It had been changing before I got really sick, that is, before I was admitted into the hospital. I was going downhill, and I could see it in my body more than anything — more than T cells, more than lab results. I could see, physically, that I was losing something, that something of my spirit was starting to diminish, was losing weight. I'd been fairly muscular because I went to the gym three, four times a week. I'd look in the mirror and my arms were starting to look kind of puny; my buttocks were starting to

look slack. I was losing the definition in my torso that I'd had for years. I attributed it for a while to not being as disciplined about working out and going to the gym. But even when I did work out, I still wasn't returning to that state of stamina that I'd once enjoyed.

TA: Which you had fought for?

MR: Exactly. Striven for — it had become part of my self-image and the source of my self-esteem.

TA: That is in some respects a homosexual ideal: to want to be as well-proportioned, as beautiful, as strong as possible.

MR: To be Mandingo — if you're African American — or Adonis if you're white, I guess. That was my ambition, and I achieved it. Then suddenly, against my will, I was starting to lose it all. I was starting to get very tired. And I was having problems keeping down my food. So before I really became ill, something was happening to my body to let me know that it was changing on me, and I felt that it was betraying me. I saw my body as this separate entity that now could have a will of its own; it wasn't subject to my disciplining and manipulation. And I became estranged from my body in a way. It was as if I were watching it go downhill; even though I wanted to do something about it, I couldn't. There was a cool kind of distance and thinking, now it's arrived — the virus.

TA: You're home now from the hospital — your body, in many ways, no longer subject to your control. Have you made peace with what is happening, or do you continue to fight it, to hate it?

MR: It's a process now. I'm learning again to be at home with this body, as it's changing and has changed. And that's taken time — learning to walk again, and learning to walk in a way that's very different from the way I walked before I became ill; learning

to what degree I can do things during the day without overstressing myself. I had far more energy before; I could go far longer without getting tired; I could take a ten-minute nap and be refreshed for another five, six hours — no more. I've had to learn not to be frustrated with the changes that have occurred, to again flow with my body and its needs. And when I feel too tired, to rest; when I have energy, to do what I want.

TA: Since you now have less energy, has your artistic focus narrowed?

MR: Being fatigued most of the time has intensified the creative aspect of my life. Before, the creative energy was diffuse. I mean diffuse during the day, as well as diffuse in my life in general. Now I know, for instance, when I get up at five in the morning I will have three or four hours of intense energy, and I can work during that time. And I will be extremely focused. It's not as if I have to draw myself back to the computer, back to the script, to figure out where next to go. I didn't have that focus before.

TA: And that time is sacrosanct, I would imagine.

MR: Oh, it is, it is, and it's wonderful because it's sacred, in the sense of being pure. And very innocent in a way, in that I'm not corrupted by exterior thoughts or worries or anxieties. There's nothing but me and the work — a clean, very linear connection between the two of us.

TA: It sounds like that would be an almost blessed state, for an artist, coming out of these nightmarish months.

MR: Well, it's been one of the blessings of this disease, if there are any. After the devastation of illness and the sense that I had no control and was losing it, to arrive at a point where I see something emerging from nothingness, from a void, which is the work

that I'm creating, and that I have a hand in it — it is in some ways godlike. Audre Lorde says that one gains strength from having faced death and not having been consumed by it. Then you've conquered the ultimate fear.

TA: Do we conquer it?

MR: I don't think we conquer it, except on a very tentative basis, in the sense that we constantly have to confront death while we're alive, and move through it, around it, over it. But I think we conquer it in the sense of not being paralyzed by death, as I think so many people are — emotionally, creatively, psychologically — paralyzed, so that all one can do is obsess about the end.

TA: I think people fear serious illness so much that they're paralyzed before they begin the sort of process you're describing. And perhaps once they're there, they find that they can actually go through it without being consumed.

MR: For most of us, I don't think we can overstate the importance of family and friends in bringing us through.

TA: You've had a lot of support?

MR: Oh, yes. I couldn't have made it, with as much thinking as I've done about death and disease, as strong as I think my soul and spirit are, I could not have made it without my mother, my lover, my friends holding my hand. The cards coming in from everywhere you can imagine in the country, and outside the country. The loving support of people who didn't even know me and had heard that I was sick — I couldn't have made it without them.

TA: Were there specific points in your recovery when you felt support from others was especially important?

MR: I remember lying in the hospital bed and feeling so very low,

that it wasn't worth it to continue, that life was meaningless. And I wanted death to come because of all the pain. At a certain point in my hospitalization, I heard within my head the voice of Harriet Tubman, who said to me: "You can cross this river. You can overcome your fear of death. You can get to the other side." It was such a powerful, wonderful moment, because I knew I would make it; that I would live.

TA: In an earlier interview, you recalled your mother's reaction to seeing *Tongues Untied* at the Berlin Film Festival, when she said, "I didn't know you had experienced such pain," referring not to physical pain, but to the emotional pain of being black and gay. Has completing *Tongues Untied* enabled you to leave some of that pain behind? Do we ever fully resolve these issues, and can they be resolved through art?

MR: *Tongues,* for me, was a catharsis. It was a release of a lot of decades-old, pent-up emotion, rage, guilt, feelings of impotence in the face of some of my experiences as a youth. So, in that sense, the documentary was therapy for me. It allowed me to move past all of those things that were bottled up inside me, that were acting as barriers to my own internal growth, as well as to any kind of interpersonal relations with my family, with friends, and especially with other black people. I could finally let go. And I could also finally express my rage about being treated as a pariah by the black community when I was younger, as my differences became more and more marked. It was a wonderful discovery to find out that my work had actually benefited me. Before, my work had been for the public — to teach, to instruct, to change, to enlighten, to entertain. But it hadn't been for me.

TA: It was a personal exorcism, in some respects, of demons?

MR: Oh, it was definitely that.

TA: You named the demons in that film, in a sense, and brought them to life.

MR: Exactly. And I named the angels of my life too, which is as important. Angels that included white people . . . When I was in the eighth grade, they desegregated Hebzibah Junior High. One time, at recess, this ugly pockmarked white guy came up to me and started calling me all kinds of names: "Coon. I hear your mother's a coon. You're just a nigger. Motherfucking coon. Darkie." Another white student, Cal Ball, intervened and said, "Leave him alone. He hasn't done anything to you. Leave him alone." And then the redneck stopped and walked away. I'd been placed in the 8A class, the top section, because of my grades; there was only one other black student there, a girl who never said a word. I didn't have any blacks in the room to relate to, and so I related to the whites who accepted me — and I remember a group of black girls out on the school grounds passing by and saying to me, "Uncle Tom." *I didn't even know what "Uncle Tom" meant.* I was caught between these two worlds where the whites hated me and the blacks disparaged me. It was so painful.

Later, I went to Harvard, and Harvard has a huge cafeteria for freshmen; I remember walking into the dining room and seeing all of the black students sitting together, and for the most part, all of the white students sitting together by themselves. I walked through the dining room wondering, Where am I going to sit? Who am I going to sit with? I was used to an integrated environment during my living in Germany — my father was in the military at that time — black and white and Asian all got along there because we were Americans, and that bound us. And here, suddenly to be confronted with the choice of black or white — it

was so difficult for me. I didn't know what to do. I just continued walking and found a place and sat alone. And that was my life in terms of the choice of where to sit for most of the four years I was there — the blacks over there, the whites over here.

TA: A chanted refrain in *Tongues Untied* is "Black men loving black men is the radical act," yet your primary lover is a white man. You've said recently that exploring interracial love would have complicated the film. Would you elaborate?

MR: Well, it complicates the notions of love that we hold dear. Still, I didn't want people to believe that black men loving black men was a total kind of love that excluded any other, that it was a monolithic love. And I didn't want people to think of that love solely in sexual-romantic terms. I still think that for African American men, our learning to love ourselves and each other would be a paramount act of revolutionary sentiment and behavior, because the opposite so much prevails now. But by acknowledging the importance and place of interracial love, one also says that there are other kinds of loves that are part of our universe.

TA: The most moving images — startling, really — to come out of this film are those you created of black men loving black men. We never see that; instead, all we see in the news, on television and film, are images of killing; situations of profound disrespect. Do you feel that visually framing those images, the physical and emotional love between black men, frightens people in power?

MR: Frightens people not in power too. I think people are often frightened of difference, and of difference that requires that they rethink their own beliefs, their own premises, their own sense of self, culture and history, and sense of belonging. When you pre-

sent anything on that level of contention, you encounter resistance. And the resistance is expressed the more people feel that the difference undermines who they are and what they stand for.

TA: What do you feel is the fundamental reason for people not celebrating difference, for being afraid of it, for denying it?

MR: We live in a culture in which difference has often been marginalized, or erased. It's only I would say in the past twenty years or so that those who were different, who were "other" in society began to celebrate themselves, and then to demand and acknowledge some sense of, if not celebration, then recognition from the mainstream. There's no way you can talk about America without talking about black culture, whether it's music, religion, or politics. In that sense, what had been obscure or invisible previously in history has now started to emerge more fully, and you see how the emergence of those things that were considered unworthy of being mentioned, or mentioned too loud, reshaped the vast stream of what we call American culture.

TA: When confronted with the serious possibility of death, do issues of race sharpen or diminish for you?

MR: I have to say that my sense of race was further underscored by the experience of coming close to death. But it's not race exclusively. My sense of race, my sense of gender, as well as my sense of being part of a particular location and historical time, all of those things are sharpened or drawn into clearer focus by the possibility of losing life. My sense of being gay, and the mechanisms of humor that at times sustain us through hardship were helpful. My sense of blackness and the music from ages past that has been part of the legacy of African Americans, a legacy of survival and endurance, and the use of culture, music in this in-

stance, to forge a path to the future, to survival — that comes through.

When I consult with spirit, I hear the voices of the ancestral dead, particularly Harriet Tubman's voice. I talk with her as she walks by my side with her cane and her hair wrapped up . . . I look at the whole history of African Americans, and what I see is survival and immense creativity in living our lives — a struggling for justice and equity within society. I talk with Bayard Rustin; I have conversations with James Baldwin. I'm inspired and animated by Fannie Lou Hamer. I have my mother, who's the most wonderful woman in the world, to affirm my life and to have faith that I too can overcome the fear of death. All of these people are a blessing to me, because we love each other without question.

I sing songs in my head or out loud to help me through the night and the hardships of the day. And what comes to the fore is my sense of being a man, a man who's exploring the complexities of his identity, not someone who's adopted some monolithic model of masculinity, but someone who's been able to integrate that which was different — exotic, perhaps, unconventional — into his personality.

TA: One's identities are thrown into relief, in some respects?

MR: And it's not as if all of them are thrown into relief at the same precise time, but within the entire experience, each of them emerges at some point, and helps one endure.

TA: What is specific to AIDS as a disease that makes it so very frightening? And how does this involve the African American's relationship to the body?

MR: Black bodies in this society have for centuries been a subject of Western repulsion, obsession, and revulsion. The black com-

munity has internalized that. So when confronted with a disease — AIDS — it immediately signifies, in the black community's eyes, death, and particularly death as punishment for who we are, African Americans, and how we see our bodies. Our bodies exist in this country and in Western society as texts in which has been inscribed the idea that black bodies are dangerous.

TA: And AIDS also typifies what is dangerous — even sinister?

MR: Yes. So AIDS in the black community signifies a fear of being judged by the rest of society as yet another defect of blackness. And black people, especially, remain silent because they fear the association with homosexuality, and the contamination that we represent to the rest of society . . . From the first contact of Western civilization with Africa, black men and black women were defined as savage, libidinous, lacking in religion, pagan — evil even, especially in terms of sexuality. Black men were seen by the Western colonialists as being particularly well endowed and given to lusts, even with animals. Black women, the same: spare in their clothing, ready to yield their bodies, and willing to consort with beasts. America inherited that legacy. When black men are viewed in this culture — when we emerge in some way in the public, general eye — what America sees is a brute. It's particulary so for men — savages who are unable to control their lustful desires for white women; the myth that black men are rapists, always seeking some white woman as a victim. For centuries, the image of, and the attitude toward, black men in Western society has been that we are oversexed.

TA: And between each other: do black men fear physical and emotional contact with other black men? Is that fear, perhaps, not intrinsic to African values?

MR: Most black men in America have internalized the self-hatred and the sense that we are what white America thinks of us and sees us as. Most black men are proud in some ways of their sexual prowess, of the dimensions of their dicks. Most black men fear that any kind of acknowledgment of affection between two black men or more is a sign of weakness, is a sign of effeminacy, of homosexuality. This large area of experience — that is, of our sexuality — doesn't get talked about. Black men don't touch, don't speak to each other about their sexualities. And you see it, especially, in much of the rap music today, in which black men glorify their penises, as if their lives are defined in being able to attract and exploit black women, as well as other black men. It's a history of silence, of neglect of the dimensions of our sexuality as black men. We pay a price for what the larger society has for the long part believed about us — internalized self-hatred.

TA: As an African American man, what is your relationship to the community of AIDS?

MR: I often think that my relationship to the community of AIDS is amorphous. It exists, but it's not as if I privilege AIDS in a way that foregrounds it above everything else in my life, or in the life of the communities that I feel attached to. In my work, for instance, I address AIDS, but it becomes part of a larger mosaic, and that mosaic addresses the other aspects of being alive in our society. Some people I know feel that I don't give enough weight to AIDS, because it has become this all-consuming experience for them. Whereas others do see a kind of balance of many different kinds of experiences and ideas and issues.

TA: I think it's critically important to maintain what you are calling balance. When did you first learn you were HIV-positive?

MR: December 1988, when I experienced kidney failure.

TA: Was it unexpected?

MR: Yes. I thought I might be positive, but it was more that I wanted to convince myself of a political identification with some of my friends. I thought, I didn't do any of the stuff that they did, I'm really at the least risk, but I should think of myself as positive so I can be supportive and be at one with those who are going through this epidemic and experiencing it in a firsthand way. Yet when they let me know in Germany at the hospital that I was positive, I was really surprised.

TA: Had you been given a normal life span after '88, had you not tested seropositive, would you have proceeded differently in your art? How would it have evolved differently?

MR: I've often thought that I wouldn't be so obsessive about my work and that I would take time to enjoy other aspects of life — companionship with my lover, time with my family, more time reading, being with friends, hanging out in the park. They're the things that define life, I would like to believe, when it's good. I would be able to enjoy more. Knowing that I was positive accelerated the need to create now, to push everything else aside. The possibility of not being positive, not having AIDS, would mean that I could finally slow down. I would probably do less work in the same time — but that would be okay. I would be like everybody else. I wouldn't have to be this person on this treadmill that keeps increasing in speed.

TA: It's paradoxical in some ways: committed artists have a goal, and perhaps they can somehow lengthen their lives during critical illness to reach it, to fulfill the needs of their art. On the other

hand, the pace can be murderous. I'm wondering if you could explore just what is gained, what is lost?

MR: Like most things in life, the experience of AIDS is wrapped up in contradiction — I think particularly for those of us who are artists, who are engaged in creative labor. In one sense, to live with this disease, to actually *live* and not simply survive it, means that you're constantly engaged in some way with it. And it may not be AIDS directly that you're engaged with, but with all of the different struggles that are part of living, and being human. That struggle can produce work that is of meaning to you as well as to others. AIDS quickens that sense of needing to and actually being able to draw forth from one's spirit that work which will have resonance for other people. At the same time, the more the quickening takes place, the more your spirit is drained of what it requires in order to endure. So I find that both you're living and you're dying, and there's nothing really unusual about that, except that we are now experiencing it in the real concrete sense.

TA: Both are enacted simultaneously: one's body and one's consciousness burn brightly in order to produce this flame, and it will be self-canceling at some point.

MR: Exactly. We'll experience our own personal novas.

TA: And what does the knowledge of that mean to you?

MR: I think it's very simplistic on a certain level: that living and dying is simultaneous; that they depend upon one another for existence. That we are simultaneously diminished by what enlarges us in life — a seeming contradiction that defines the fundamental meaning of existence.

IN THE POST OFFICE

Saw someone yesterday looked like you did,
Being short with long blond hair, a sturdy kid
Ahead of me in line. I gazed and gazed
At his good back, feeling again, amazed,
That almost envious sexual tension which
Rubbing at made the greater, like an itch,
An itch to steal or otherwise possess
The brilliant restive charm, the boyishness
That half aware — and not aware enough —
Of what it did, eluded to hold off
The very push of interest it begot,
As if you'd been a tease, though you were not.
I hadn't felt it roused, to tell the truth,
In several years, that old man's greed for youth,
Like Pelias's that boiled him to a soup,
Not since I'd had the sense to cover up
My own particular seething can of worms,
And settle for a friendship on your terms.

Meanwhile I had to look: his errand done,
Without a glance at me or anyone,
The kid unlocked his bicycle outside,
Shrugging a backpack on. I watched him ride
Down 18th Street, rising above the saddle

For the long plunge he made with every pedal,
Expending far more energy than needed.
If only I could do whatever he did,
With him or as a part of him, if I
Could creep into his armpit like a fly,
Or like a crab cling to his golden crotch,
Instead of having to stand back and watch.
Oh complicated fantasy of intrusion
On that young sweaty body. My confusion
Led me at length to recollections of
Another's envy and his confused love.

That Fall after you died I went again
To where I had visited you in your pain
But this time for your — friend, roommate, or wooer?
I seek a neutral term where I'm unsure.
He lay there now. Figuring she knew best,
I came by at his mother's phoned request
To pick up one of your remembrances,
A piece of stained-glass you had made, now his,
I did not even remember, far less want.
To him I felt, likewise, indifferent.

"You can come in now," said the friend-as-nurse.
I did, and found him altered for the worse.
But when he saw me sitting by his bed,
He would not speak, and turned away his head.
I had not known he hated me until
He hated me this much, hated me still.
I thought that we had shared you more or less,
As if we shared what no one might possess,
Since in a net we sought to hold the wind.

There he lay on the pillow, mortally thinned,
Weaker than water, yet his gesture proving
As steady as an undertow. Unmoving
In the sustained though slight aversion, grim
In wordlessness. Nothing deflected him,
Nothing I did and nothing I could say.
And so I left. I heard he died next day.

I have imagined that he still could taste
That bitterness and anger to the last,
Against the roles he saw me in because
He had to: of victor, as he thought I was,
Of heir, as to the cherished property
His mother — who knows why? — was giving me,
And of survivor, as I am indeed,
Recording so that I may later read
Of what has happened, whether between sheets,
Or in post offices, or on the streets.

POST SCRIPT: THE PANEL

Reciprocation from the dead. Having finished the post-office poem, I think I will take a look at the stained-glass panel it refers to, which C made I would say two years before he died. I fish it out from where I have kept it, between a filing cabinet and a small chest of drawers. It has acquired a cobweb, which I brush off before I look at it. In the lower foreground are a face with oriental features and an arm, as of someone lying on his stomach: a mysteriously tiered cone lies behind and above him. What I had forgotten is that the picture is surrounded on all four sides by the following inscription:

The needs of ghosts embarrass the living. A ghost must
eat and shit, must pack his body someplace. Neither buyer
nor bundle, a ghost has no tally, no readjusting value, no
soul counted at a bank.

Is this an excerpt from some Chinese book of wisdom, or is it C
himself speaking? When he made the panel, C may have already
suspected he had AIDS, but the prescience of the first sentence
astonishes me — as it does also that I remembered nothing of the
inscription while writing the poem but looked it up immediately
on finishing it.

Yes, the needs of him and his friend to "embarrass" me after
their deaths. The dead have no sense of tact, no manners, they
enter doors without knocking, but I continue to deal with them,
as proved by my writing the poem. They pack their bodies into
my dreams, they eat my feelings, and shit in my mind. They are
no good to me, of no value to me, but I cannot shake them and
do not want to. Their story, being part of mine, refuses to reach
an end. They present me with new problems, surprise me, con-
tradict me, my dear, my everpresent dead.

JEROME CAJA's artwork has been the subject of numerous showings, including Facing the Finish at the San Francisco Museum of Modern Art. Profiles of his work have appeared in *Artforum*, *Artweek*, *Art New England*, the *Los Angeles Times*, and elsewhere.

TORY DENT's poems have been published in *The Kenyon Review*, *Partisan Review*, *Agni Review*, and elsewhere. She is profiled in Andrea Vaucher's anthology *Muses from Chaos and Ash*, and her collection *What Silence Equals* was released by Persea Books in October 1993.

WILLIAM DICKEY recently retired after thirty years in the English and Creative Writing departments at San Francisco State University. His first book, *Of the Festivity*, appeared in the Yale series of younger poets; *The Rainbow Grocery* received the Juniper Prize; and *In the Dreaming: Selected Poems* will be released by the University of Arkansas Press in 1994.

MICHAEL FLANAGAN, the president and archivist of Documentation of AIDS Issues and Research (DAIR), is the principal research associate for composer Diamanda Galás. His interviews and writings have been widely published.

Vocalist and composer DIAMANDA GALÁS is the creator of *Plague Mass,* described by the *New York Times* as a "powerful indictment of people who regard AIDS as divine retribution," and by the *Observer* as "the most profound musical contribution yet made to the support of the AIDS community." Ms. Galás has released nine critically acclaimed albums, and her solo performances have taken her from Lincoln Center (which premiered her *Masque of the Red Death* and *Insekta)* to Queen Elizabeth Hall. She has collaborated extensively with composers Iannis Xenakis and Vinko Globokar and directors Derek Jarman, Rosa von Praunheim, and Francis Ford Coppola.

Photographer NAN GOLDIN is the author of several collections of photographs including, most recently, *The Other Side. The Ballad of Sexual Dependency,* described as an "artistic masterwork" by the *New York Times* and as a *"Beggar's Opera* of recent time" by *Artforum,* has been produced as both a book and an installation with soundtrack. Her work has been exhibited at New York's Museum of Modern Art, the Berlin Film Festival, the Tokyo Metropolitan Museum of Photography, and elsewhere.

THOM GUNN, author of several books, including *My Sad Captains, The Passages of Joy,* and *Selected Poems,* is the recipient of a MacArthur Fellowship for 1993. His most recent collection, *The Man with Night Sweats,* has won a number of major awards.

ESSEX HEMPHILL is the editor of the award-winning *Brother to Brother: New Writings by Black Gay Men* (Alyson, 1991) and author of the award-winning *Ceremonies: Prose and Poetry* (Plume, 1992). He was featured in two critically acclaimed films: *Tongues Untied* by Marlon Riggs, and *Looking for Langston* by Isaac Julien.

Hemphill recently completed a one-year visiting scholar residency with the J. Paul Getty Trust. He is currently at work on a novel and an anthology of short fiction by Black gay men, and has received a fifteen-month fellowship in literature from the Pew Charitable Trusts in Philadelphia, where he currently resides.

B O H U S T O N (1959 – 1993) is the author of *Remember Me, Horse and Other Stories* (both Alyson), and *The Dream Life* (St. Martin's Press). *The Listener: A Novella and Five Stories* was released posthumously by St. Martin's Press.

A D A M K L E I N received his master's degree in Creative Writing from San Francisco State University. His writing has been featured in *Bastard Review* and *The Florida Review,* and his short story "Club Feet" is forthcoming in *Men on Men 5.* He is a recipient of a Vogelstein Foundation grant and an Academy of American Poetry Award.

T O N Y K U S H N E R received the 1993 Pulitzer Prize and the 1993 Tony Award for *Millennium Approaches,* the first half of his revolutionary play *Angels in America.* The second half, *Perestroika,* premiered in late 1993. He is also the author of *A Bright Room Called Day.*

M A R L O N R I G G S has created many films, incuding the Emmy Award-winning *Ethnic Notions. Tongues Untied,* his exploration of the lives of black gay men, received numerous awards including a Blue Ribbon in the American Film and Video Festival and Best Video in the New York Documentary Festival. He is a professor in the Department of Journalism at the University of California, Berkeley.

SEVERO SARDUY died of AIDS in June 1993 in Paris. He had lived there for years as a Cuban expatriate associated with the *Tel Quel* group of writers and critics. His books include *From Cuba with a Song* and *Written on a Body.*

EDMUND WHITE is the author of eleven books, among them five novels, including *Nocturnes for the King of Naples, A Boy's Own Story,* and *The Beautiful Room Is Empty.* He recently edited the *Faber Book of Gay Short Fiction* and has just released *Genet: A Biography* (Knopf) and the *The Selected Writings of Jean Genet* (Ecco).

DAVID WOJNAROWICZ (1956-1991) drew tremendous awareness to AIDS through his startlingly controversial works in art and his uncompromising political stance. He is the author of *Close to the Knives, Tongues of Flame,* and *Memories That Smell Like Gasoline.* A book of his photographs is forthcoming from Aperture.

Thomas Avena is the founder and editor of *Bastard Review*, a literary publication based in San Francisco. His collection, *death and desire*, supported by a grant from the San Francisco Foundation, features new writing by forty-five contributors, including a memoir by Octavio Paz. Mr. Avena's work as writer and editor for the multimedia exhibit Project Face to Face led to its installation at the inauguration of the Smithsonian Institution's Experimental Gallery. In residency there, Mr. Avena created a highly intimate series of printed stories based on oral histories from persons living with AIDS. More than 100,000 visitors viewed the resulting exhibit in 1991. Since 1987, Mr. Avena has worked with the underground "guerrilla" AIDS clinics in San Francisco, first as an individual battling AIDS-related-complex, and later as a speaker focusing on the profile of the long-term survivor. His work has taken him from forums for ACT UP and the pages of *GEO*, to profiles on CNN, ABC, and European television. Mr. Avena conceived *Life Sentences* during his residency at the Headlands Center for the Arts.

Editors:
Thomas Christensen, Hazel White,
Cynthia Gitter, & William Lyon Strong

Text Designer: David Peattie
Text Type: Bembo 11/16
Display Type: Avenir 45
Printer/Binder: Haddon Craftsmen Book Manufacturing